WATCHING NEW YORK

This book is dedicated to my son,

Cassius Z. Cirillo.

Street Style A to Z

WATCHING NEW YORK

JOHNNY CIRILLO

Abrams Image, New York

Contents

FOREWORD
by Gigi Hadid

If you ask me when I first started follow-ing Johnny's Watching New York account, I don't remember the exact moment, or how many years I've been following it. I do remember that his photos sparked the same joy that walking through the city and people-watching do for me. We all tend to see a repetitive group of public figures being photographed and published in their well-known styles, but to me it's refreshing to scroll through people I don't know who are so clearly expressing themselves in their own way.

New York is such a melting pot. I find the style here has a certain freedom of expression that, even in its wildest examples, is still based in reality of what you'll encounter here.

Every time I see a Watching New York post, I am inspired by how the people of New York City find their own language in how they dress and tell their story. It inspires me to do the same. From seeing someone wear a piece in a new way, taking that concept to the design office with me, to someone just carrying their style so well that it makes me smile, I am constantly enjoying and studying what people are saying with what they wear.

Watching New York is an impor-tant storyteller of our generation in this city and has given the world outside of NYC the chance to experience just what makes the city magical with us.

ℐNTRODUCTION

I was sixteen years old the first time the thought of being a photographer entered my mind. I was little, rambunctious, and growing. I took photography class in eleventh grade as a way to avoid any kind of responsibility and do as little as possible with my time inside the school. I often cut class or doodled during the lessons, but Mr. Caskey, bless him, was patient with me. I tortured him by constantly being a disruptive, obnoxious, and pesty teen. "Cirillo!" I can still hear the blunt, stern power of his kind voice. He seemed to look past all the caution tape and provided me with confidence and nurture. He entered a photo of mine into a high school contest without me knowing, and that gesture alone meant more to me than winning. I began cutting other classes to spend more time in the darkroom and dedicated my free time to learning and shooting and developing. I can still smell the chemicals from printing my photos and remember the excitement of the process. I fell down the rabbit hole and I never looked back.

After high school, I took over a small basement room in my parents'

house and built out a darkroom. I went ballistic. I was buying hundreds of feet of film and rolling them myself. I would shoot all day long and develop well into the night. I was free to make mistakes and learn from them.

I moved into my first apartment in Greenpoint, Brooklyn, in 2004. From 2004 until 2010 I worked in a restaurant and shot solely for my own enjoyment. Then I got a job at Colony Studios, where I got to observe great photo giants like Guy Aroch and Alexei Hay. I saw a seventeen-year-old Bella Hadid photographed for her very first magazine cover! Bands I adored like Blonde Redhead filmed music videos there. I wanted to immerse myself in the studio, but my boss, Gio, had other plans. "Sitting at a desk and making a schedule for photographers isn't your bag. You should be the one shooting, so I'm doing this for you," and he told me to pack my things and take a hike. I owe him for his decision. When I went home and told my wife, Kristin, she afforded me all the time I needed to build my portfolio. I started with friends and family

FOREWORD
by Gigi Hadid

If you ask me when I first started following Johnny's Watching New York account, I don't remember the exact moment, or how many years I've been following it. I do remember that his photos sparked the same joy that walking through the city and people-watching do for me. We all tend to see a repetitive group of public figures being photographed and published in their well-known styles, but to me it's refreshing to scroll through people I don't know who are so clearly expressing themselves in their own way.

New York is such a melting pot. I find the style here has a certain freedom of expression that, even in its wildest examples, is still based in reality of what you'll encounter here.

Every time I see a Watching New York post, I am inspired by how the people of New York City find their own language in how they dress and tell their story. It inspires me to do the same. From seeing someone wear a piece in a new way, taking that concept to the design office with me, to someone just carrying their style so well that it makes me smile, I am constantly enjoying and studying what people are saying with what they wear.

Watching New York is an important storyteller of our generation in this city and has given the world outside of NYC the chance to experience just what makes the city magical with us.

ᕭINTRODUCTION

I was sixteen years old the first time the thought of being a photographer entered my mind. I was little, rambunctious, and growing. I took photography class in eleventh grade as a way to avoid any kind of responsibility and do as little as possible with my time inside the school. I often cut class or doodled during the lessons, but Mr. Caskey, bless him, was patient with me. I tortured him by constantly being a disruptive, obnoxious, and pesty teen. "Cirillo!" I can still hear the blunt, stern power of his kind voice. He seemed to look past all the caution tape and provided me with confidence and nurture. He entered a photo of mine into a high school contest without me knowing, and that gesture alone meant more to me than winning. I began cutting other classes to spend more time in the darkroom and dedicated my free time to learning and shooting and developing. I can still smell the chemicals from printing my photos and remember the excitement of the process. I fell down the rabbit hole and I never looked back.

After high school, I took over a small basement room in my parents' house and built out a darkroom. I went ballistic. I was buying hundreds of feet of film and rolling them myself. I would shoot all day long and develop well into the night. I was free to make mistakes and learn from them.

I moved into my first apartment in Greenpoint, Brooklyn, in 2004. From 2004 until 2010 I worked in a restaurant and shot solely for my own enjoyment. Then I got a job at Colony Studios, where I got to observe great photo giants like Guy Aroch and Alexei Hay. I saw a seventeen-year-old Bella Hadid photographed for her very first magazine cover! Bands I adored like Blonde Redhead filmed music videos there. I wanted to immerse myself in the studio, but my boss, Gio, had other plans. "Sitting at a desk and making a schedule for photographers isn't your bag. You should be the one shooting, so I'm doing this for you," and he told me to pack my things and take a hike. I owe him for his decision. When I went home and told my wife, Kristin, she afforded me all the time I needed to build my portfolio. I started with friends and family

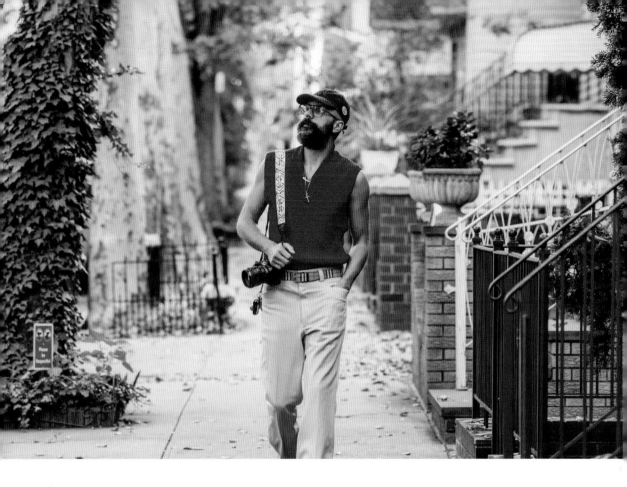

and began building a clientele. Within a year, I was freelance shooting with a full schedule. Weddings, newborns, engagements, events, products, anything I could get my lens on. I did that for years.

Initially, Watching New York was only supposed to be a one-day project. Before there was a name, or any structure or interviews, I just wanted to honor a man whose work I admired for many years. When Bill Cunningham, the legendary *New York Times* street fashion photographer passed away on June 25, 2016, I felt a void. I had never met him but oftentimes felt his presence while walking down a busy NYC street. I was fascinated with him as a photographer and as a person. He encapsulated beautifully what it meant to be an artist in my eyes: shooting photographs of what he loved well into his eighties and working for the biggest publication on earth. This wasn't a young, hungry, fresh-out-of-college whippersnapper. He never stopped shooting; it was his air. I enjoyed his photographs, but I adored his dedication to the streets. It was rare to see

an older man riding a bicycle down a Manhattan street in the rain and jumping off like a spring just to catch a yellow raincoat, but that's passion. On that day, I thought going out and doing what he did so well and dedicated so much of his life to would be my way of honoring him.

I headed into SoHo on that smoldering, bright Saturday. The streets were filled, and I didn't know where to start. I used a very long 200mm lens so that I didn't have to feel the fear of someone catching me in the act of snagging their photo. The day was a slog. I struggled, I fumbled, and I felt frustrated. It was the good frustration. The kind that you know there's a way out of.

The sun went down, and I thought, I'll try again tomorrow. And eight years later, I have tried every tomorrow since. In some weird way, I always thought of Watching New York as an extension of Bill's work. I pretend he nods at me at times and gets behind me with a nudge when I'm feeling tired, as if to say, "Don't stop now, kid, one might get away."

It became my personal summer project that year. I wasn't sharing the images anywhere, really, just enjoying the process and learning to find my voice.

I linked up with a local publication called *Greenpointers*, and on Sundays we would share my top ten favorite looks from the week in a column called "Fashion Sundae." It was the first time anyone started recognizing my work. "Fashion Sundae" gave me slightly more purpose, which was nice. I felt a responsibility to document what I was seeing on the streets. The bold, the dashing, the rich, the poor, and everything in between. One day I posted a photo of a guy and a girl holding hands, smiling. I got a message shortly after I posted. "That's me in the photo. My girlfriend and I are huge fans of your work; unfortunately, that's not my girlfriend in the photo." From that day forward, I have asked permission from every person I have photographed.

Having to speak to everyone in order to receive their permission, the page naturally became evolutionary rather than revolutionary. It was hard at first, but eventually I grew to love stopping strangers on the street. Naturally, I would start to ask questions about their outfits, which then led to questions about the people themselves. Before I knew it, fifteen minutes would pass, and I would be hugging a total stranger and sharing with them a life moment that enriched the way I was feeling. The people of New York opened up to me, and I felt my life expanding. It was therapeutic for us both. Sometimes the conversation would be happy and sometimes sad, but overall, the work set me free. We walk around with the world on our shoulders, always thinking, I'm the only one, until you start talking deeply with loads of strangers and you realize, Maybe we're all going through this together.

I'd like to think we were helping one another while sharing these intimate interactions with a growing audience. People started to relate more and more to the stories and often told me that they found comfort in seeing themselves in others. I could feel my purpose growing with every interaction.

A day that I'll never forget is when I posted Monday Blues, a once-struggling artist now designing clothes based on their experiences of being homeless. The day I met Monday, they were wearing an outfit made of coffee bean bags, and I'd never seen anything like it before. They told me that while on a train in Chicago, Monday spotted some discarded Starbucks coffee bean bags out the window. Out of necessity, they had made an entire outfit out of it. I posted their story, and the next morning the world was embracing Monday Blues. That was a light bulb moment for me: highlighting these incredible New York creatives who just need a small microphone to be heard.

I leaned into it and made it part of my daily hunting.

Some days I pace up and down blocks for hours and don't find what I'm looking for. Some days I see trends I've grown slightly tired of. Once in a while I just want to sit inside a restaurant and eat lunch, but the thought of missing the next person haunts me. I'll grab a bite on the go and that's usually when the magic starts. I'll see a possible new trend! Or find exactly what I was searching for! I might talk to a now-no-longer stranger who has changed the entire vibration of my day for the better and I'm fully recharged again. The flame is bright inside, and I am filled with being thankful and very proud to be here. I'm filled with loving this work and feeling like these small interactions matter, even if to no one else but me and them. It's never lost on me where I am. Standing in New York City with my camera around my neck is a treasure to me. I think about Mr. Caskey and me at sixteen and smile.

How I Got Started

Back in September 2015, this guy named Austin Mitchell saw me with my camera and we started to chat. He told me he had an idea for a podcast and wanted to see if I would be interested. Essentially, we would walk around the city and stop and chat with a stranger. The idea was to see a glimpse into a stranger's life. Maybe feel a connection and ultimately, hopefully, see the people around you not so much as strangers but as comrades. Austin would conduct the interview and I would snap a portrait. Each day a new episode would come out and would be exactly one minute long. We made 200 episodes of *Profiles: NYC*, and it was the first time I dipped my toes into the pond of approaching strangers on the street. The podcast began to gain momentum, and before long, Austin was hired by Gimlet, a podcast company, and didn't have time to make the show anymore. The podcast ended on June 10, 2016, just two weeks before Bill Cunningham passed away and I would start Watching New York.

It was that podcast that gave me the little extra boost I needed at the beginning when approaching these strangers.

I think I had around three thousand followers when I was posting for "Fashion Sundae" with *Greenpointers* when a local fashion creator, Rachel Martino, posted about me in her stories. She said something along the lines of, "If you're into fashion, @watchingnewyork is a must follow," and I woke up with 10K followers. I remember that morning, opening Instagram and saying to my wife, Kristin, "Whoa, something's happening!" It was a moment I'll never forget. By the end of the day, I think I was at around 14K. It was the second step that boosted me to a larger audience.

Three months later, I got a message from Joelle Garguilo at NBC. She interviewed me inside my apartment and on the streets of Brooklyn. I had 30K followers when that aired, and within three months I was at 100K. I have a great deal of gratitude for Joelle and NBC. That was the third and very giant step that pushed me to a higher level.

But the biggest boost I got was from the people. Day in and day out, people have been sharing my work. I couldn't believe that my photos were being seen by people all over the country and beyond.

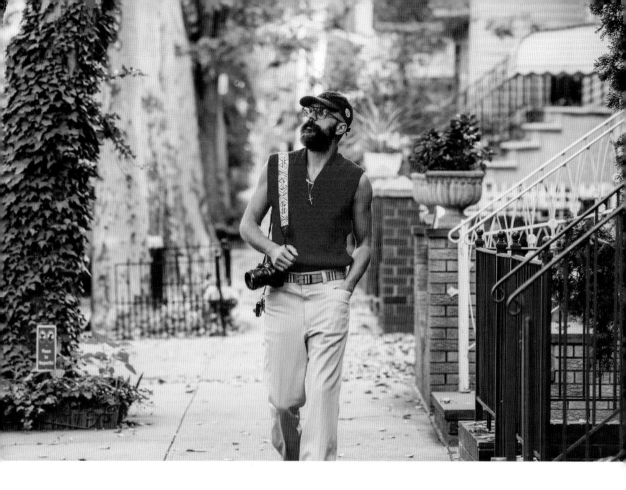

and began building a clientele. Within a year, I was freelance shooting with a full schedule. Weddings, newborns, engagements, events, products, anything I could get my lens on. I did that for years.

Initially, Watching New York was only supposed to be a one-day project. Before there was a name, or any structure or interviews, I just wanted to honor a man whose work I admired for many years. When Bill Cunningham, the legendary *New York Times* street fashion photographer passed away on June 25, 2016, I felt a void. I had never met him but oftentimes felt his presence while walking down a busy NYC street. I was fascinated with him as a photographer and as a person. He encapsulated beautifully what it meant to be an artist in my eyes: shooting photographs of what he loved well into his eighties and working for the biggest publication on earth. This wasn't a young, hungry, fresh-out-of-college whippersnapper. He never stopped shooting; it was his air. I enjoyed his photographs, but I adored his dedication to the streets. It was rare to see

an older man riding a bicycle down a Manhattan street in the rain and jumping off like a spring just to catch a yellow raincoat, but that's passion. On that day, I thought going out and doing what he did so well and dedicated so much of his life to would be my way of honoring him.

I headed into SoHo on that smoldering, bright Saturday. The streets were filled, and I didn't know where to start. I used a very long 200mm lens so that I didn't have to feel the fear of someone catching me in the act of snagging their photo. The day was a slog. I struggled, I fumbled, and I felt frustrated. It was the good frustration. The kind that you know there's a way out of.

The sun went down, and I thought, I'll try again tomorrow. And eight years later, I have tried every tomorrow since. In some weird way, I always thought of Watching New York as an extension of Bill's work. I pretend he nods at me at times and gets behind me with a nudge when I'm feeling tired, as if to say, "Don't stop now, kid, one might get away."

It became my personal summer project that year. I wasn't sharing the images anywhere, really, just enjoying the process and learning to find my voice.

I linked up with a local publication called *Greenpointers*, and on Sundays we would share my top ten favorite looks from the week in a column called "Fashion Sundae." It was the first time anyone started recognizing my work. "Fashion Sundae" gave me slightly more purpose, which was nice. I felt a responsibility to document what I was seeing on the streets. The bold, the dashing, the rich, the poor, and everything in between. One day I posted a photo of a guy and a girl holding hands, smiling. I got a message shortly after I posted. "That's me in the photo. My girlfriend and I are huge fans of your work; unfortunately, that's not my girlfriend in the photo." From that day forward, I have asked permission from every person I have photographed.

Having to speak to everyone in order to receive their permission, the page naturally became evolutionary rather than revolutionary. It was hard at first, but eventually I grew to love stopping strangers on the street. Naturally, I would start to ask questions about their outfits, which then led to questions about the people themselves. Before I knew it, fifteen minutes would pass, and I would be hugging a total stranger and sharing with them a life moment that enriched the way I was feeling. The people of New York opened up to me, and I felt my life expanding. It was therapeutic for us both. Sometimes the conversation would be happy and sometimes sad, but overall, the work set me free. We walk around with the world on our shoulders, always thinking, I'm the only one, until you start talking deeply with loads of strangers and you realize, Maybe we're all going through this together.

I'd like to think we were helping one another while sharing these intimate interactions with a growing audience. People started to relate more and more to the stories and often told me that they found comfort in seeing themselves in others. I could feel my purpose growing with every interaction.

A day that I'll never forget is when I posted Monday Blues, a once-struggling artist now designing clothes based on their experiences of being homeless. The day I met Monday, they were wearing an outfit made of coffee bean bags, and I'd never seen anything like it before. They told me that while on a train in Chicago, Monday spotted some discarded Starbucks coffee bean bags out the window. Out of necessity, they had made an entire outfit out of it. I posted their story, and the next morning the world was embracing Monday Blues. That was a light bulb moment for me: highlighting these incredible New York creatives who just need a small microphone to be heard.

I leaned into it and made it part of my daily hunting.

Some days I pace up and down blocks for hours and don't find what I'm looking for. Some days I see trends I've grown slightly tired of. Once in a while I just want to sit inside a restaurant and eat lunch, but the thought of missing the next person haunts me. I'll grab a bite on the go and that's usually when the magic starts. I'll see a possible new trend! Or find exactly what I was searching for! I might talk to a now-no-longer stranger who has changed the entire vibration of my day for the better and I'm fully recharged again. The flame is bright inside, and I am filled with being thankful and very proud to be here. I'm filled with loving this work and feeling like these small interactions matter, even if to no one else but me and them. It's never lost on me where I am. Standing in New York City with my camera around my neck is a treasure to me. I think about Mr. Caskey and me at sixteen and smile.

How I Got Started

Back in September 2015, this guy named Austin Mitchell saw me with my camera and we started to chat. He told me he had an idea for a podcast and wanted to see if I would be interested. Essentially, we would walk around the city and stop and chat with a stranger. The idea was to see a glimpse into a stranger's life. Maybe feel a connection and ultimately, hopefully, see the people around you not so much as strangers but as comrades. Austin would conduct the interview and I would snap a portrait. Each day a new episode would come out and would be exactly one minute long. We made 200 episodes of *Profiles: NYC*, and it was the first time I dipped my toes into the pond of approaching strangers on the street. The podcast began to gain momentum, and before long, Austin was hired by Gimlet, a podcast company, and didn't have time to make the show anymore. The podcast ended on June 10, 2016, just two weeks before Bill Cunningham passed away and I would start Watching New York.

It was that podcast that gave me the little extra boost I needed at the beginning when approaching these strangers.

I think I had around three thousand followers when I was posting for "Fashion Sundae" with *Greenpointers* when a local fashion creator, Rachel Martino, posted about me in her stories. She said something along the lines of, "If you're into fashion, @watchingnewyork is a must follow," and I woke up with 10K followers. I remember that morning, opening Instagram and saying to my wife, Kristin, "Whoa, something's happening!" It was a moment I'll never forget. By the end of the day, I think I was at around 14K. It was the second step that boosted me to a larger audience.

Three months later, I got a message from Joelle Garguilo at NBC. She interviewed me inside my apartment and on the streets of Brooklyn. I had 30K followers when that aired, and within three months I was at 100K. I have a great deal of gratitude for Joelle and NBC. That was the third and very giant step that pushed me to a higher level.

But the biggest boost I got was from the people. Day in and day out, people have been sharing my work. I couldn't believe that my photos were being seen by people all over the country and beyond.

A

Accessories,

All in Black,

Alternative,

Best of Amber,

Best of Anthony Sneed

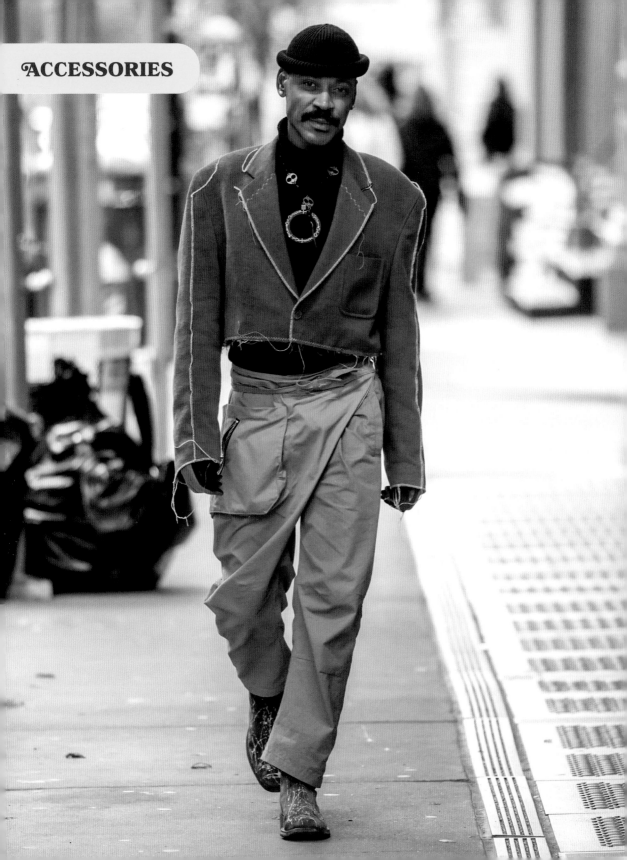

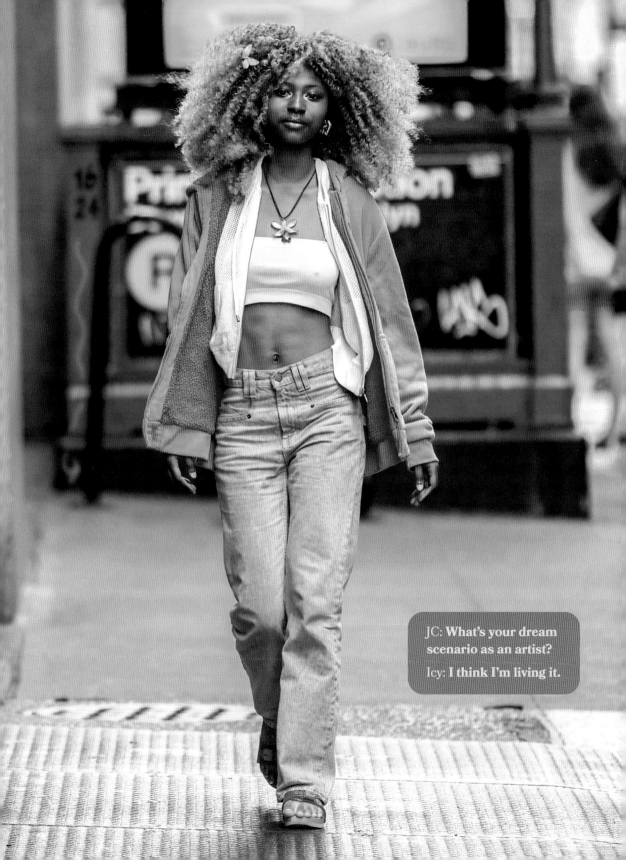

JC: **What's your dream scenario as an artist?**

Icy: **I think I'm living it.**

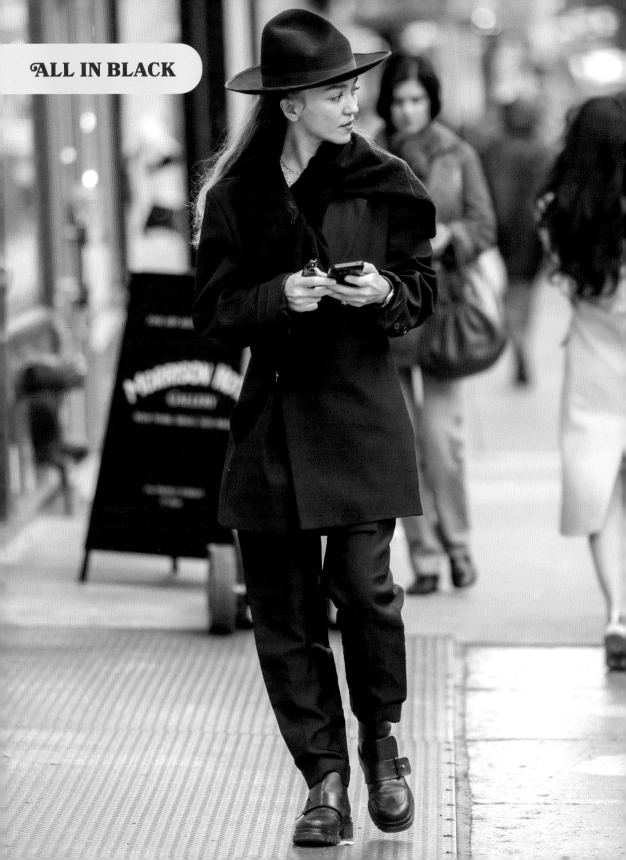

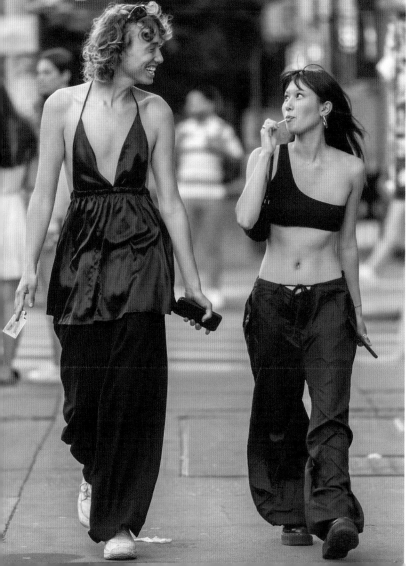
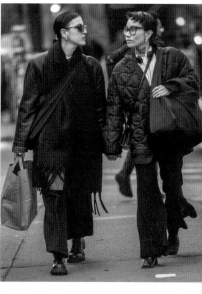
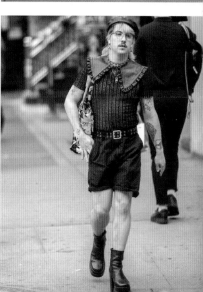

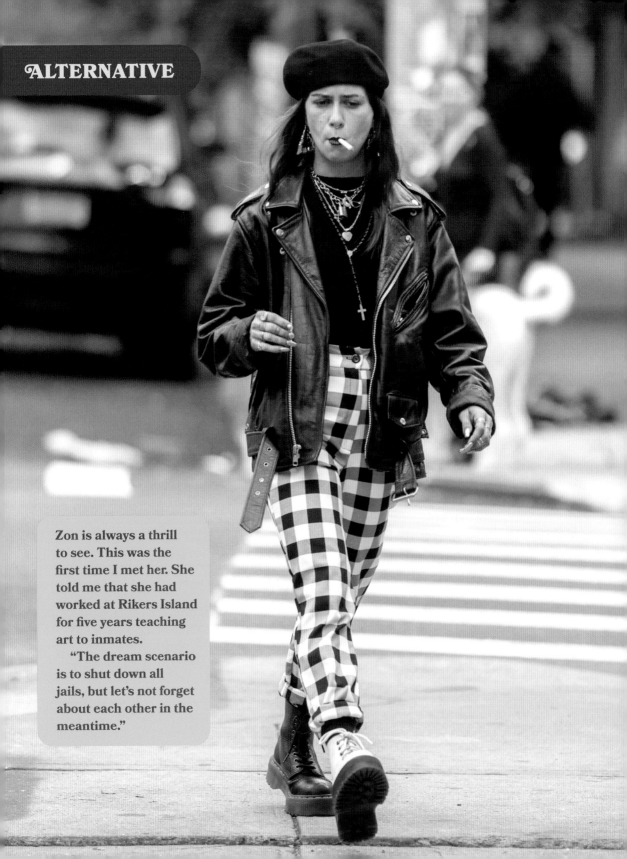

Zon is always a thrill to see. This was the first time I met her. She told me that she had worked at Rikers Island for five years teaching art to inmates.

"The dream scenario is to shut down all jails, but let's not forget about each other in the meantime."

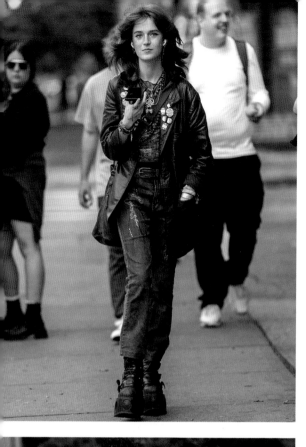
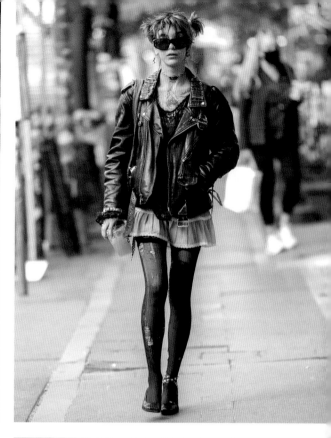
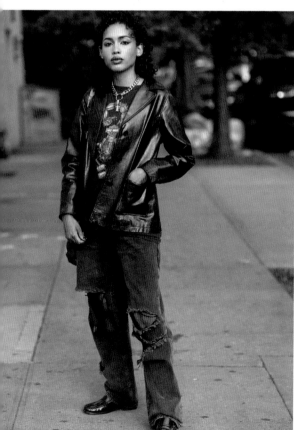
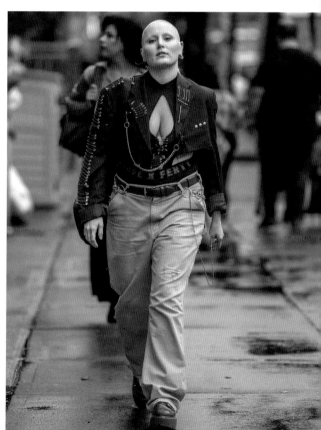

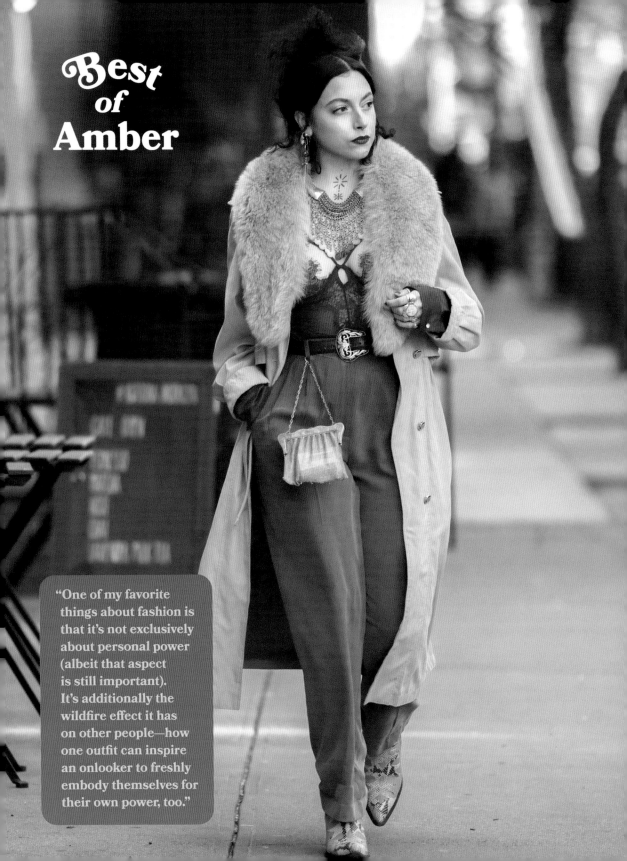

Best of Amber

"One of my favorite things about fashion is that it's not exclusively about personal power (albeit that aspect is still important). It's additionally the wildfire effect it has on other people—how one outfit can inspire an onlooker to freshly embody themselves for their own power, too."

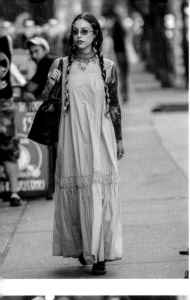
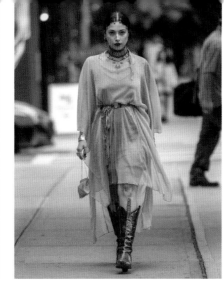
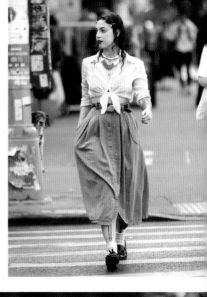
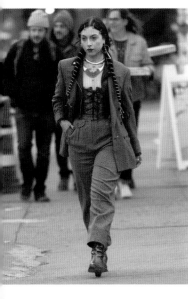
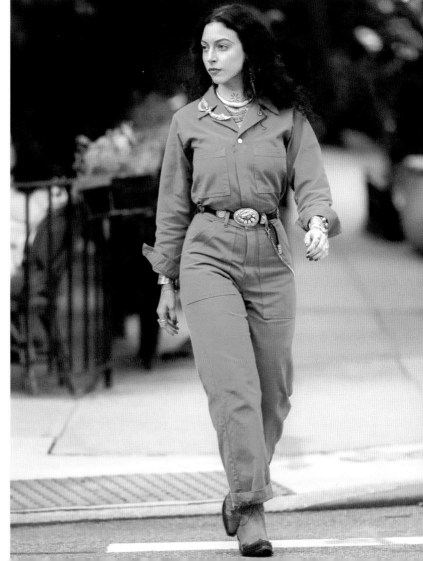
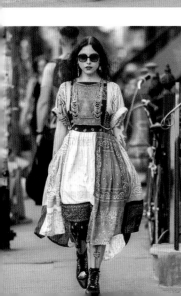

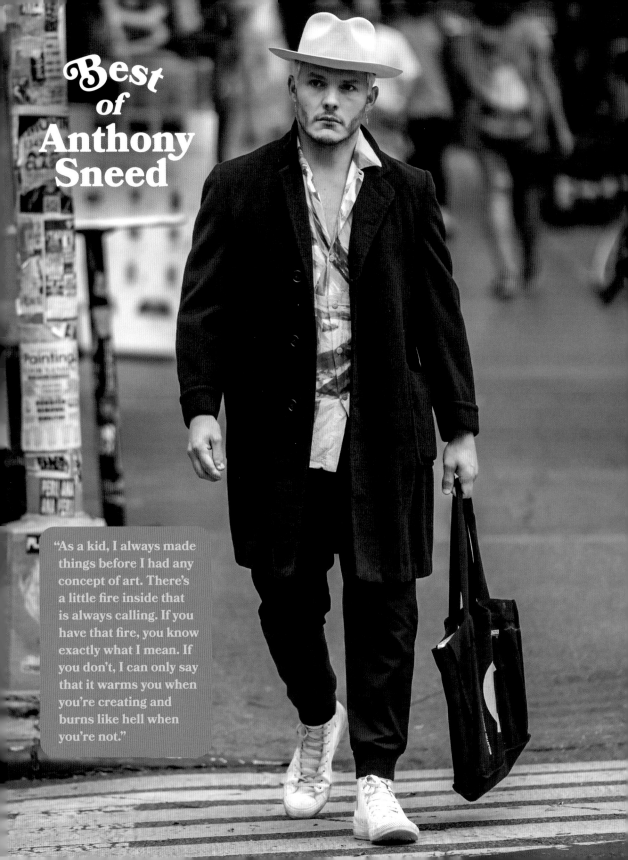

Best
of
Anthony
Sneed

"As a kid, I always made things before I had any concept of art. There's a little fire inside that is always calling. If you have that fire, you know exactly what I mean. If you don't, I can only say that it warms you when you're creating and burns like hell when you're not."

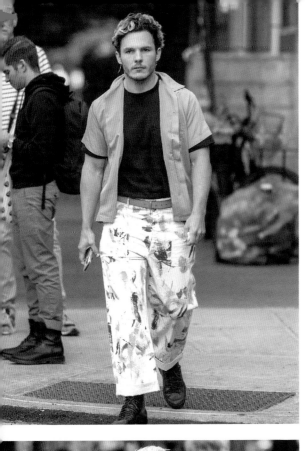
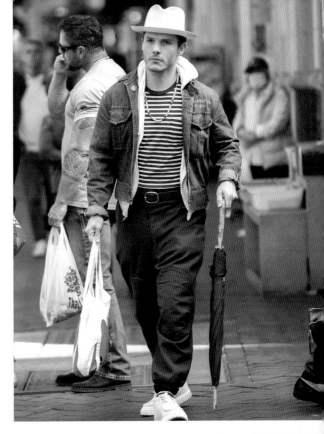
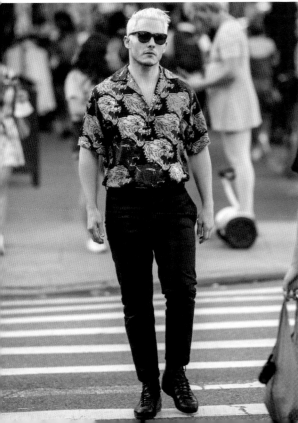
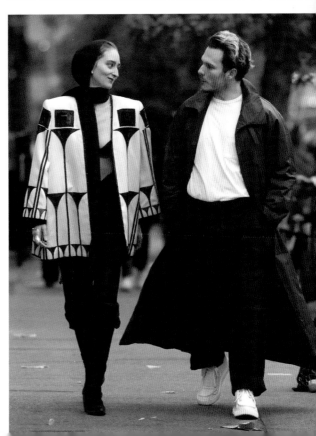

**Baggy, Band Tees,
Bandanas and Headscarves,
Belts, Berets,
Blazers, Bohemian,
Bucket Hats**

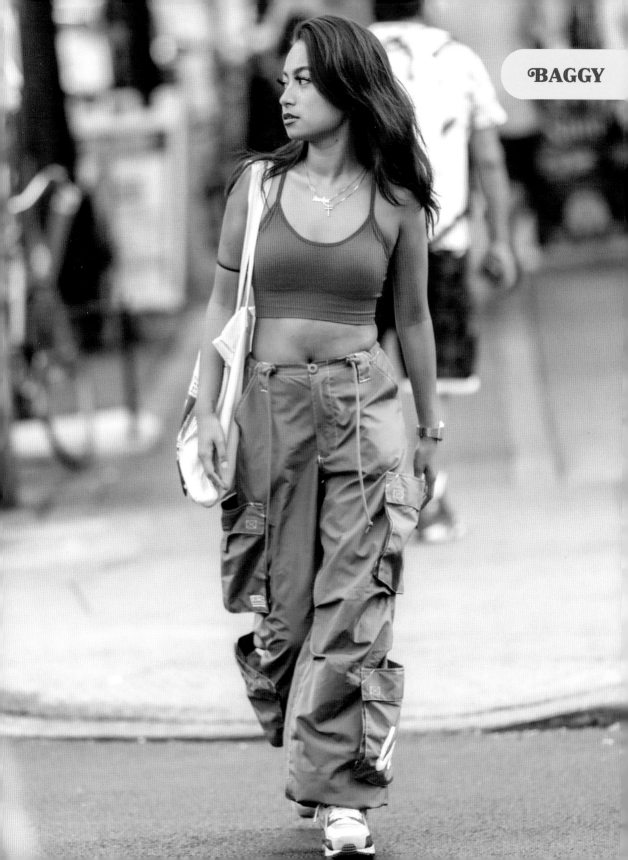

BAGGY

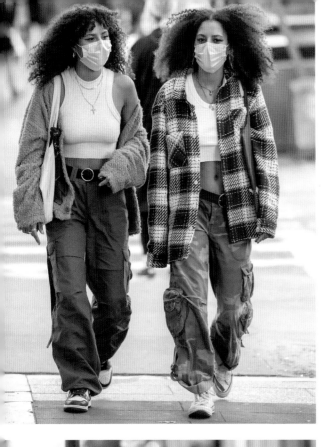
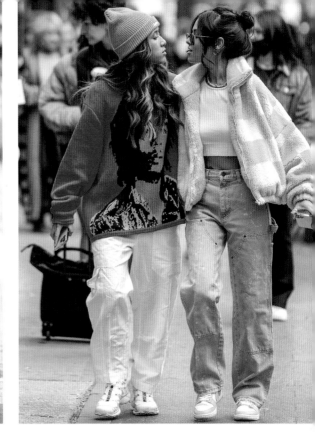
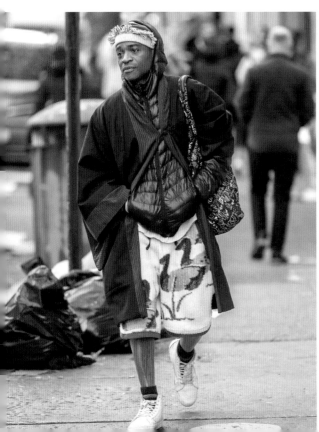
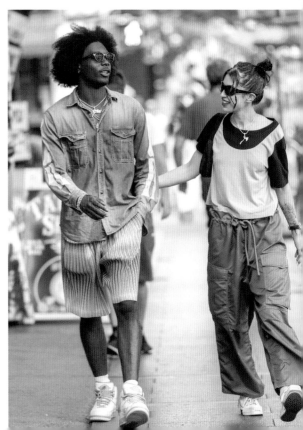

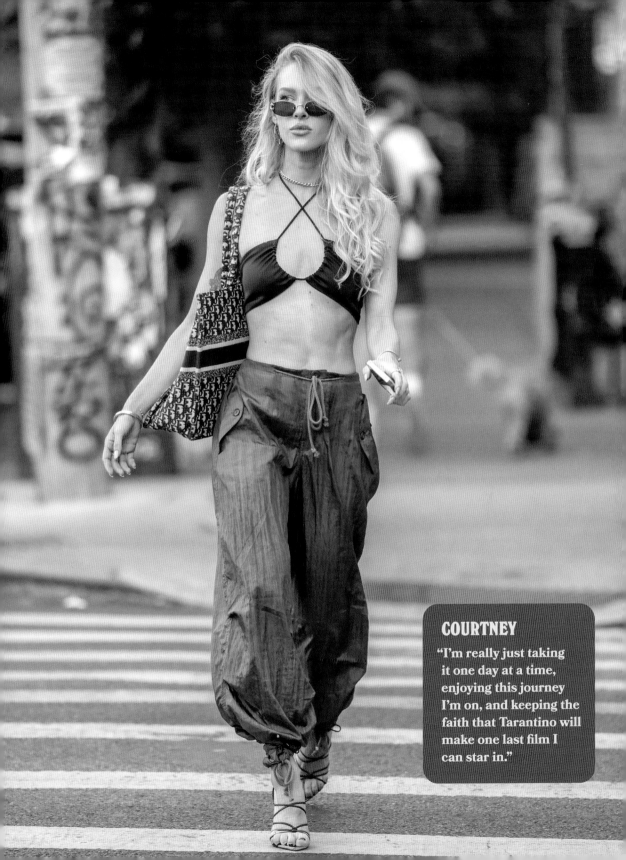

COURTNEY

"I'm really just taking it one day at a time, enjoying this journey I'm on, and keeping the faith that Tarantino will make one last film I can star in."

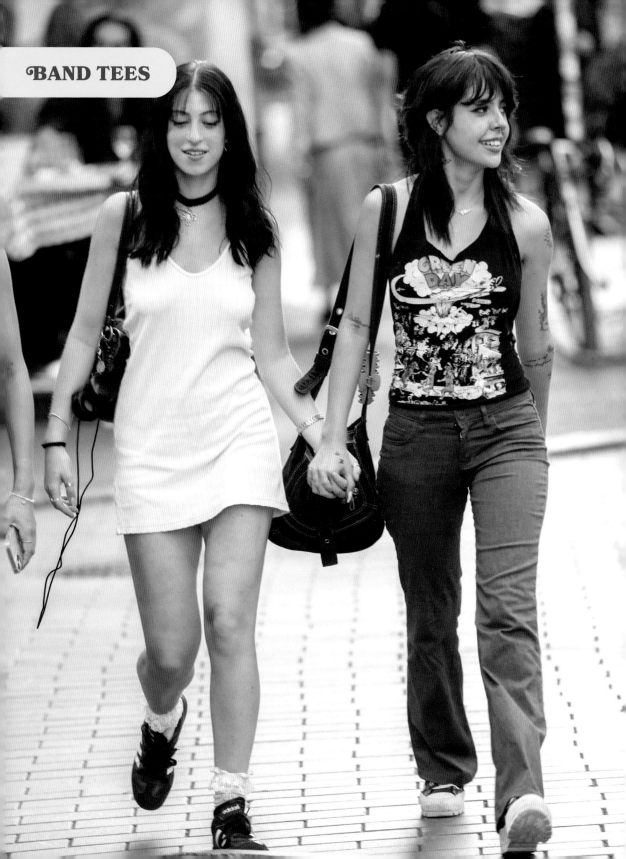

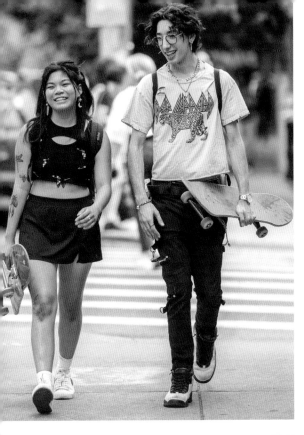
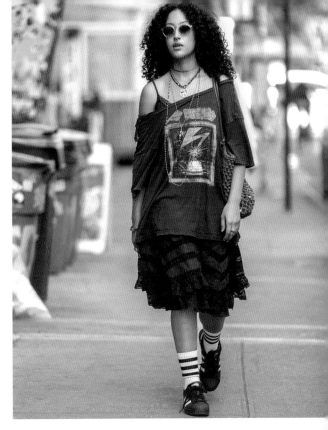
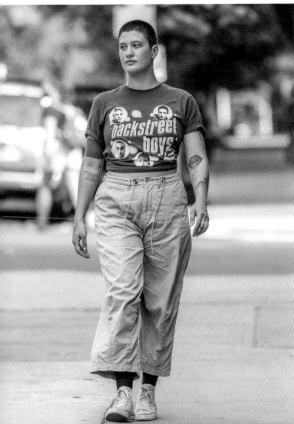
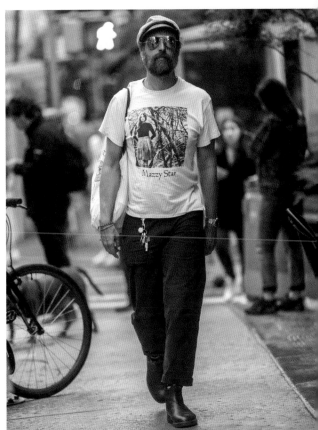

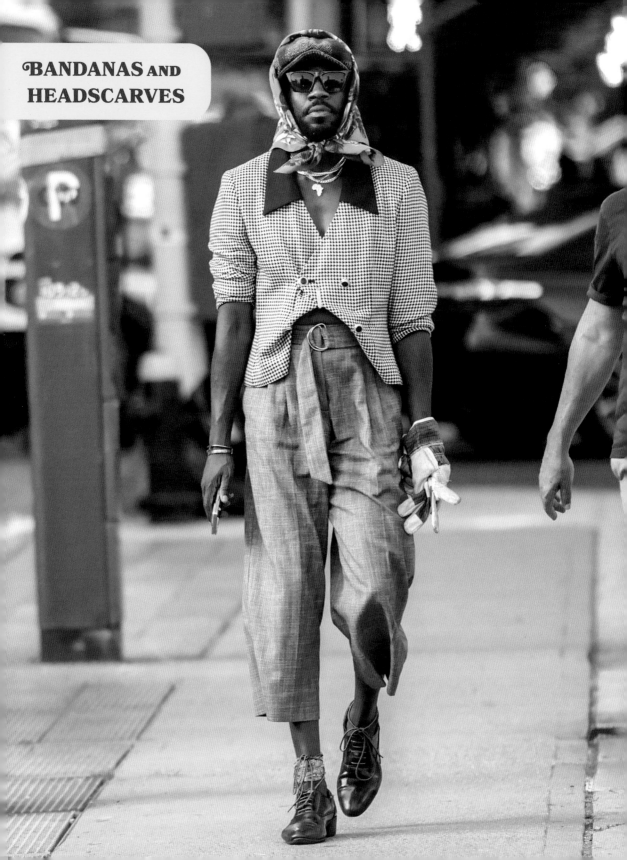

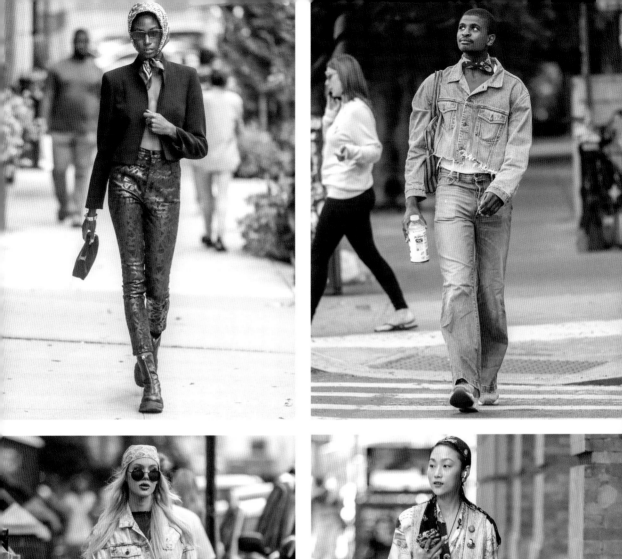
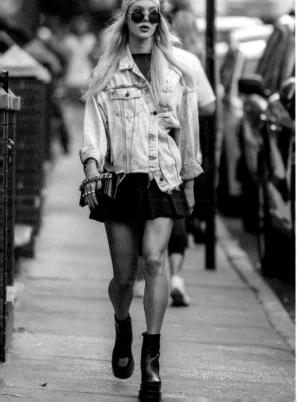
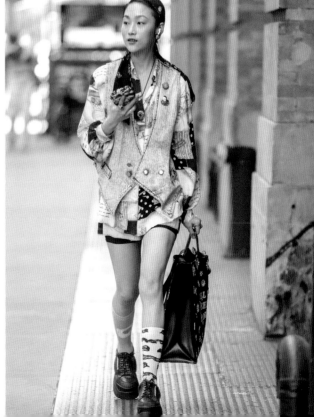

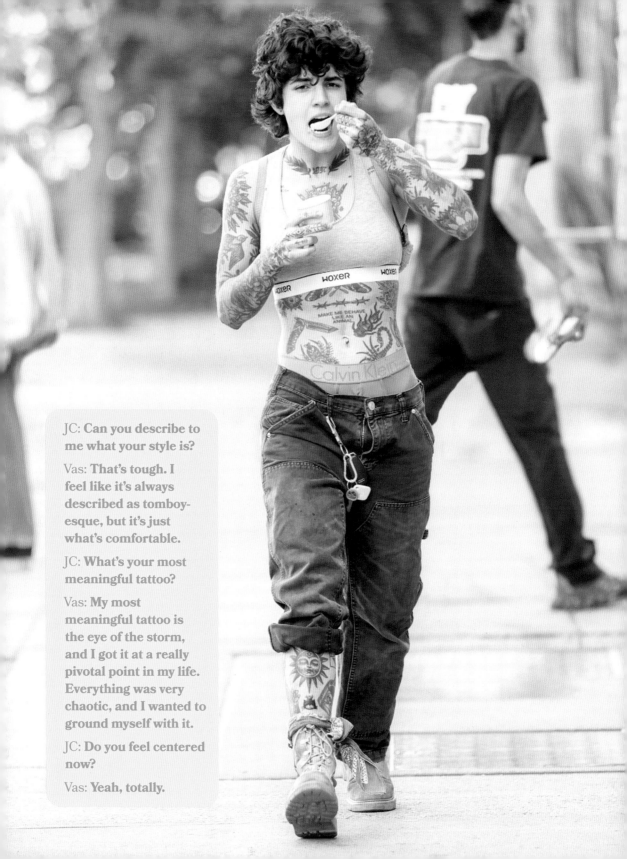

JC: **Can you describe to me what your style is?**

Vas: **That's tough. I feel like it's always described as tomboy-esque, but it's just what's comfortable.**

JC: **What's your most meaningful tattoo?**

Vas: **My most meaningful tattoo is the eye of the storm, and I got it at a really pivotal point in my life. Everything was very chaotic, and I wanted to ground myself with it.**

JC: **Do you feel centered now?**

Vas: **Yeah, totally.**

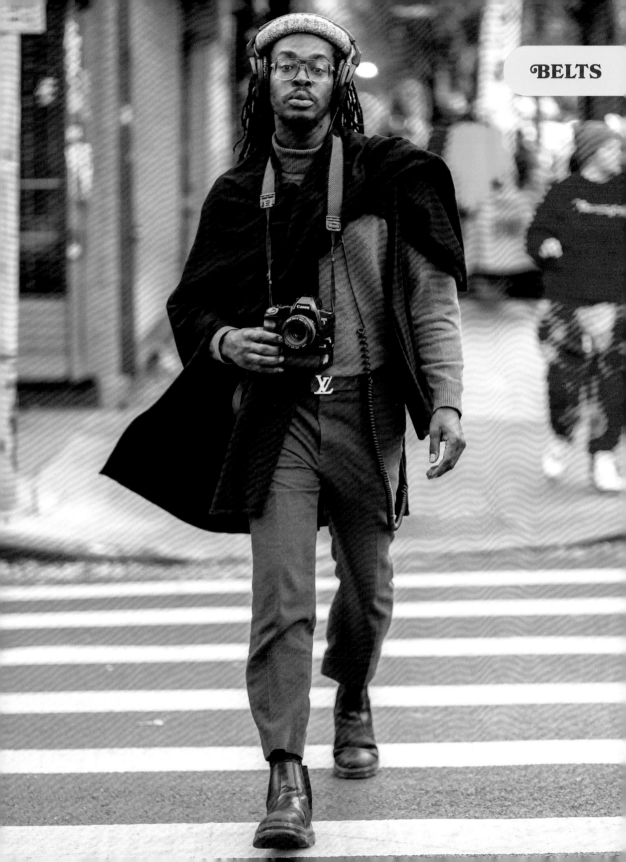

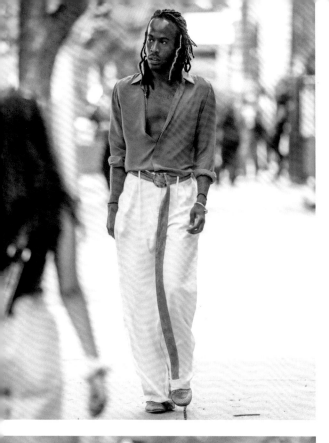
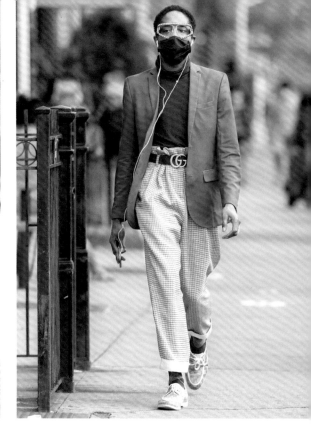
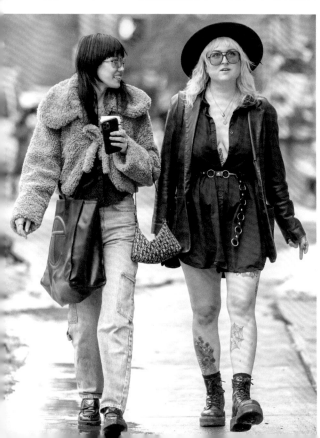
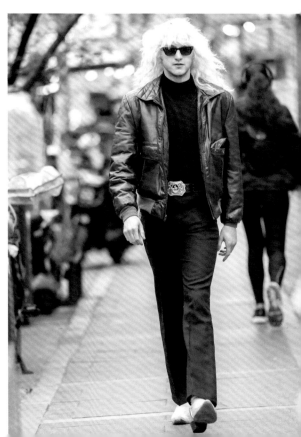

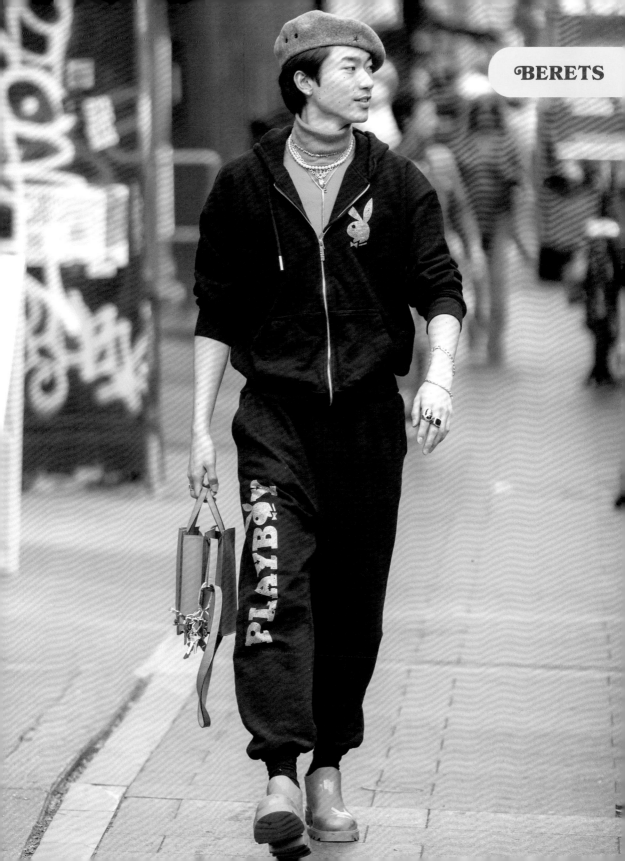

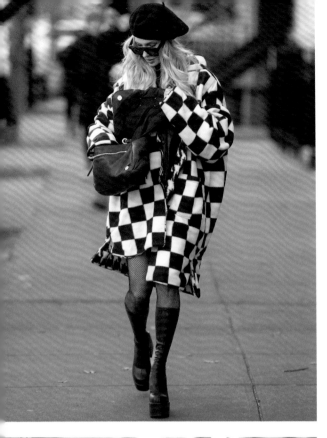
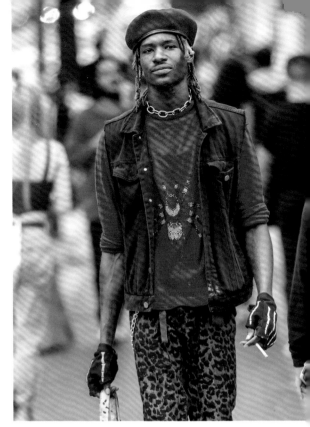
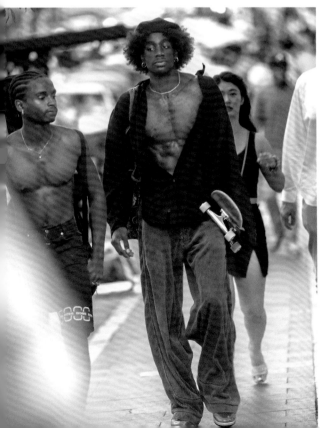
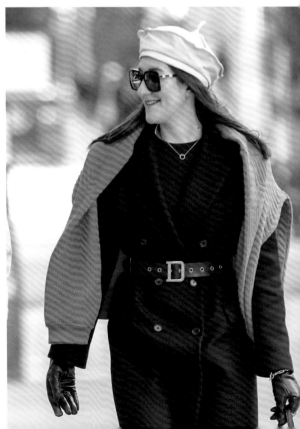

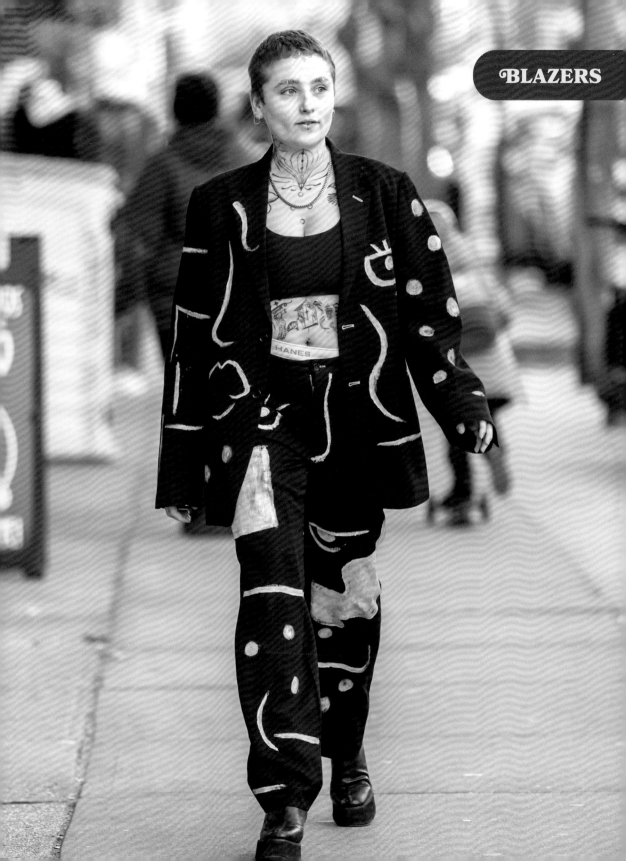

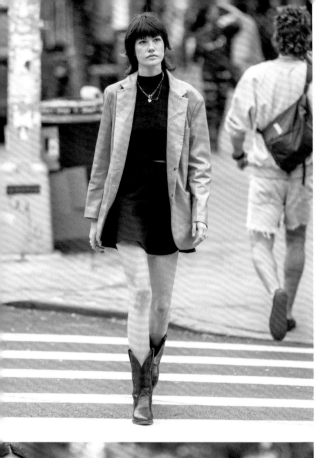
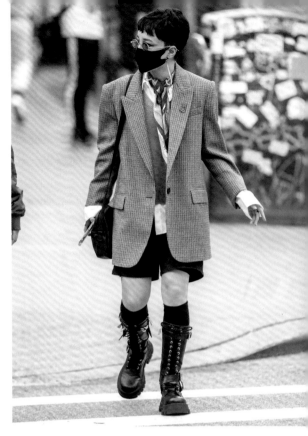
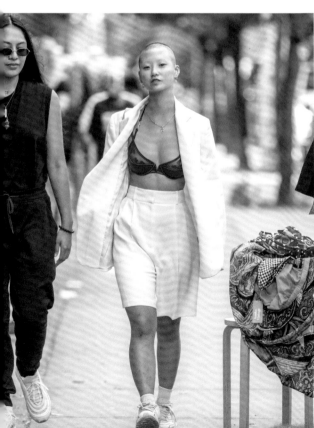
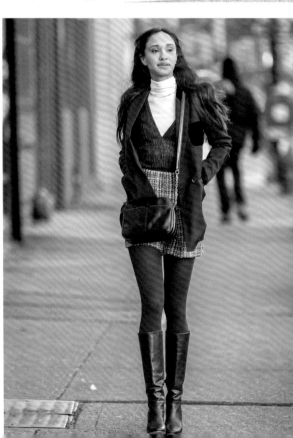

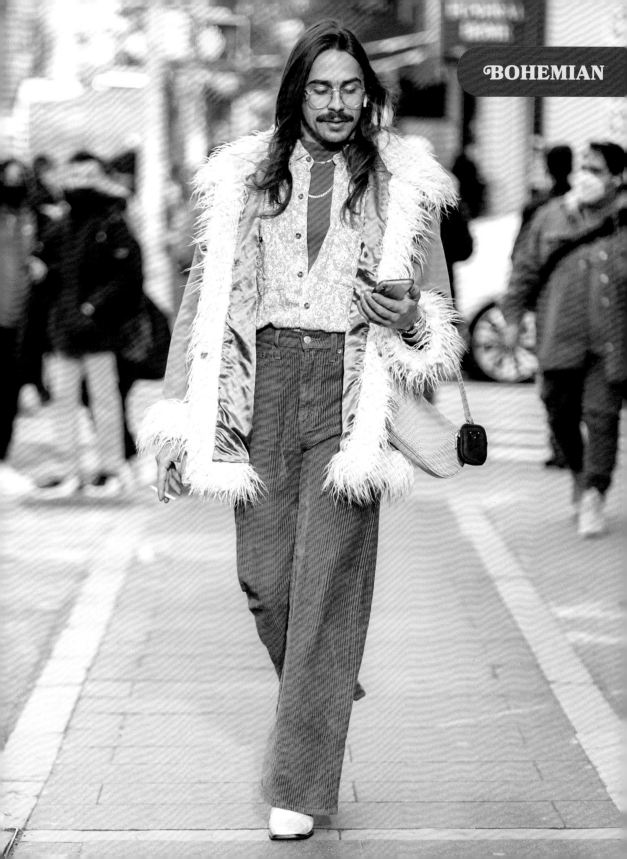

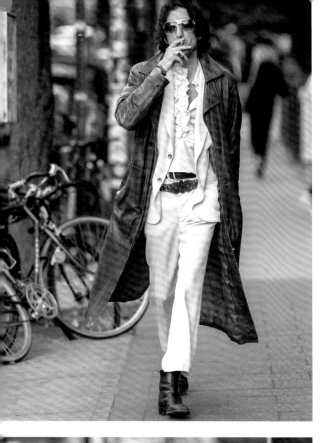
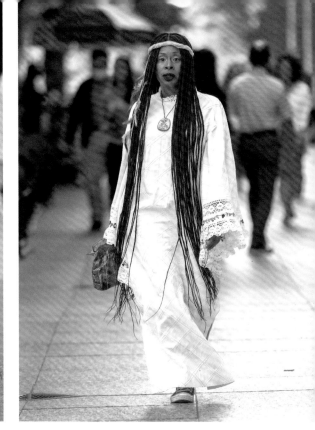
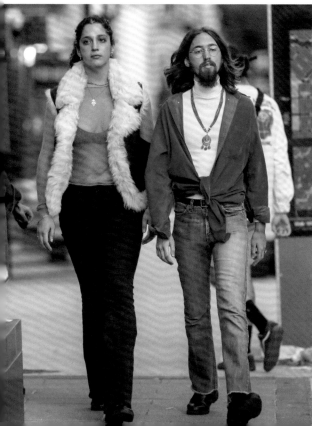
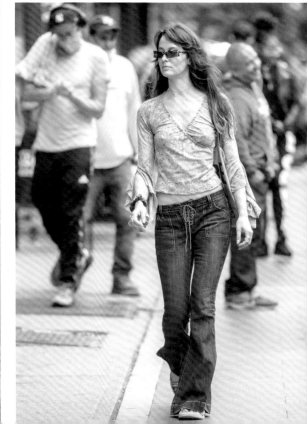

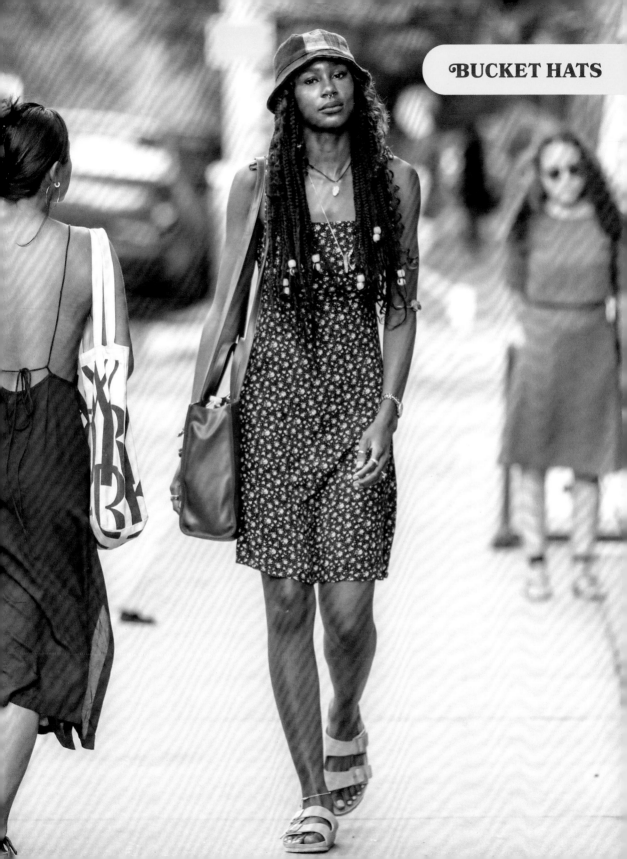

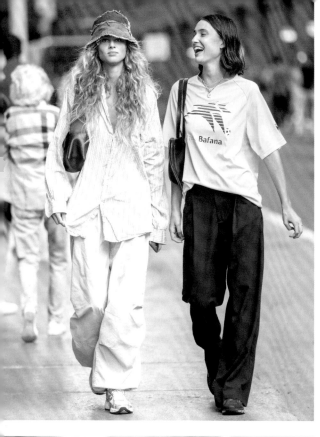
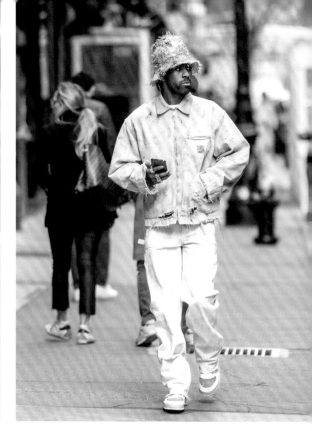
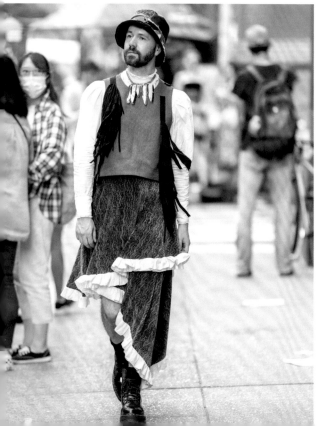
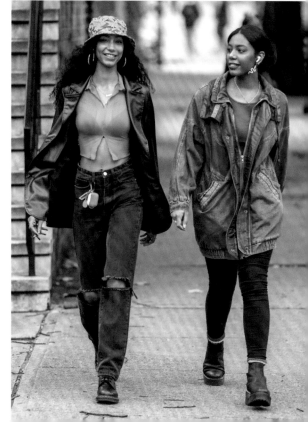

C

**Cardigans, Casual,
Color Blocking,
Coordinating,
Corset Tops, Cowboy
Boots, Cropped**

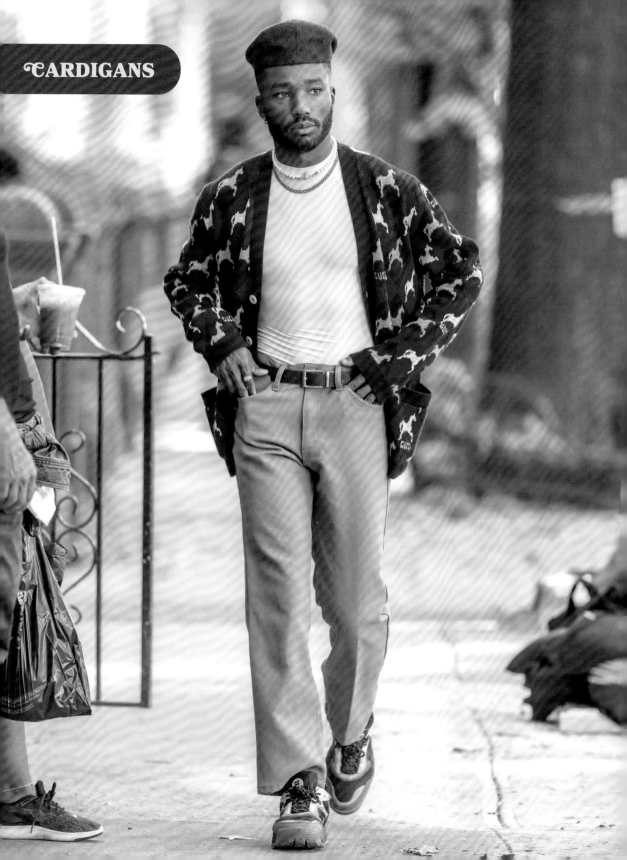

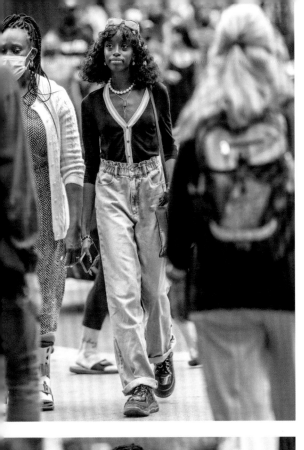
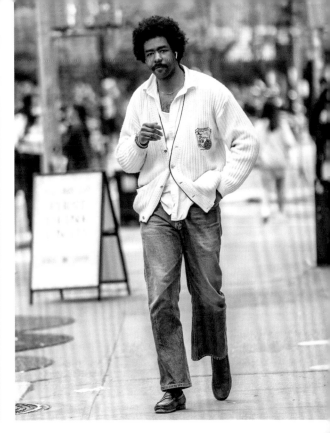
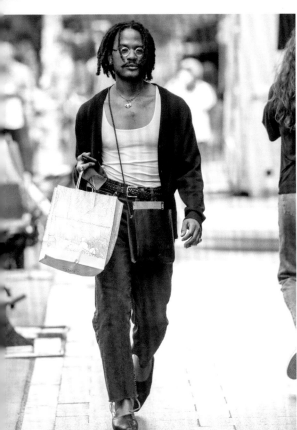
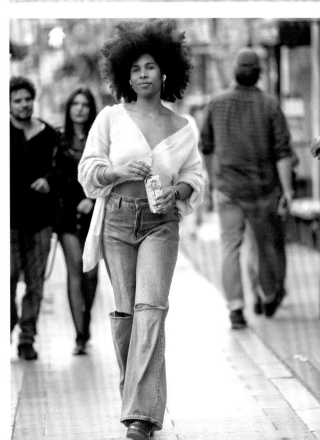

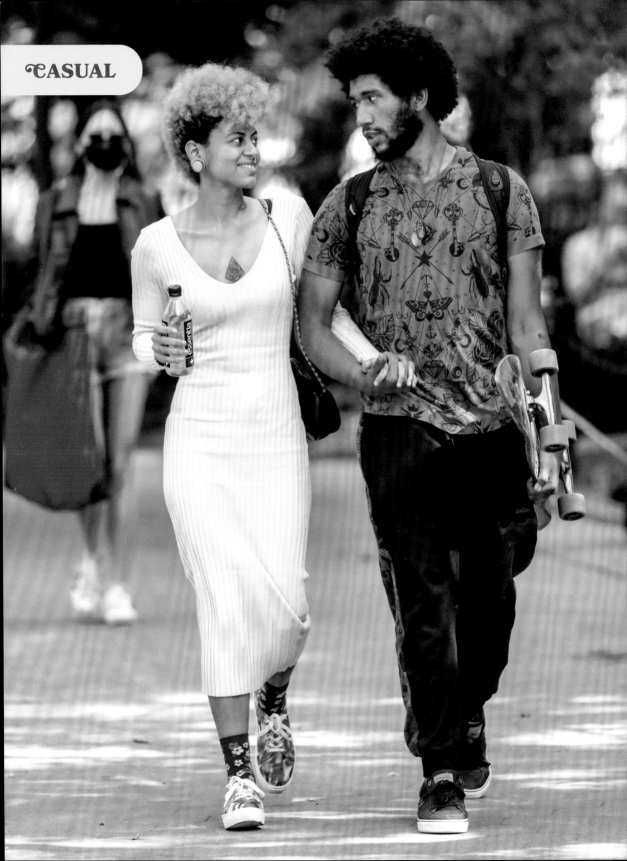

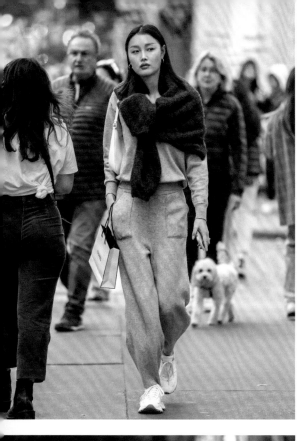
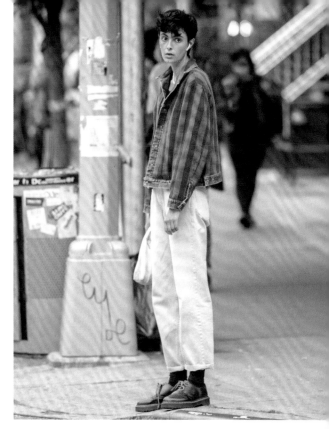
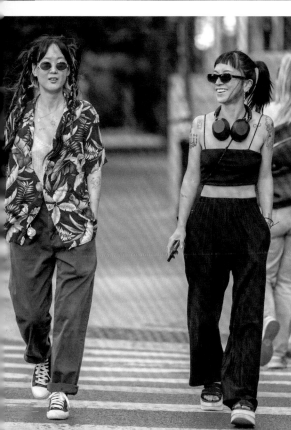
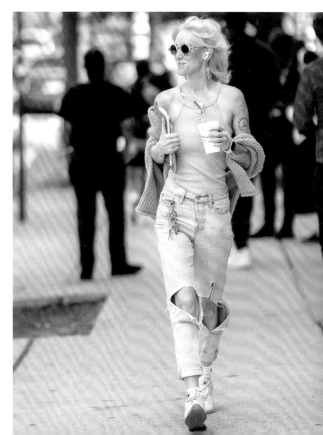

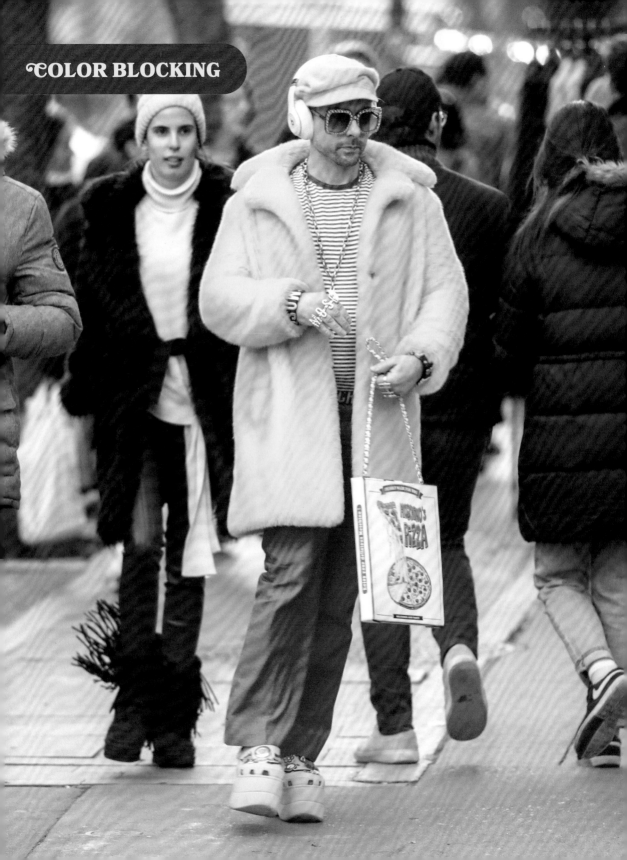

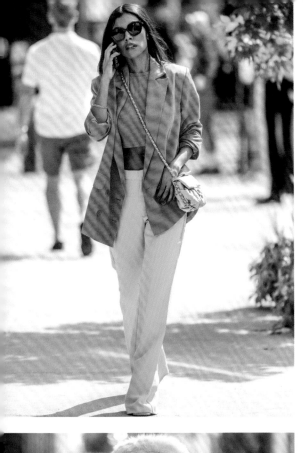
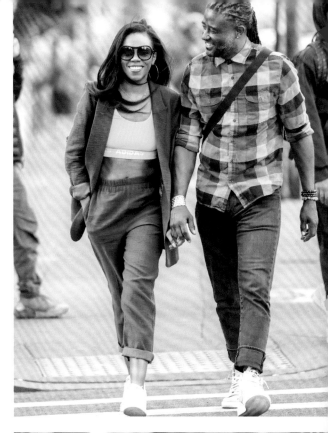
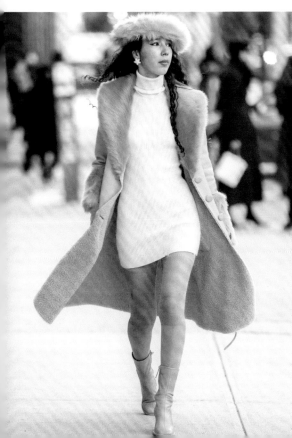
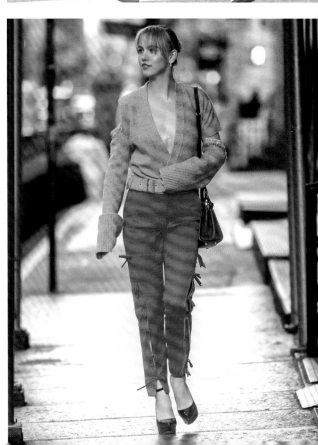

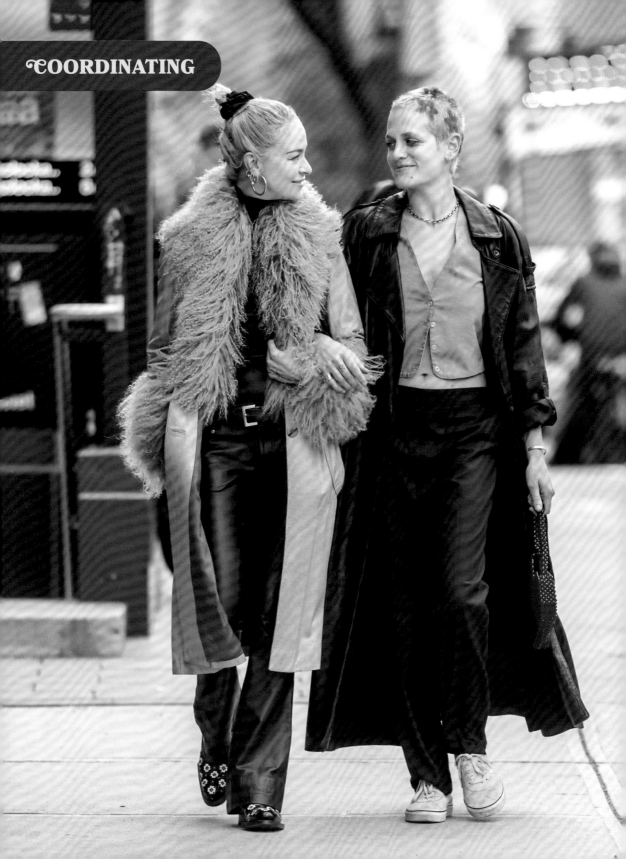

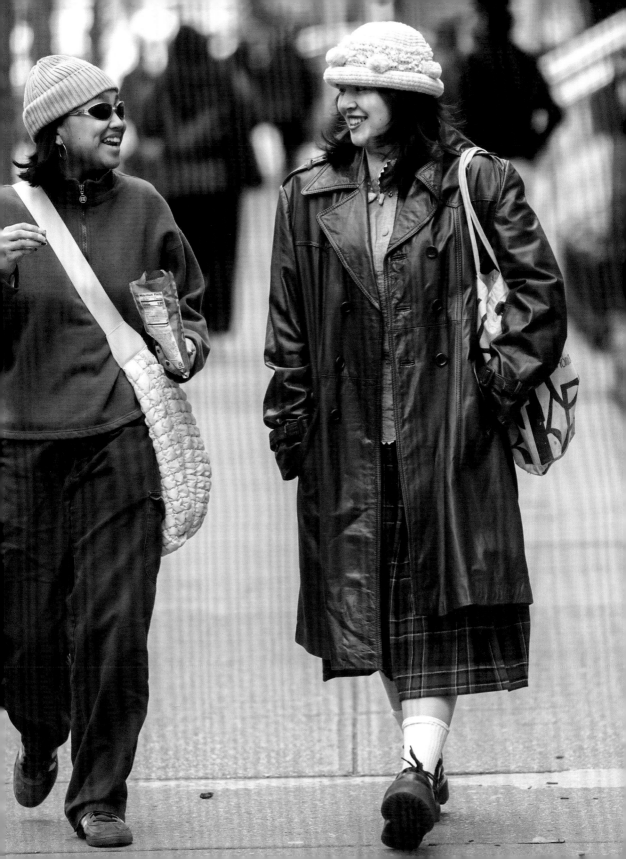

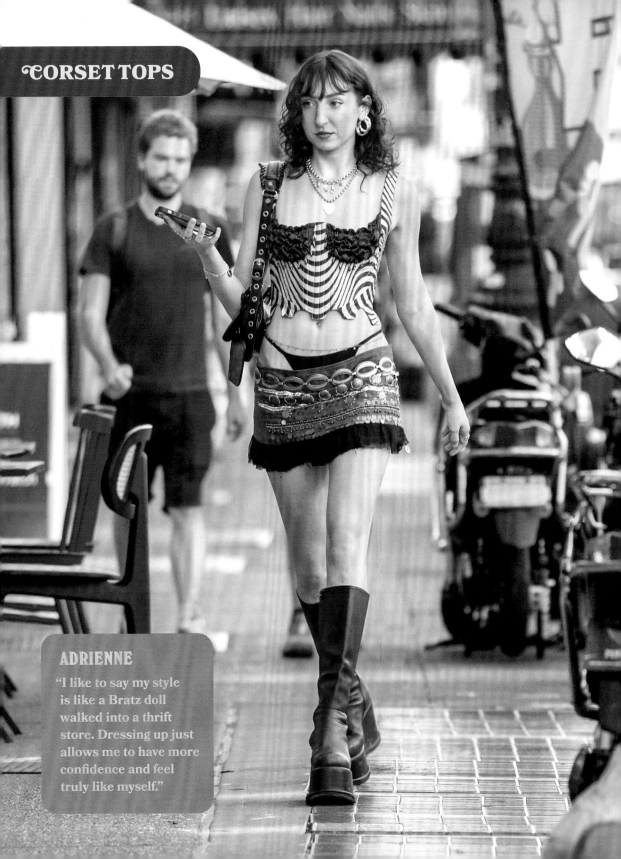

ADRIENNE

"I like to say my style is like a Bratz doll walked into a thrift store. Dressing up just allows me to have more confidence and feel truly like myself."

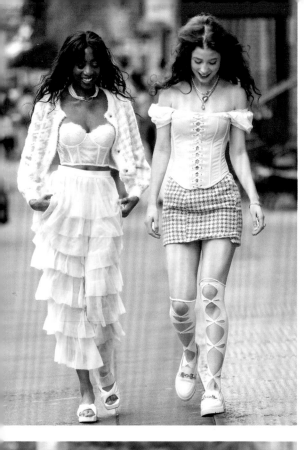
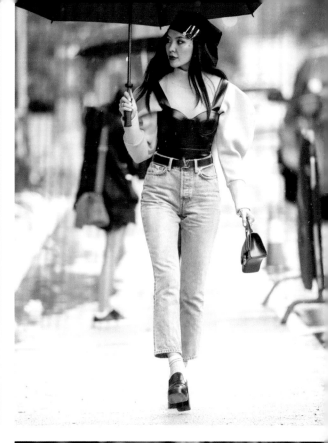
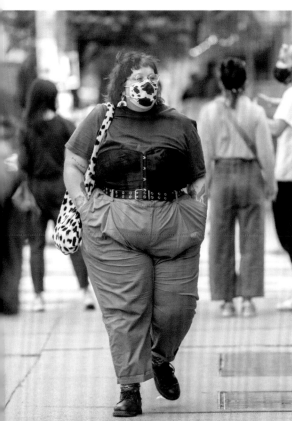
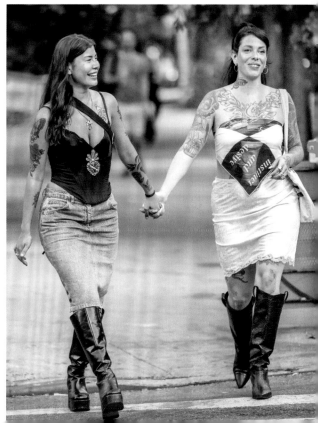

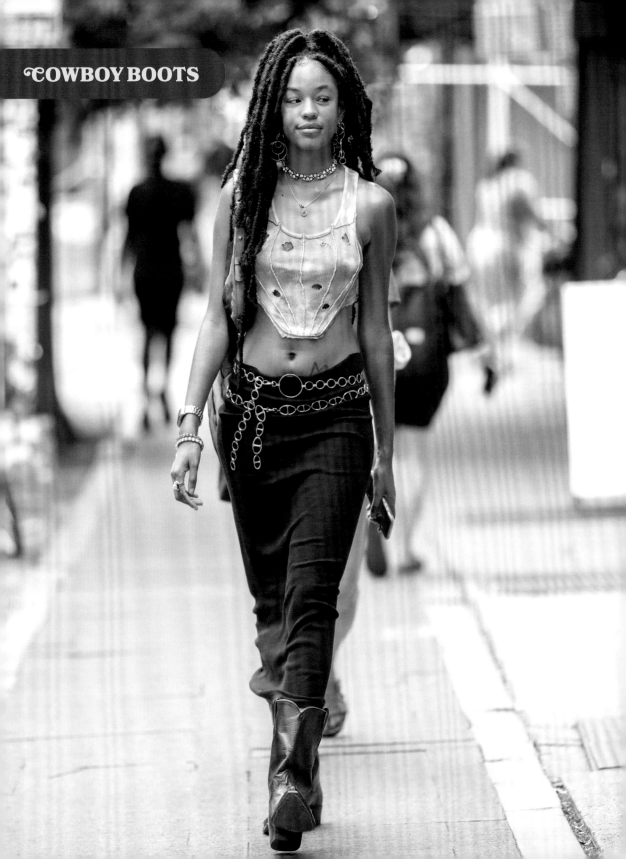

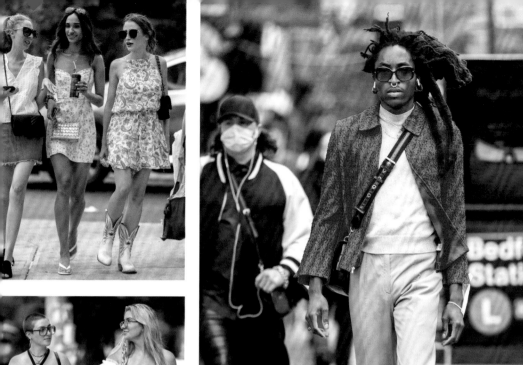
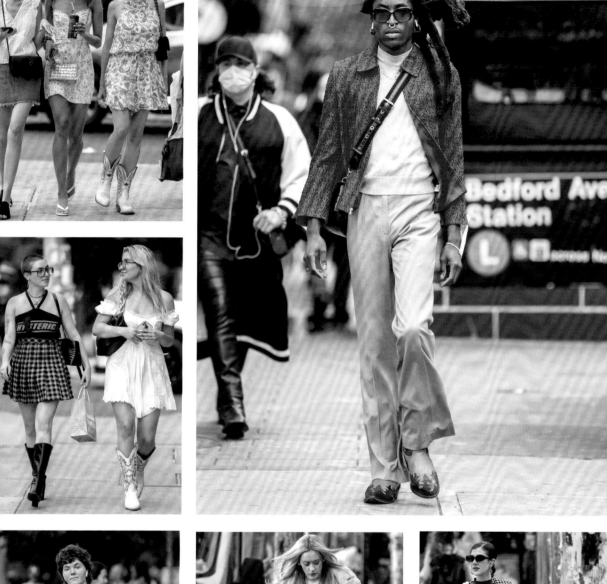
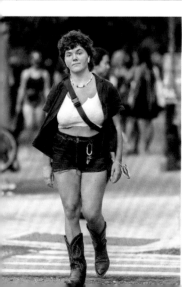
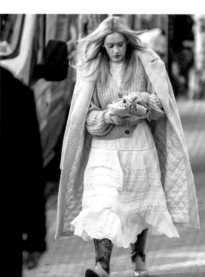
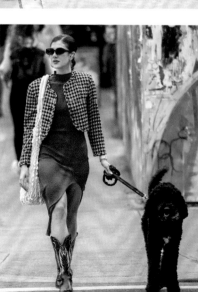

Dev: **Over quarantine, I was stuck at my grandma's house. I was just keeping myself entertained, and I started designing. She had a gray minivan, and so these recycled seat belts came to life. I've been really into making dad clothes hot basically. This was just a little old sweater, and I call it the asymmetrical knit.**

JC: **What is this necklace?**

Dev: **This is my timeless choker. I'm obsessed with chokers. I've always been a choker girl, and vintage watches are just super sexy and cool. My favorite part is wearing something that embodies my energy and wearing that out and people being like, "That's dope," and that's just the best compliment you can give me.**

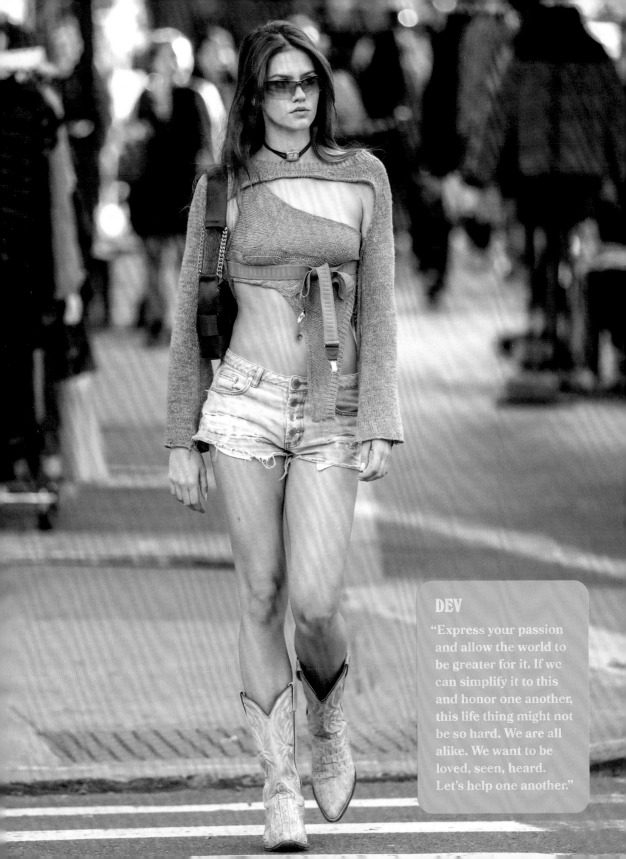

DEV

"Express your passion and allow the world to be greater for it. If we can simplify it to this and honor one another, this life thing might not be so hard. We are all alike. We want to be loved, seen, heard. Let's help one another."

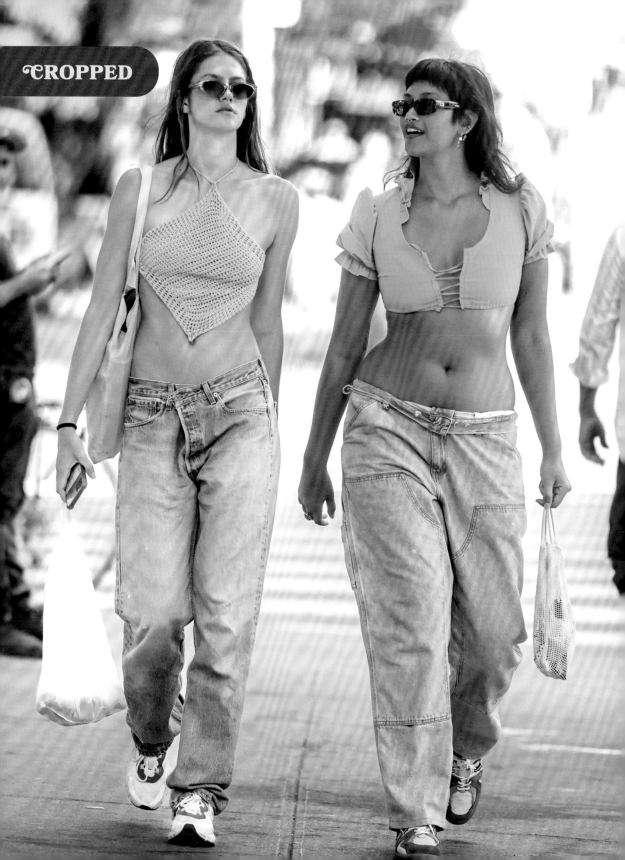

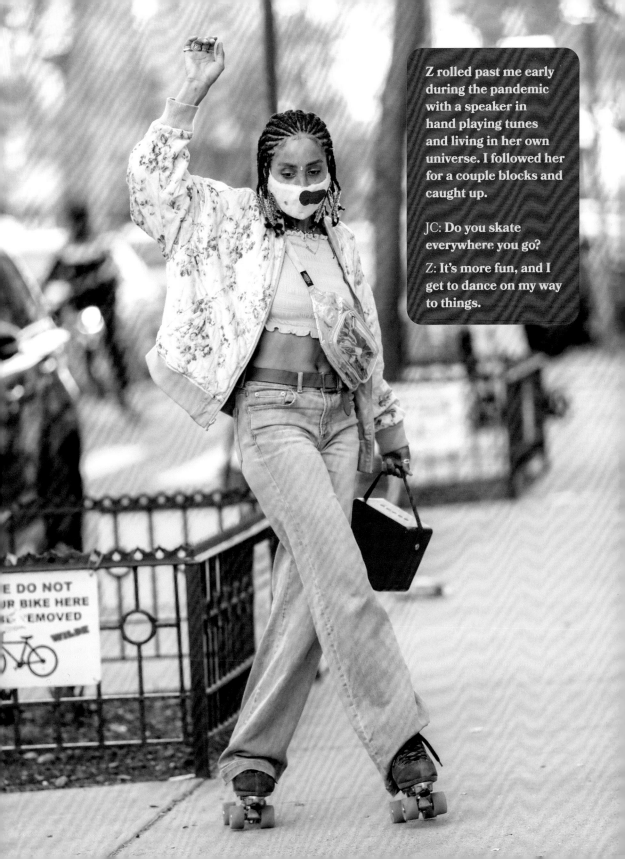

Z rolled past me early during the pandemic with a speaker in hand playing tunes and living in her own universe. I followed her for a couple blocks and caught up.

JC: Do you skate everywhere you go?

Z: It's more fun, and I get to dance on my way to things.

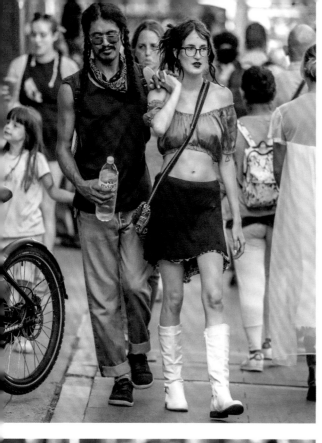
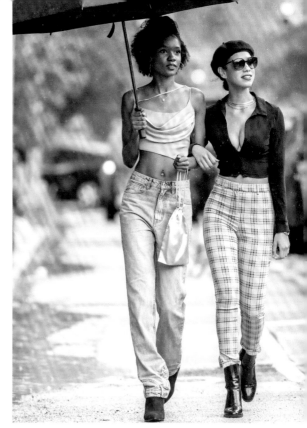
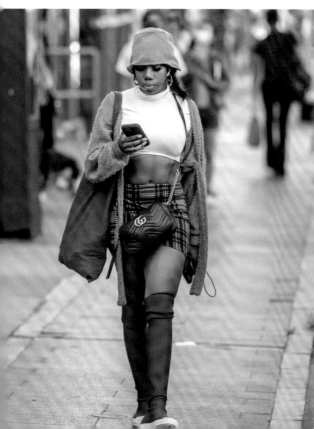
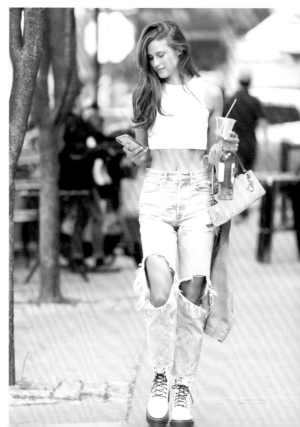

Denim,

Design,

Dogs of NY,

Best of Darnell

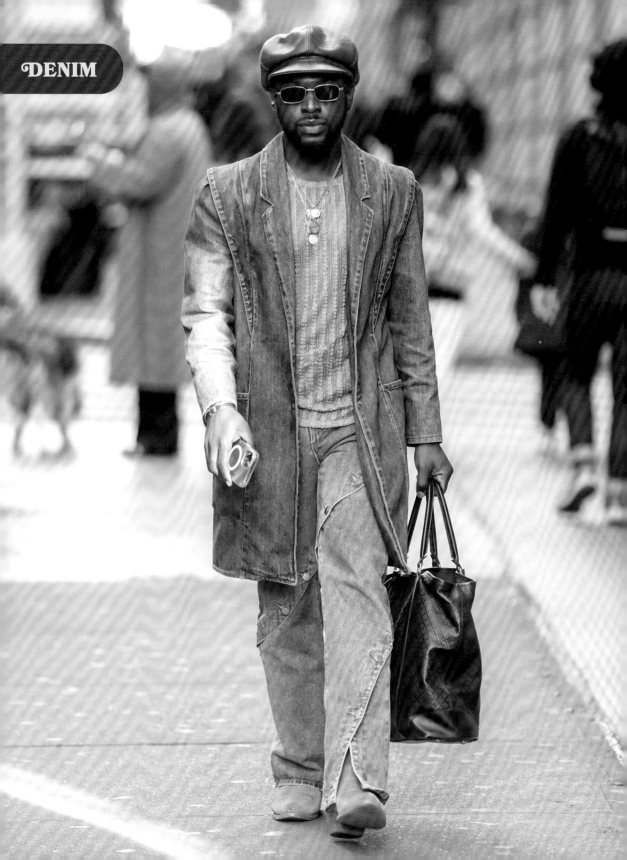

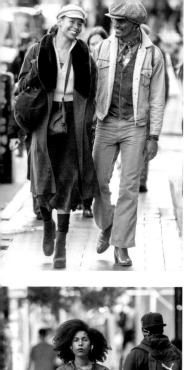 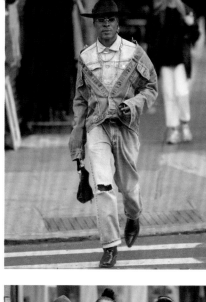 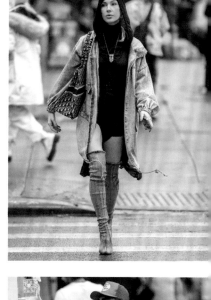

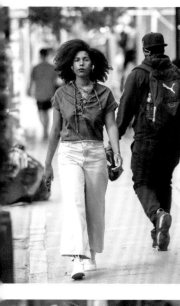 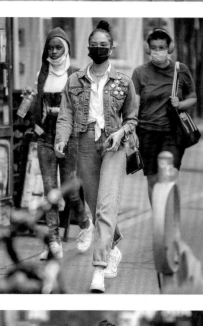 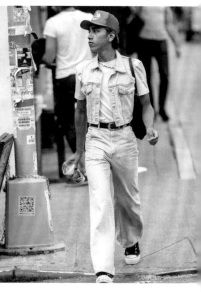

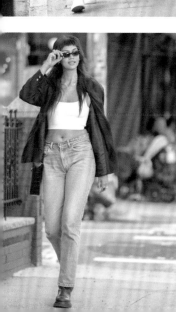 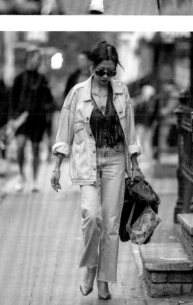 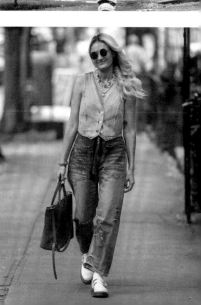

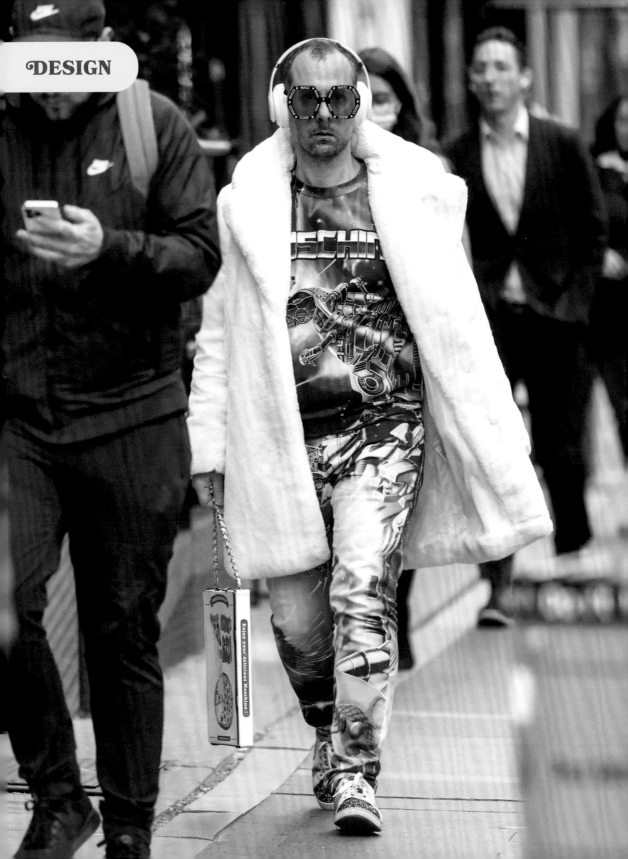

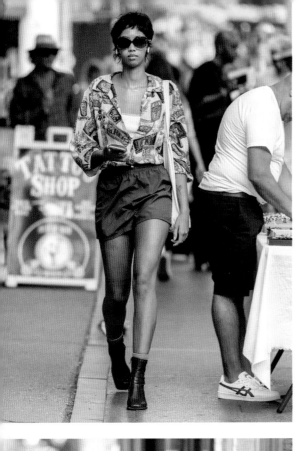

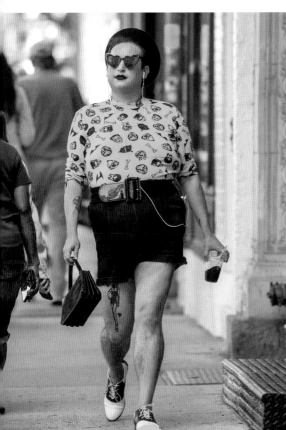
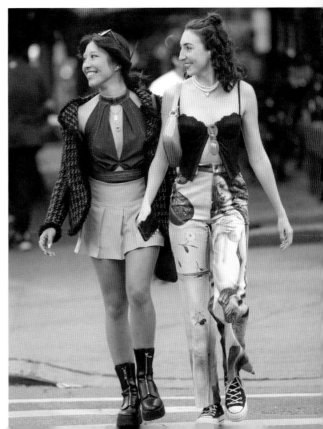

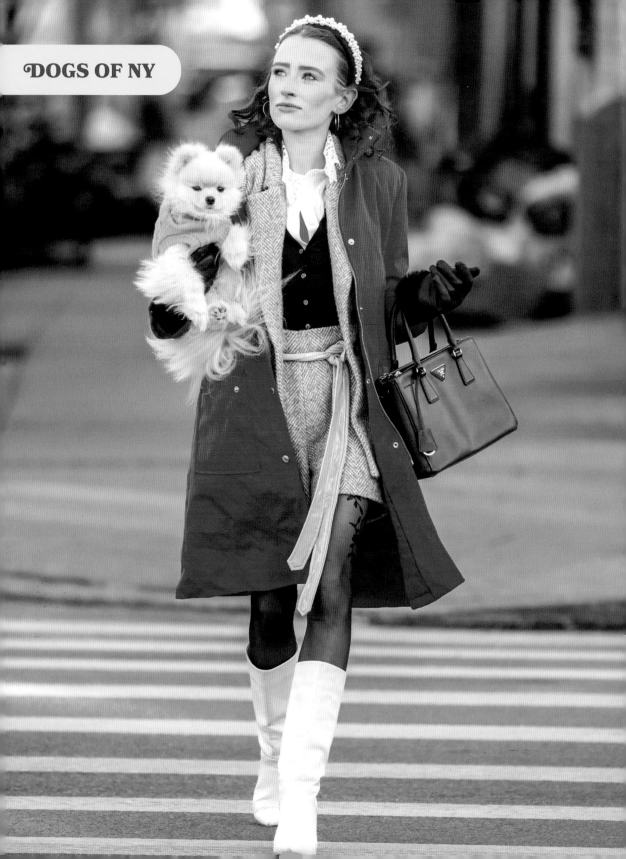

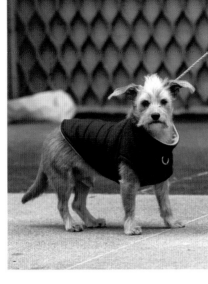
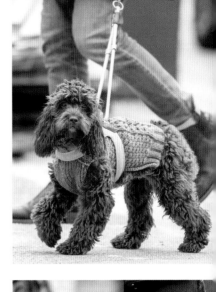
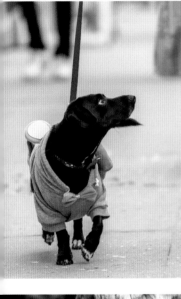
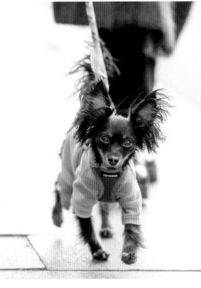
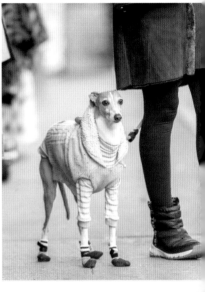
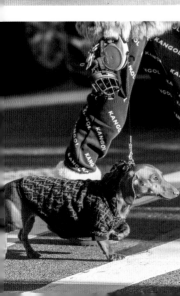
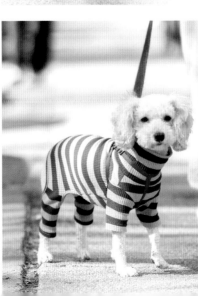
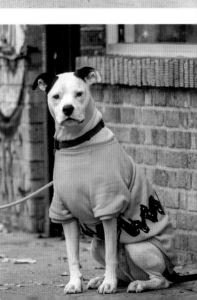

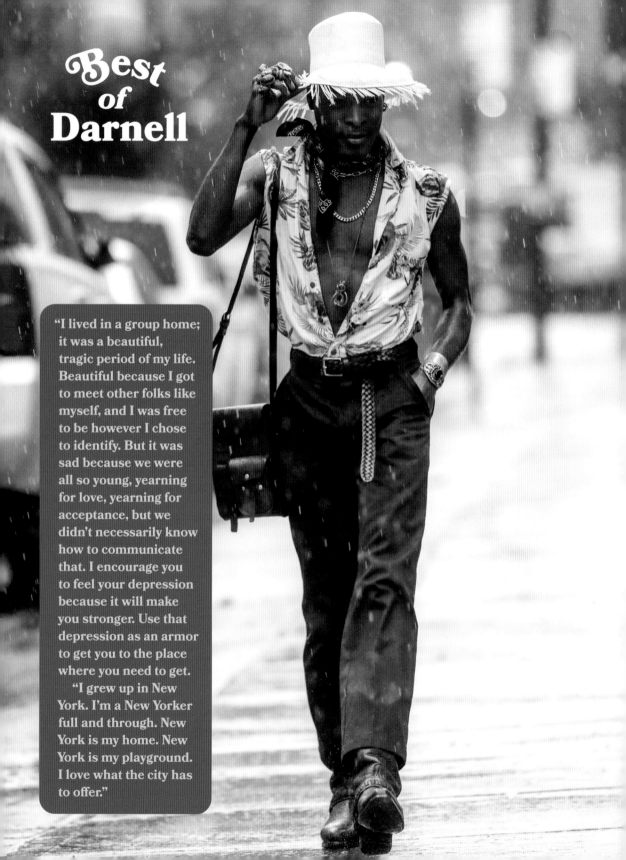

Best
of
Darnell

"I lived in a group home; it was a beautiful, tragic period of my life. Beautiful because I got to meet other folks like myself, and I was free to be however I chose to identify. But it was sad because we were all so young, yearning for love, yearning for acceptance, but we didn't necessarily know how to communicate that. I encourage you to feel your depression because it will make you stronger. Use that depression as an armor to get you to the place where you need to get.

"I grew up in New York. I'm a New Yorker full and through. New York is my home. New York is my playground. I love what the city has to offer."

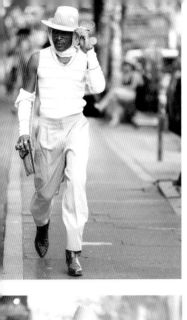
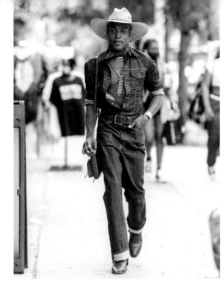
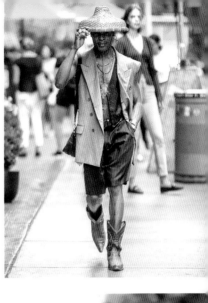
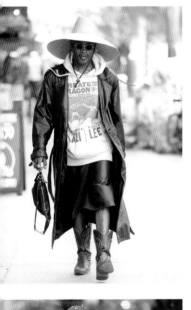
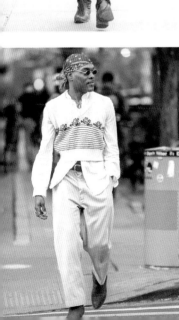
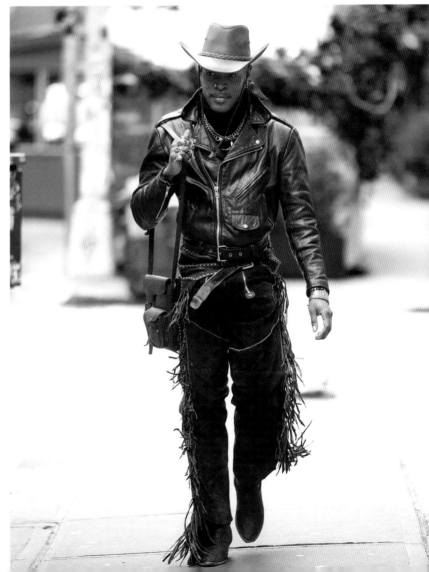

Embroidery,

Eyewear

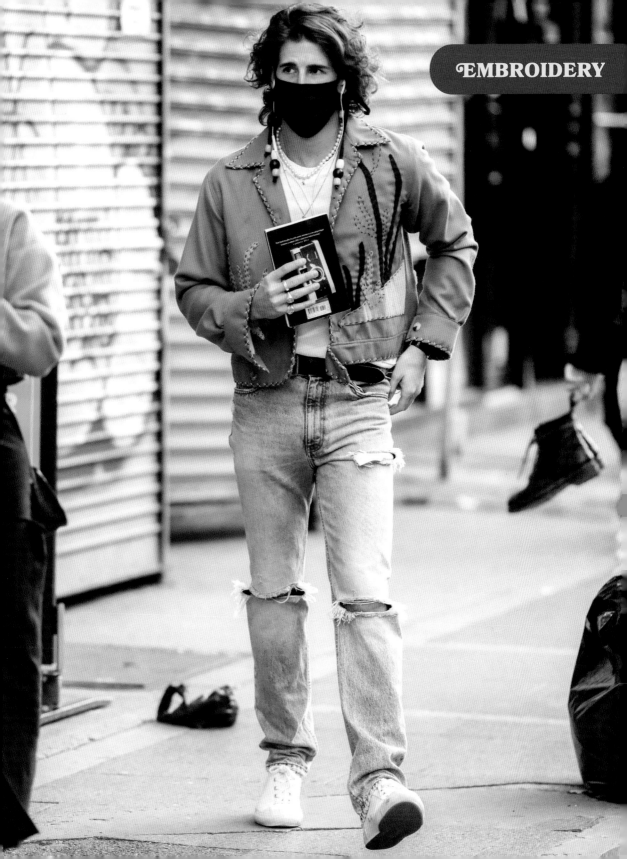

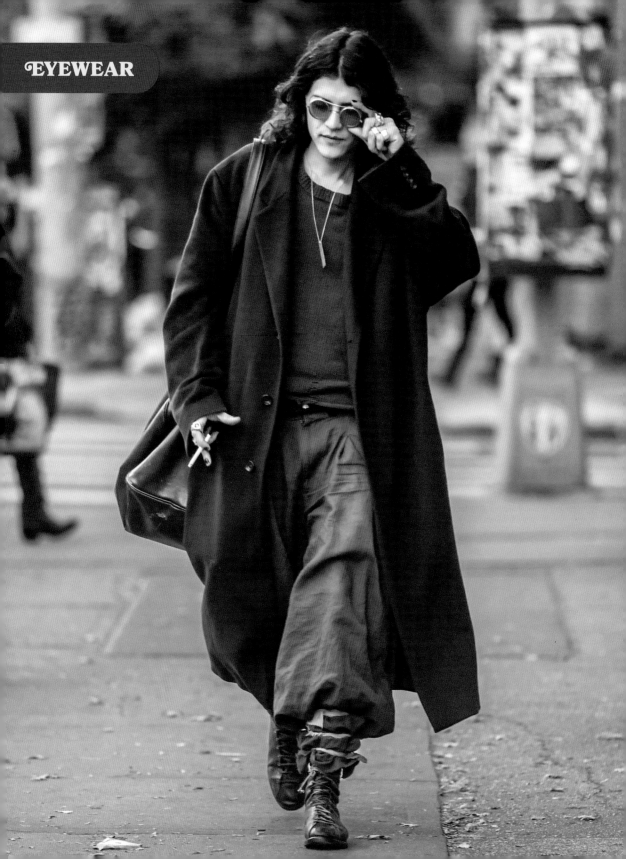

Hiro is the future. A guy who is known as one of the Fashion Kings of NYC but has no problem wrapping his old shoes in gaffer tape to keep them together and somehow makes it look awesome. The first time I met him, he explained to me that he's a jewelry maker but does a lot of custom grills.

JC: Can you tell me what you got going on here, Hiro?

Hiro: Vintage Rick going on here, vintage Guidi, homemade pants, Nordstrom's coat from, like, 1980? They're 1920s/1930s motorcycle glasses for welders, so these are actually my studio goggles as well.

JC: Did you make your rings?

Hiro: Yeah, I make everything.

JC: What is the most outrageous request you've gotten making grills?

Hiro: Everybody loves the hyper fangs. Sometimes I cement them in if somebody really wants them forever.

JC: Do you brush them?

Hiro: Yeah, every once in a while. I give them a nice little polish. It's insane to me that I live a life where I made up this job of making teeth for people.

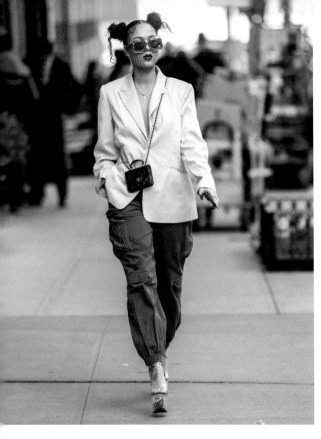
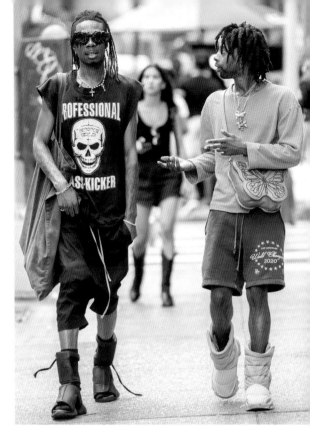
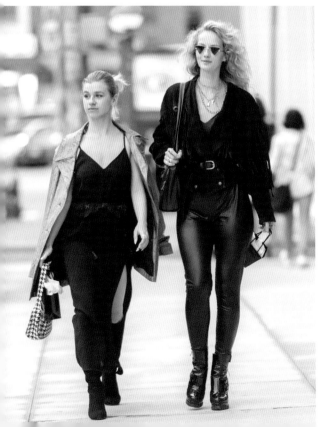
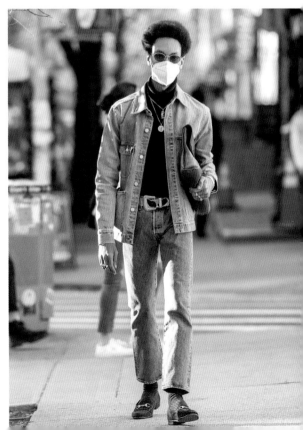

**Fishnet,
Floral, Flowy,
Formal, Fur,
Future NYC Icons,
Futuristic**

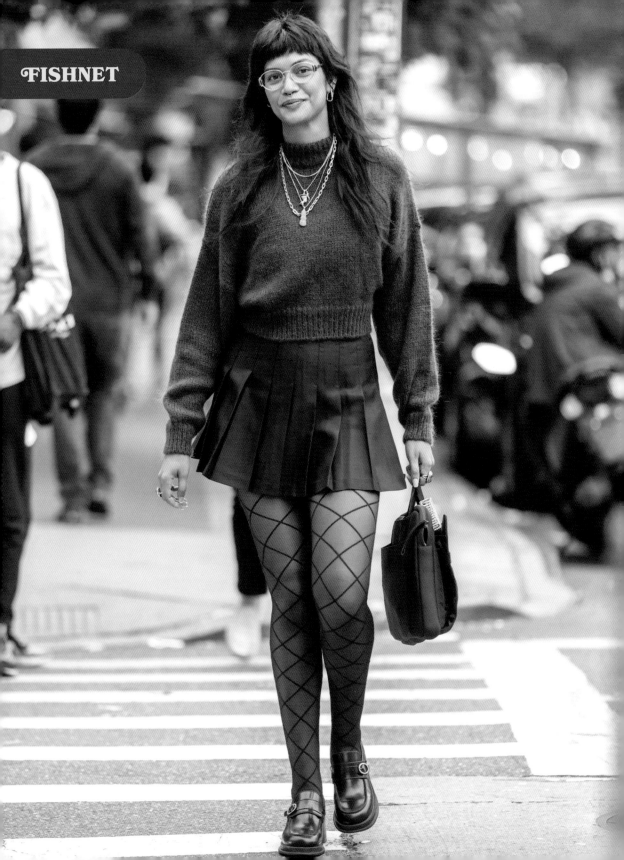

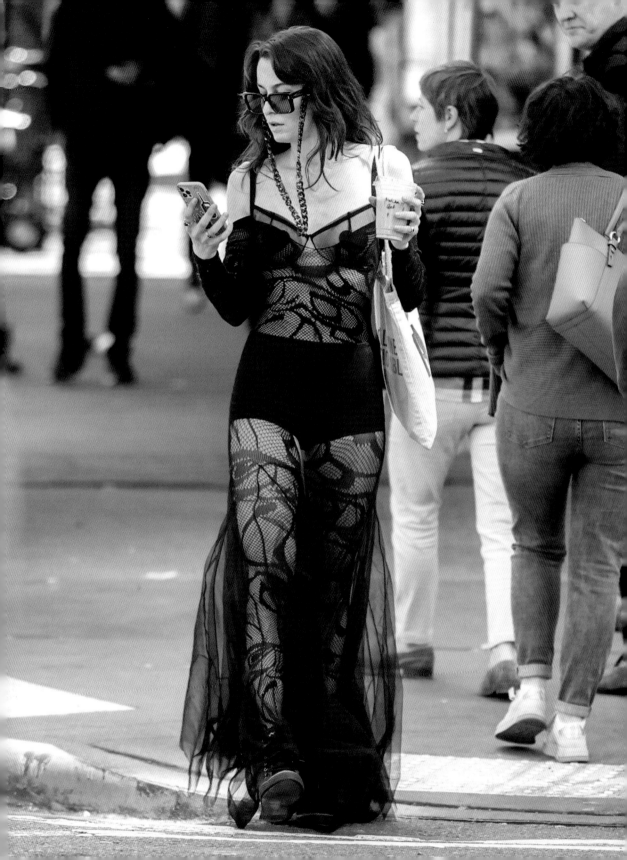

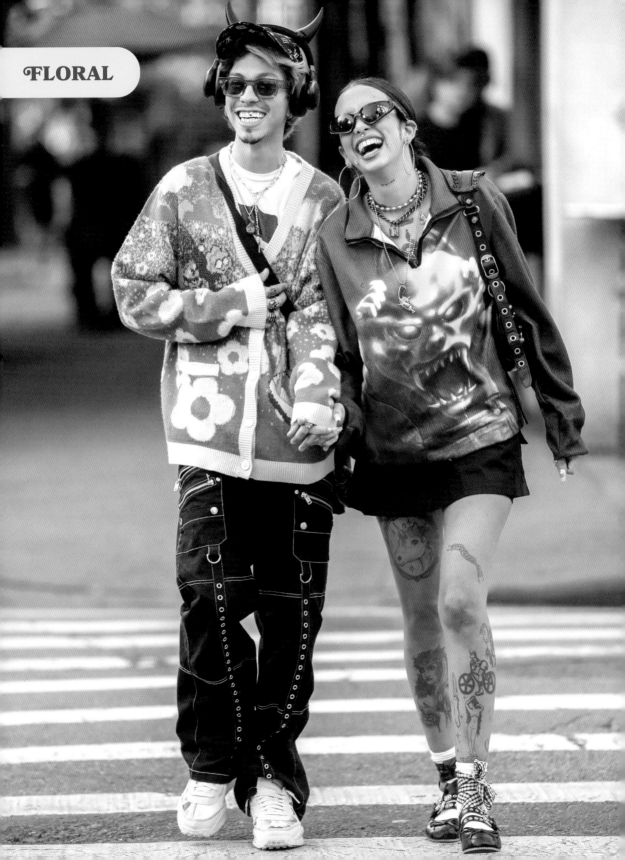

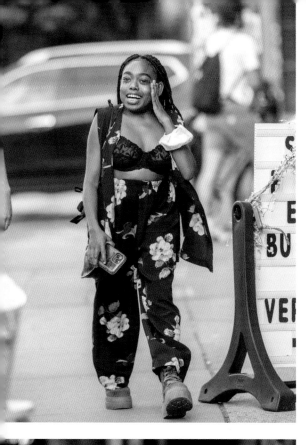
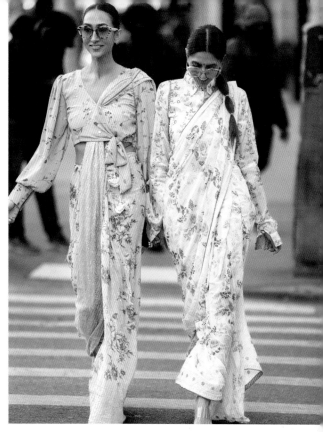
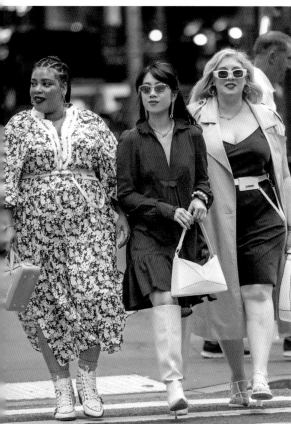
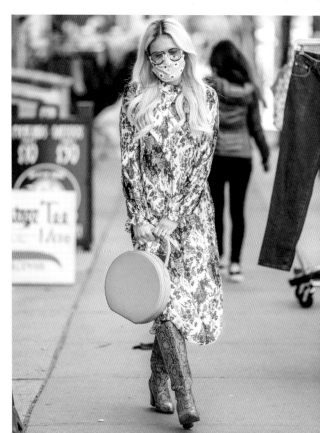

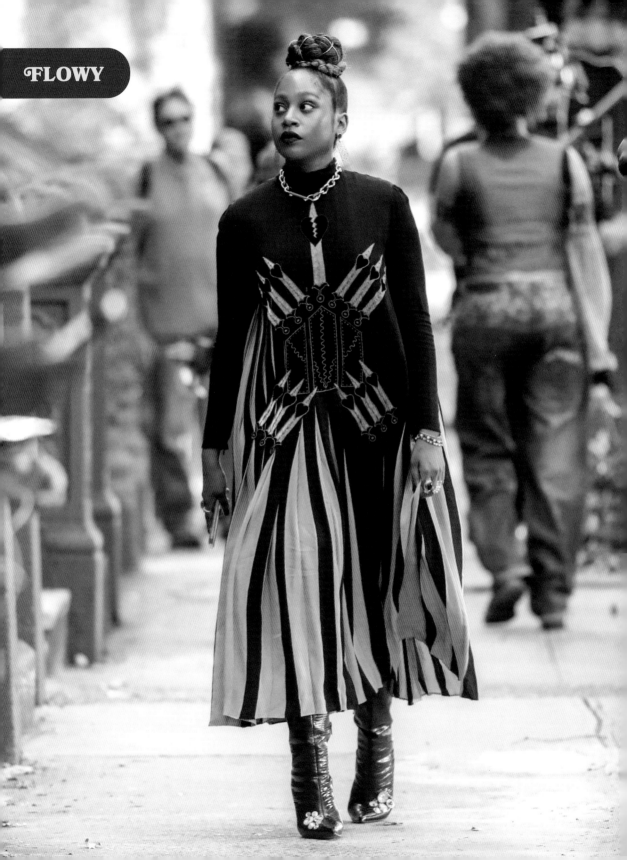

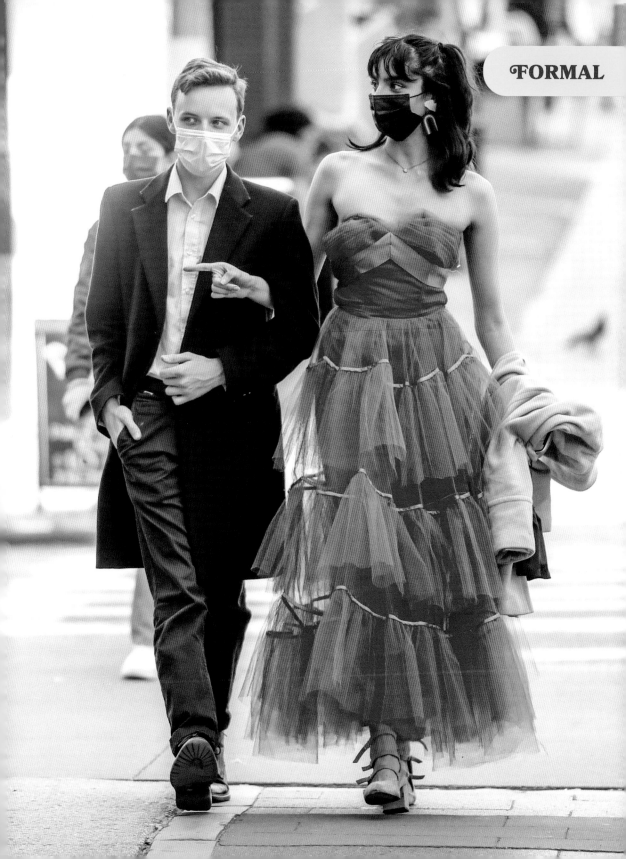

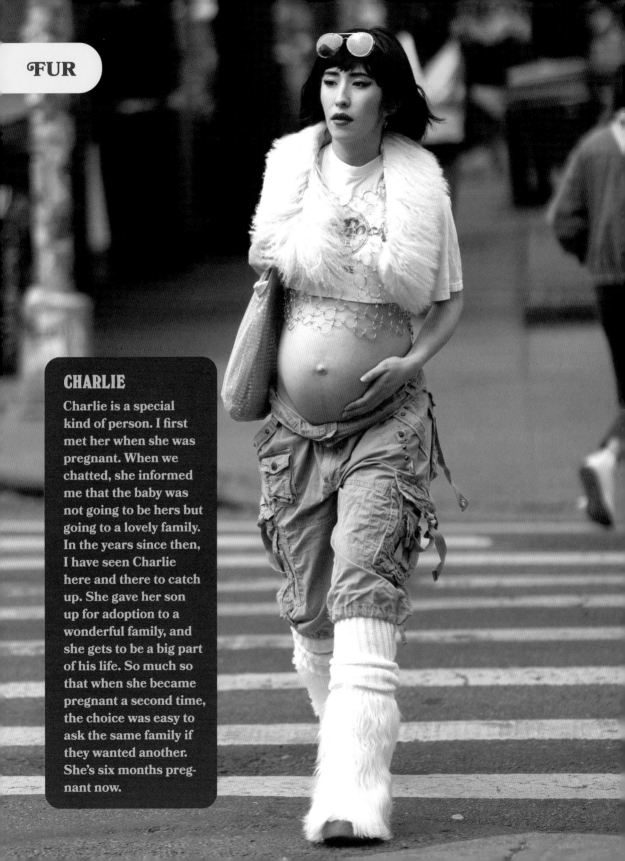

CHARLIE

Charlie is a special kind of person. I first met her when she was pregnant. When we chatted, she informed me that the baby was not going to be hers but going to a lovely family. In the years since then, I have seen Charlie here and there to catch up. She gave her son up for adoption to a wonderful family, and she gets to be a big part of his life. So much so that when she became pregnant a second time, the choice was easy to ask the same family if they wanted another. She's six months pregnant now.

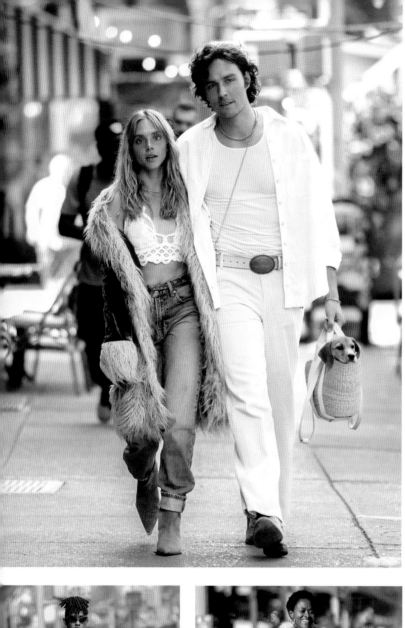
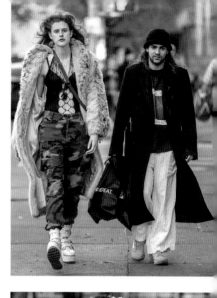
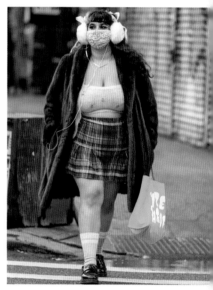
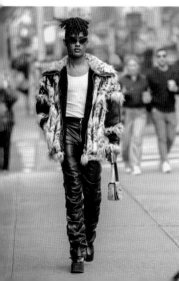
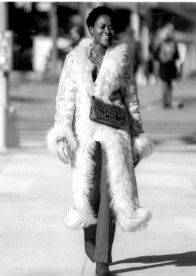
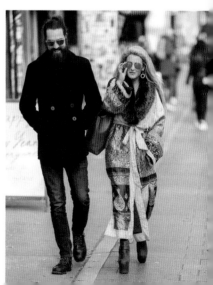

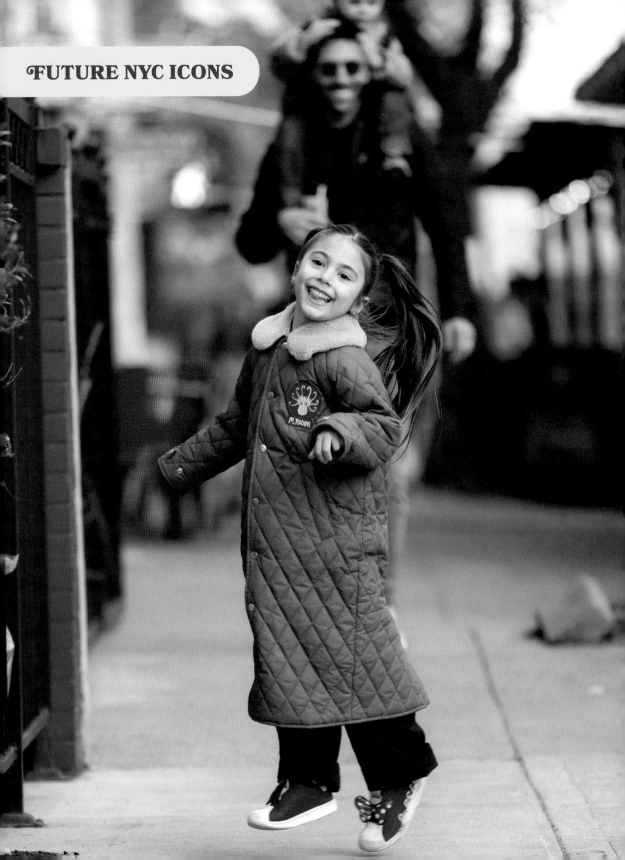

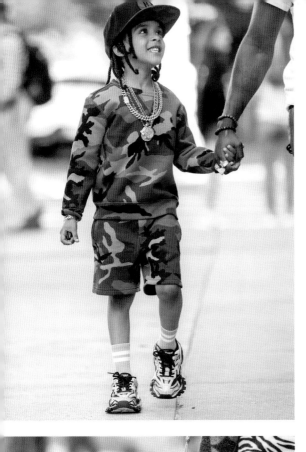
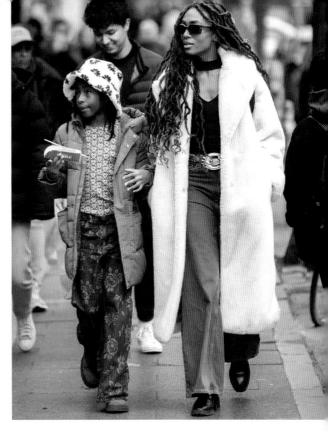
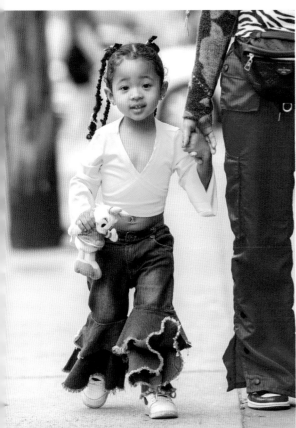
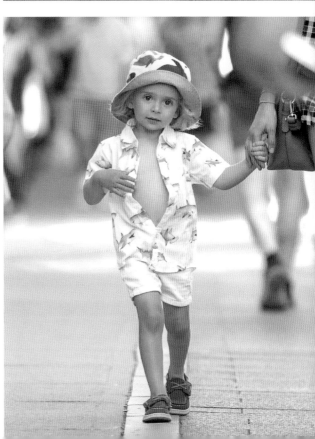

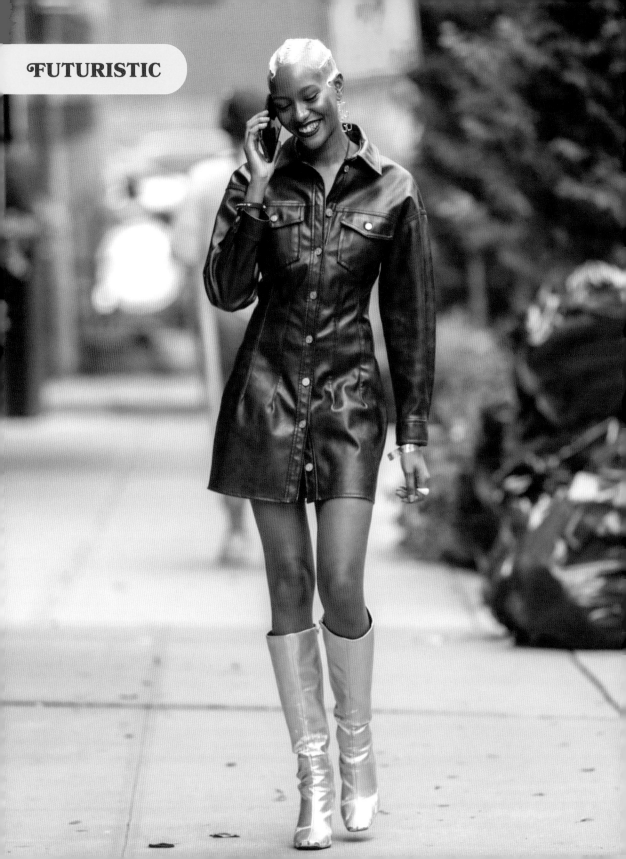

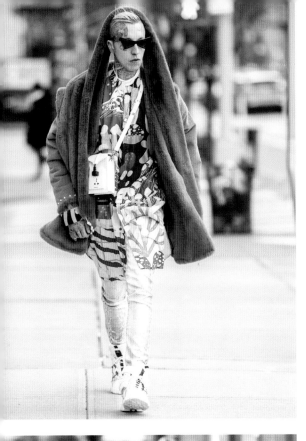
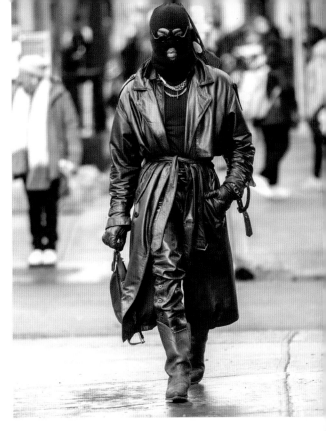
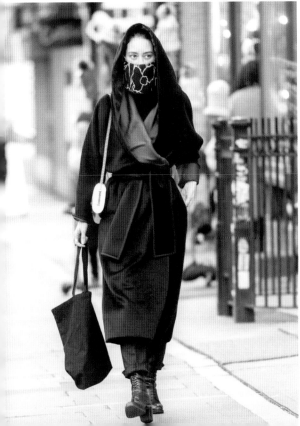
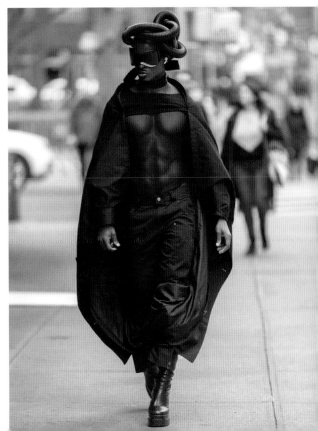

Gingham,

Gothic,

Graphic

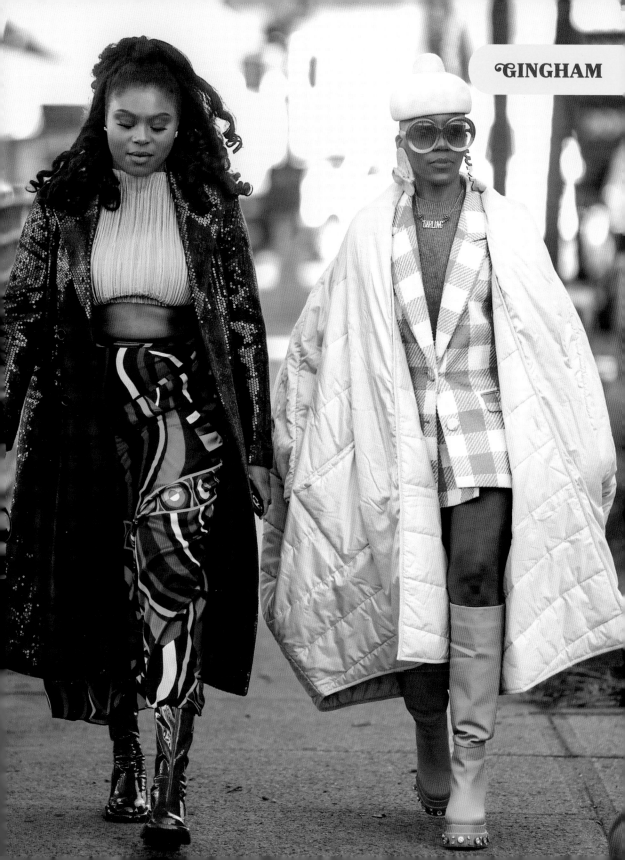

GINGHAM

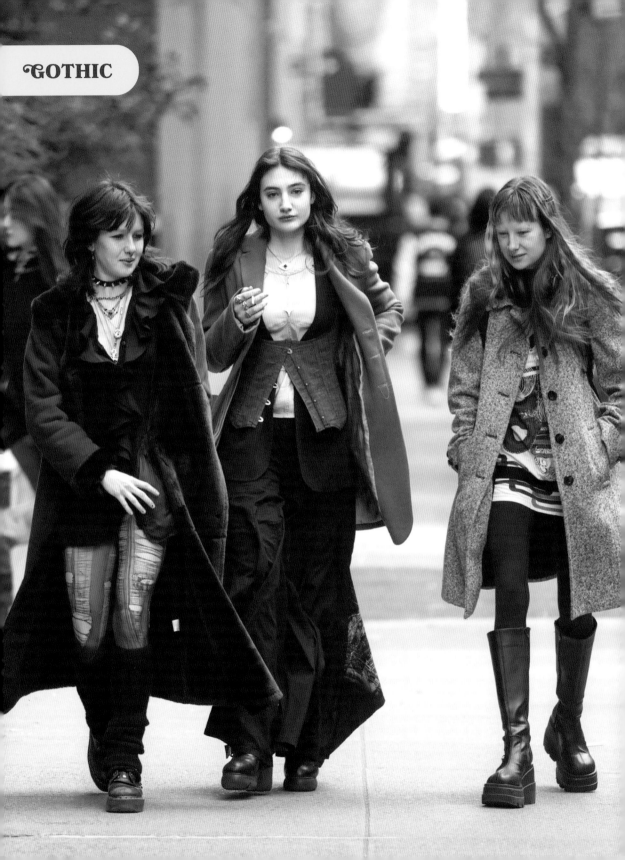

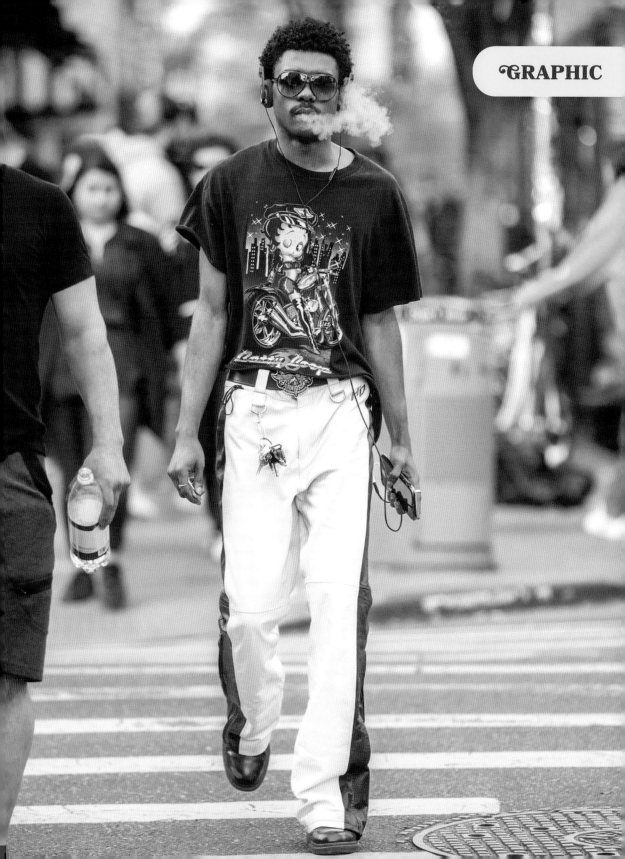

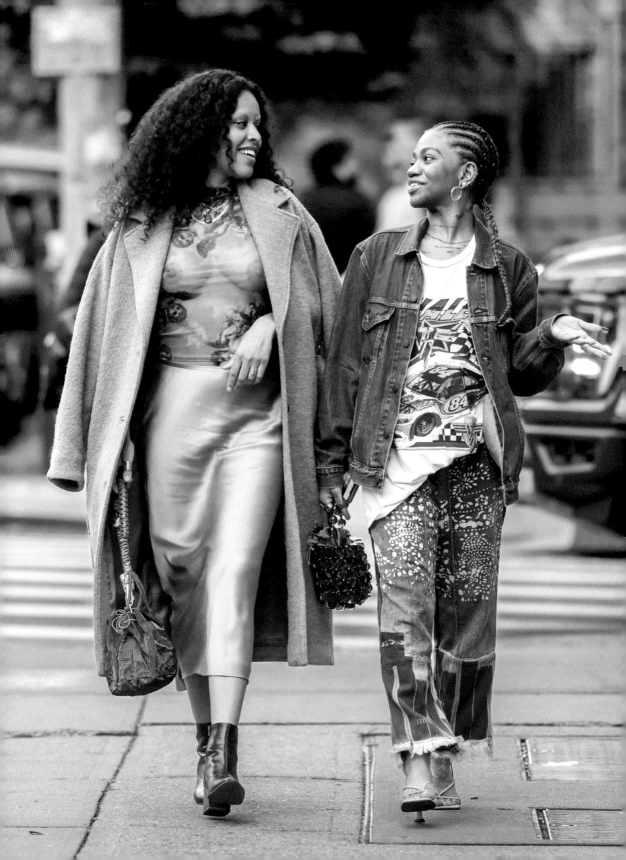

JC: **Raven, can you give me a quick little rundown of what it is that you're wearing here?**

Raven (left): **A little rundown? Let's see, the coat is & Other Stories. The bag is Miista, a brand from Spain. I believe the shirt is Urban Classic; this skirt is vintage Calvin Klein, and the shoes are Vagabond. I would say earthy tones, sheer silk. I love any play on texture.**

JC: **Do you bleach your eyebrows?**

Raven: **I do. I just want something that will lighten up my face. And recently they were a really bright yellow. I love anything that opens up my face and draws a little bit of attention.**

JC: **And you're not afraid of sheer? We can talk about that?**

Raven: **Not at all, I'm very comfortable in my most natural state. I've studied art my entire life, so I am not foreign to the human anatomy. I'm very comfortable with it, and I'm comfortable with myself.**

La-Tasha (right): **We got a cute little Levi's jacket, I have a graphic Carti, and beautiful—the sweetest person I've ever met—Studio Myke pants. These are one-of-one.**

JC: **Can you tell me about these tooth gems right here?**

La-Tasha: **I got a money sign, a *Playboy* bunny, a butterfly, and a *K* for my son, Knox.**

JC: **Hold on a minute, how old is your son?**

La-Tasha: **He's three.**

JC: **Is he your first?**

La-Tasha: **He is my first and my only.**

JC: **How do you feel about being a mom?**

La-Tasha: **It's my purpose. Everything in life just started to make sense, like OK, this is it. This is exactly where I need to be.**

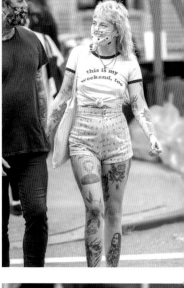
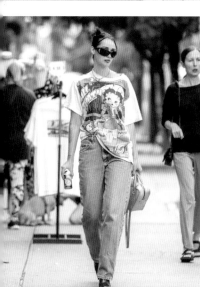
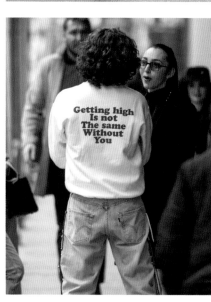
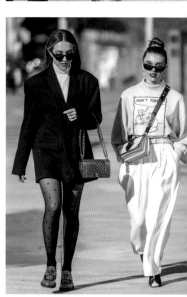
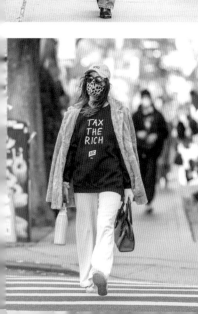
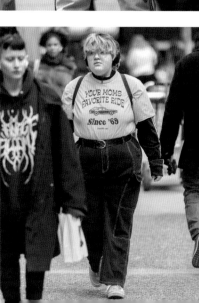
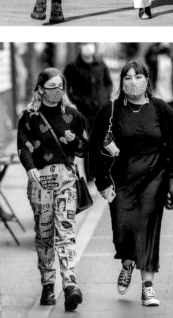

Halloween,

Handbags,

Handmade,

Hats

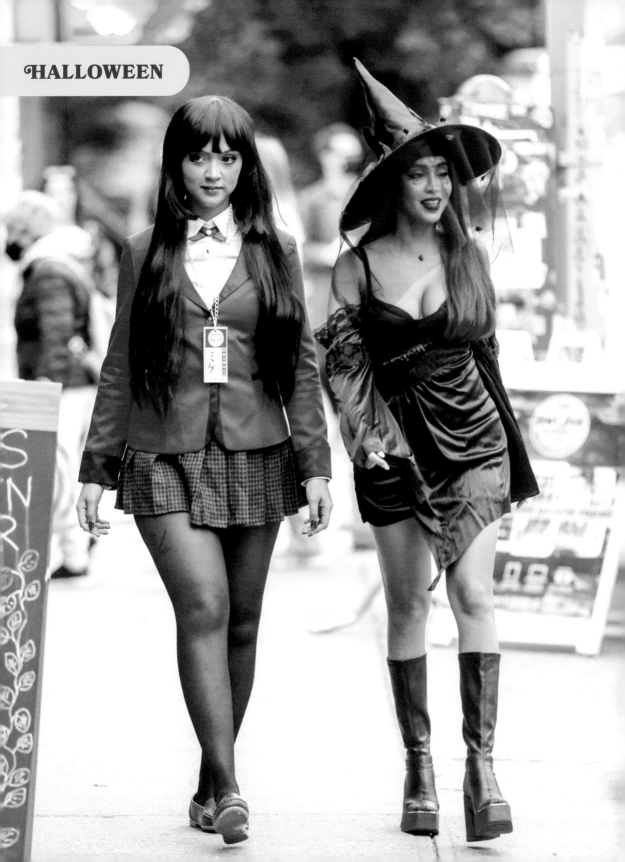

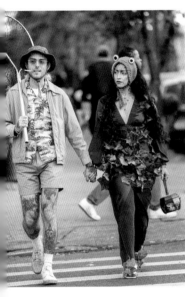
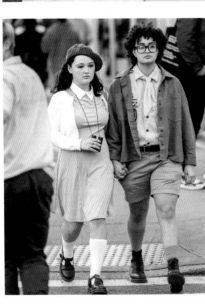
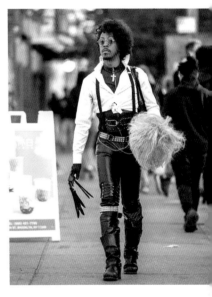
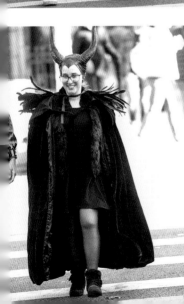
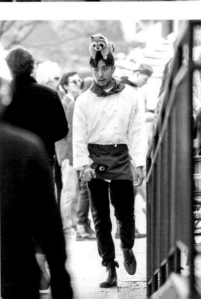
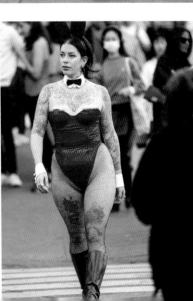

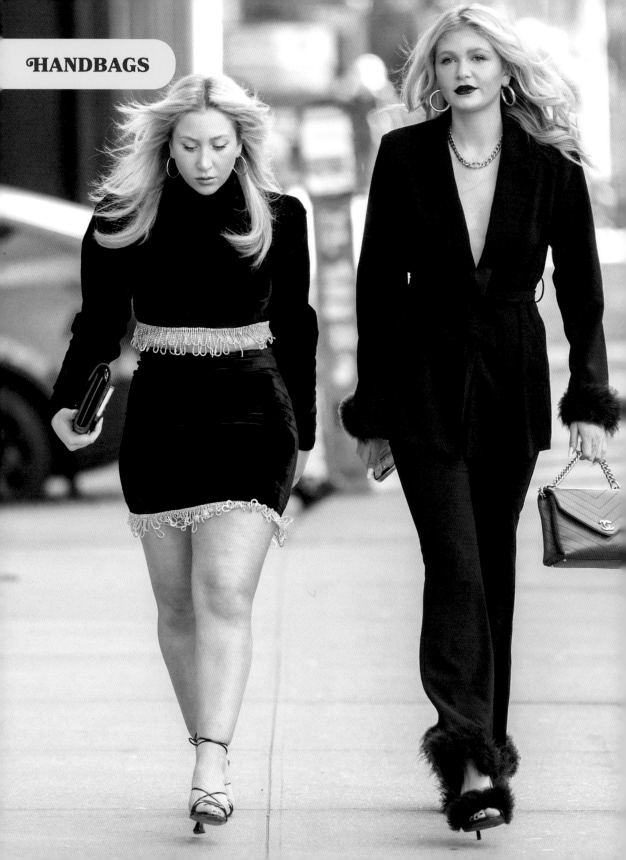

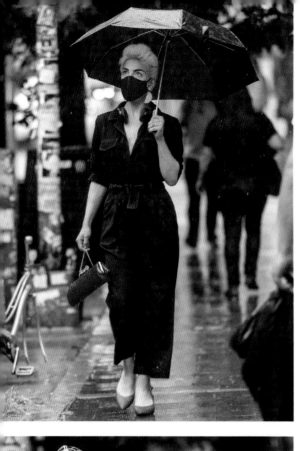
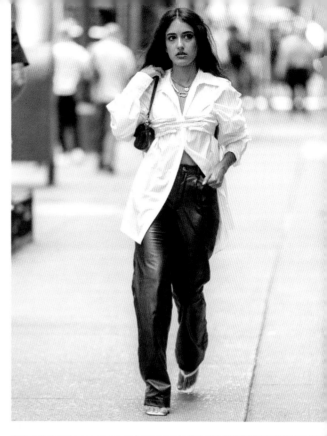
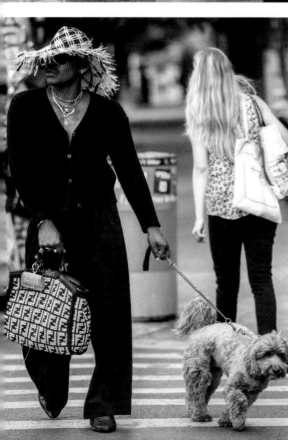
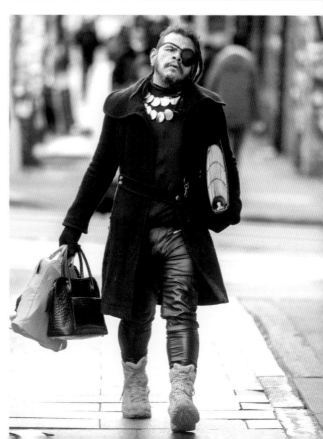

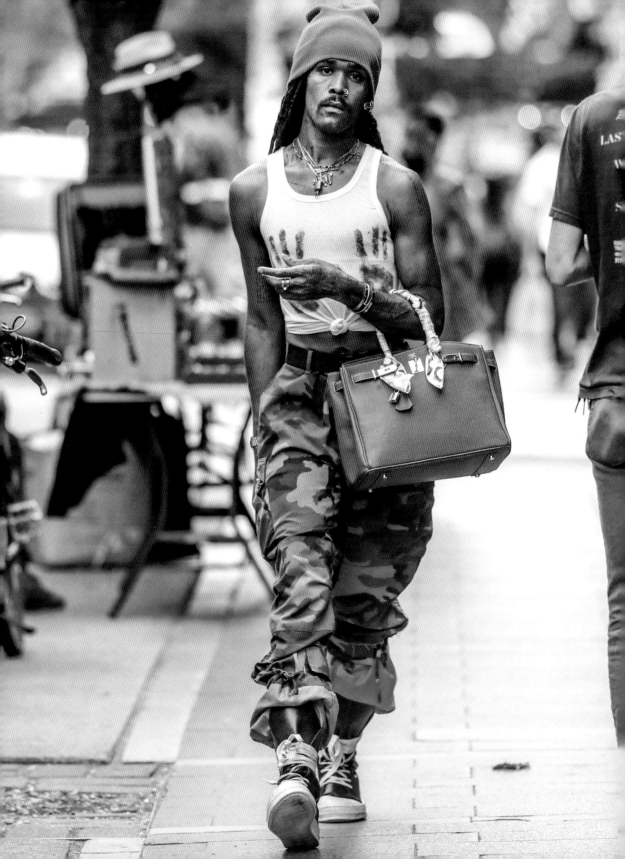

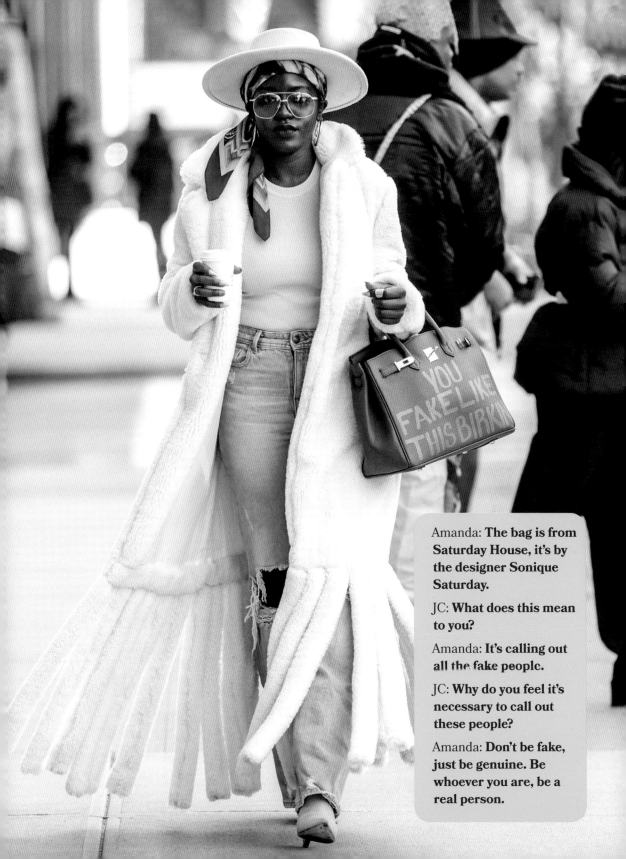

Amanda: **The bag is from Saturday House, it's by the designer Sonique Saturday.**

JC: **What does this mean to you?**

Amanda: **It's calling out all the fake people.**

JC: **Why do you feel it's necessary to call out these people?**

Amanda: **Don't be fake, just be genuine. Be whoever you are, be a real person.**

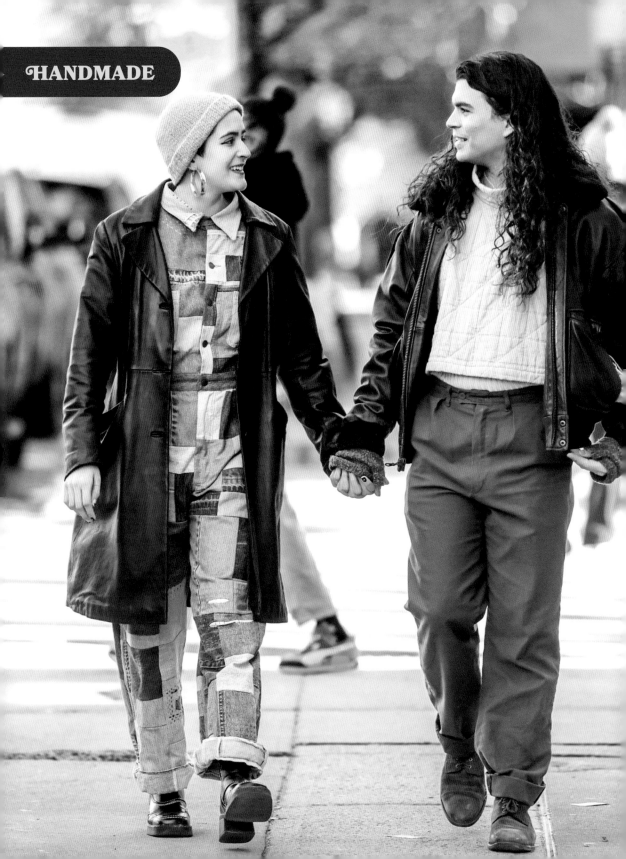

JC: **This is really unique. It's actually a one-of-one denim jumpsuit. Where is it from?**

Sofie: **I made it. It's all denim scraps and mostly pant legs. I used to work at Awoke Vintage, and people would ask us to cut things into shorts and whatever, and I would just grab the denim, so a lot of bits from there. Assembly of the fabric is the main thing, and it is kind of like a giant puzzle. I unpicked all the seams, reassembled it into fabric, made the pattern, sewed it, and then I did some repairs on the parts that were kind of, like, already damaged.**

JC: **It's a work of art.**

JC: **Monday, I had to stop you. This is like burlap, and you said you created this.**

Monday: **Yes, I created this, and the little backstory is I actually created this while homeless on a train in Chicago. I made it by hand. I was passing by a Starbucks and a coffee bag caught my eye. I went in and I asked them, "By chance, are those coffee bags for sale? Can I get them?" And they were like, "I will give them to you for free," and that worked out for me because I didn't have much money at the time, obviously.**

JC: **So this is fully upcycled bags of coffee beans?**

Monday: **Yes.**

JC: **Do you make and sell these?**

Monday: **Yes, I do.**

JC: **Just incredible. I love it so much.**

Monday: **Like I said, the image caught my eye in passing, and I was like, "Oh, I can make something out of that." This is all hand embroidery, and it says Monday Blues as well.**

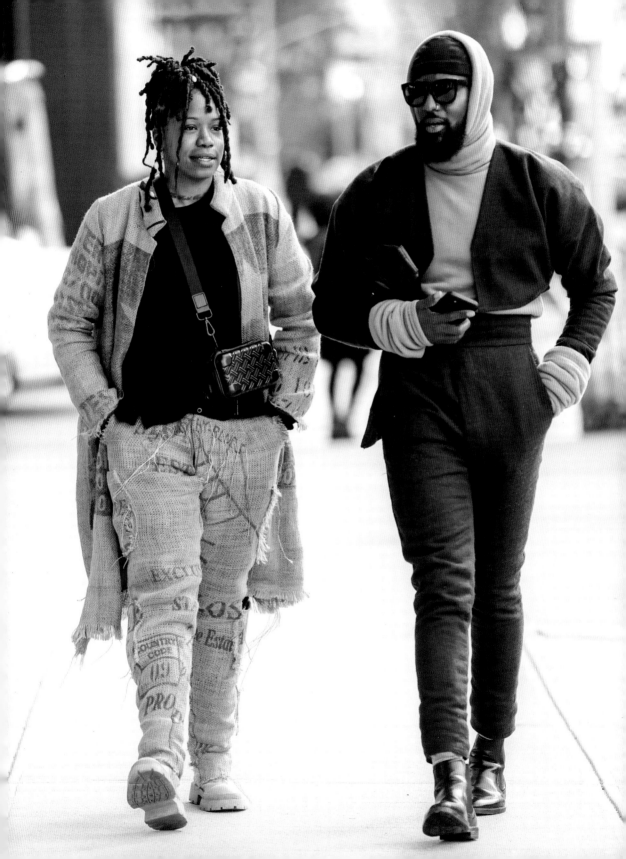

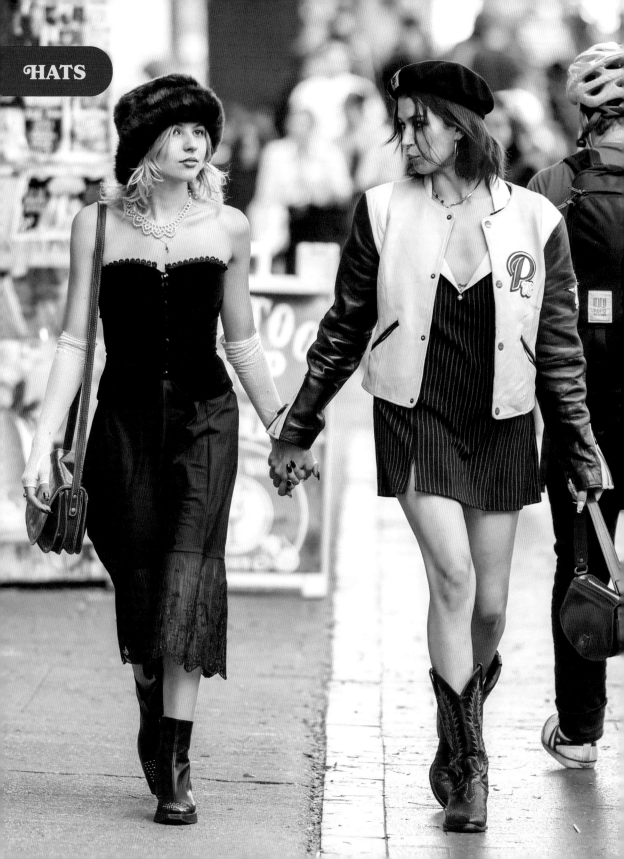

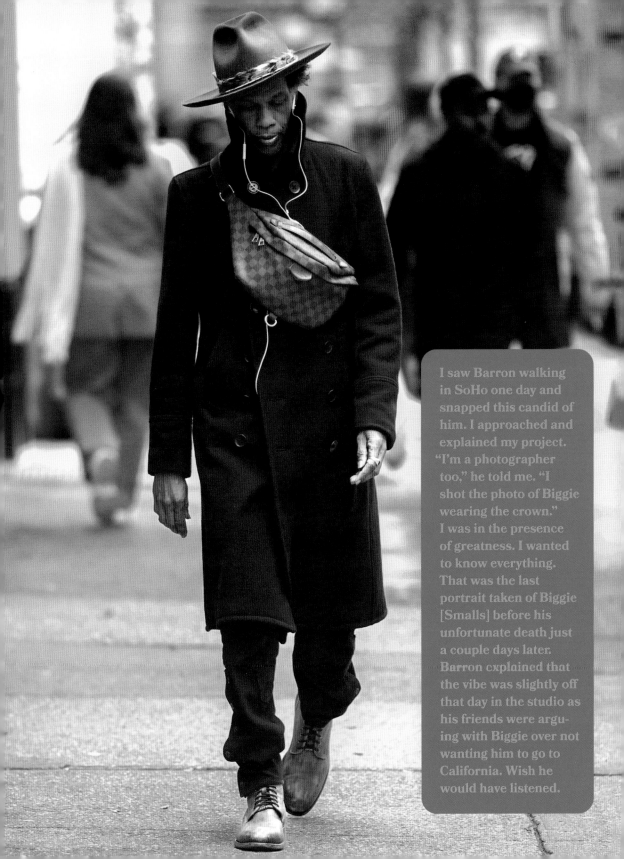

I saw Barron walking in SoHo one day and snapped this candid of him. I approached and explained my project. "I'm a photographer too," he told me. "I shot the photo of Biggie wearing the crown." I was in the presence of greatness. I wanted to know everything. That was the last portrait taken of Biggie [Smalls] before his unfortunate death just a couple days later. Barron explained that the vibe was slightly off that day in the studio as his friends were arguing with Biggie over not wanting him to go to California. Wish he would have listened.

Rich Oliver grew up in Brooklyn and learned to be a milliner through crafting hats for the Jewish community. He named his company Oliver Lewis after the first Black jockey that ever won the Kentucky Derby. He wanted to show him homage and pay his respects. Each of his unique handmade hats have a stone that sits atop, and I asked him about it.

JC: One of your friends walked by just now and told me that you made this hat.

Rich: I started making the Jewish guys' shtreimels in Brooklyn years ago, and then I switched over and started making my own hats.

JC: So what is this made out of, is it rabbit? Is it beaver?

Rich: This one is made out of rabbit, and it has a green aventurine stone at the top for calmness, leadership, and prosperity, so you know you have a good stone charging in the sun.

JC: How did you get into this?

Rich: I'm from Brooklyn. I'm from Flatbush, so I have some friends that are from the Hasidic community. A friend of mine was a fair dealer, and he was like, "I have a friend who makes hats, and he needs somebody, would you want to do it? I'll give you three months to learn." I was an apprentice for three months, and I just learned how to make shtreimels, so half of Williamsburg—a lot of those Hasidic guys—are wearing most of my hats.

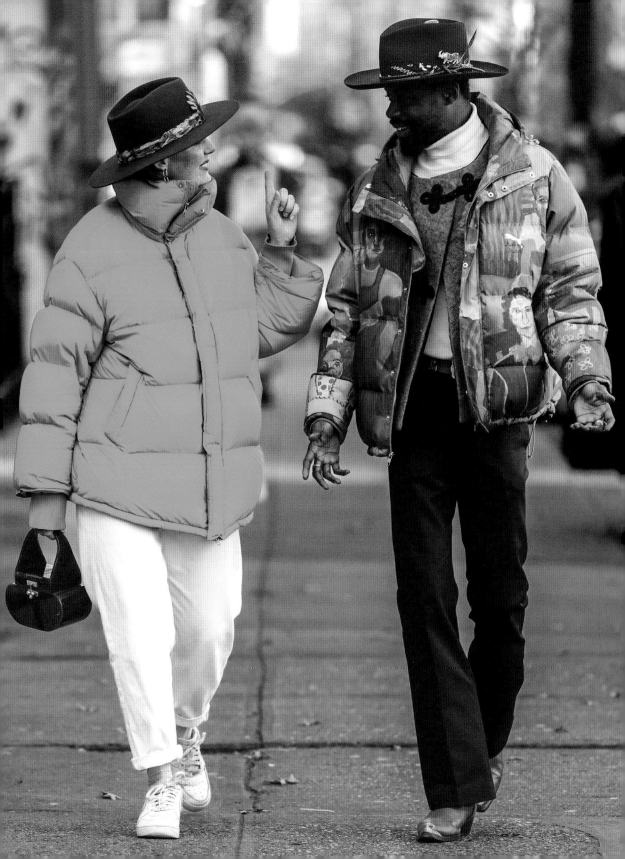

JC: **What does this say? What have you got here around your neck?**

O: **Pardon my glow.**

JC: **What does "pardon my glow" mean?**

O: **"Pardon my glow" means I'm not here to offend you. But here I am.**

JC: **O was telling me that she was an educator for over twenty years, but now what are you doing with your life?**

O: **Now, creatively, I am the founder of ObyDezign.**

JC: **Where do you get your creative energy from?**

O: **Well, I wanted to visit West Africa, and Ghana was the first country that I visited, and I absolutely fell in love. All of my fabric is sourced in Ghana, every last stitch of it. I've just fallen in love with the process because I get to be a part of this community.**

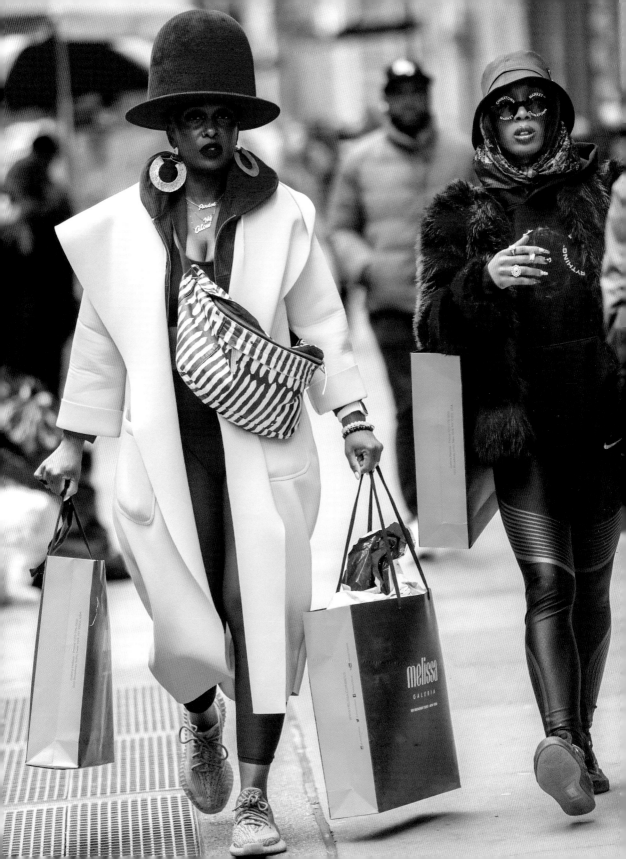

I Love NY

Jackets,

Jumpsuits

Knitwear

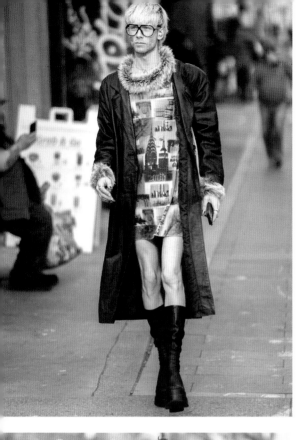

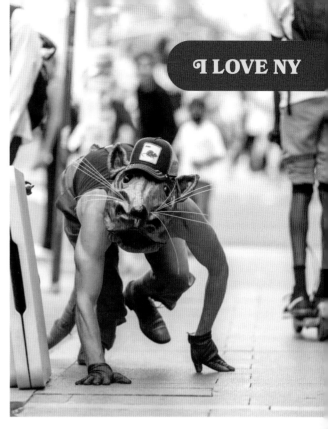

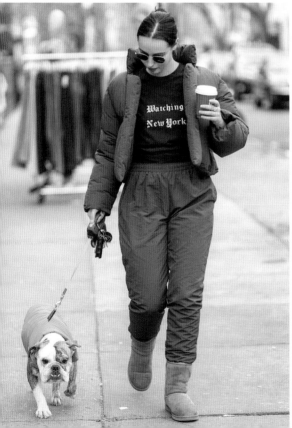

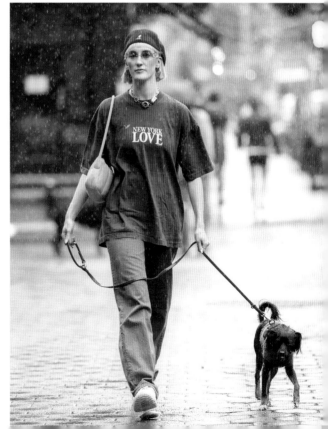

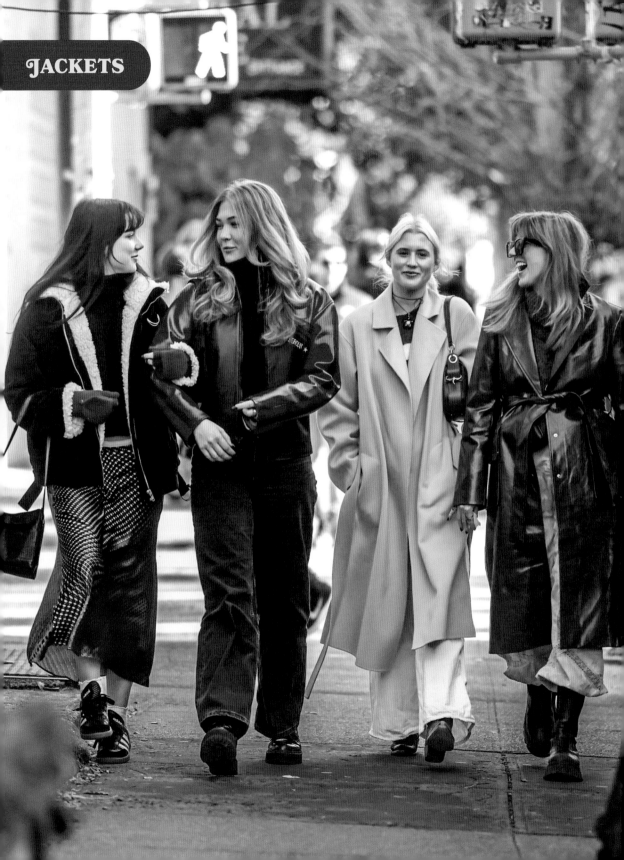

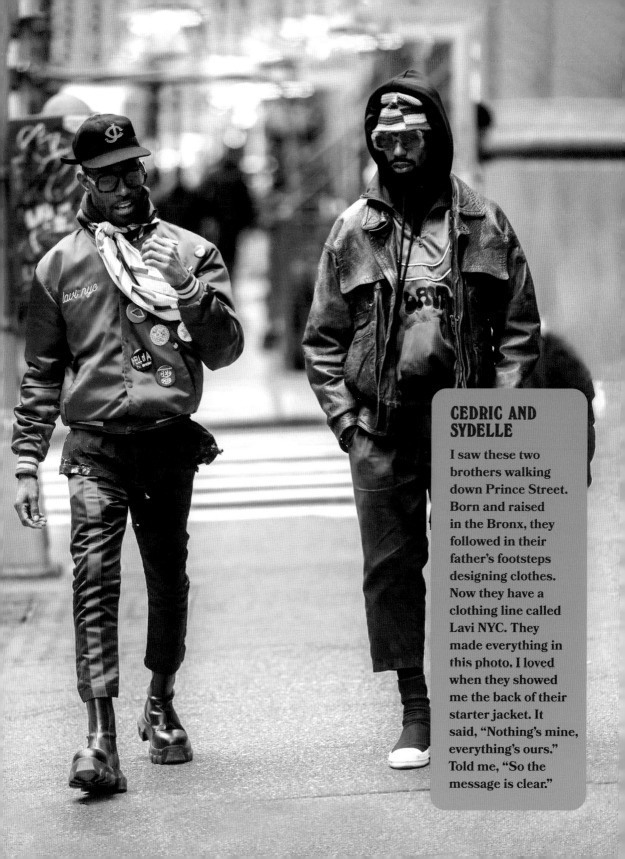

CEDRIC AND SYDELLE

I saw these two brothers walking down Prince Street. Born and raised in the Bronx, they followed in their father's footsteps designing clothes. Now they have a clothing line called Lavi NYC. They made everything in this photo. I loved when they showed me the back of their starter jacket. It said, "Nothing's mine, everything's ours." Told me, "So the message is clear."

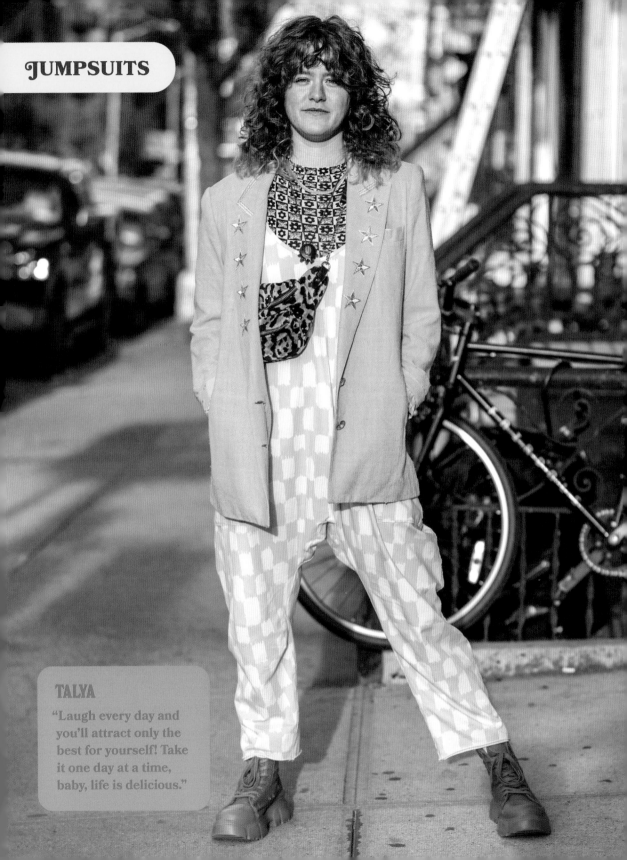

JUMPSUITS

TALYA

"Laugh every day and you'll attract only the best for yourself! Take it one day at a time, baby, life is delicious."

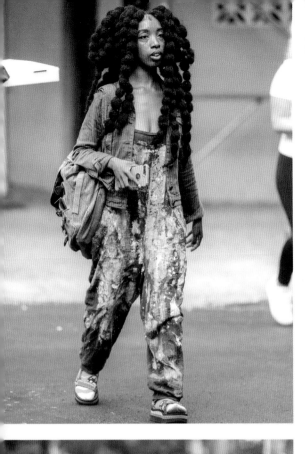
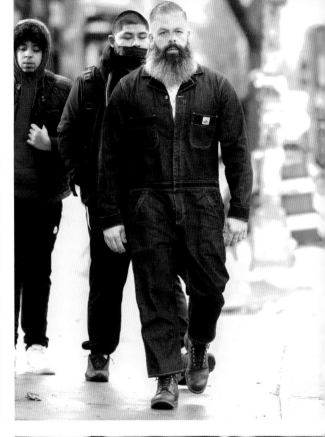
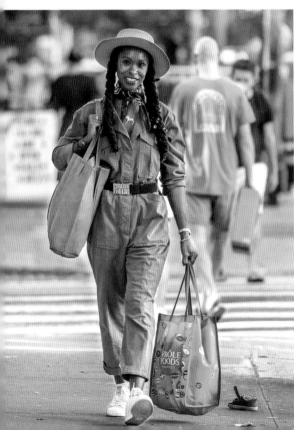
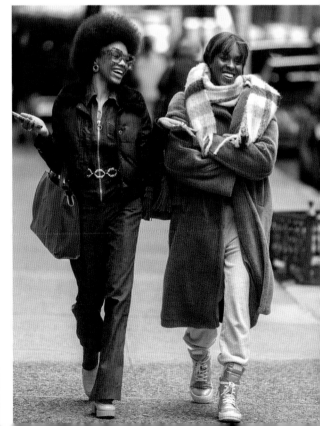

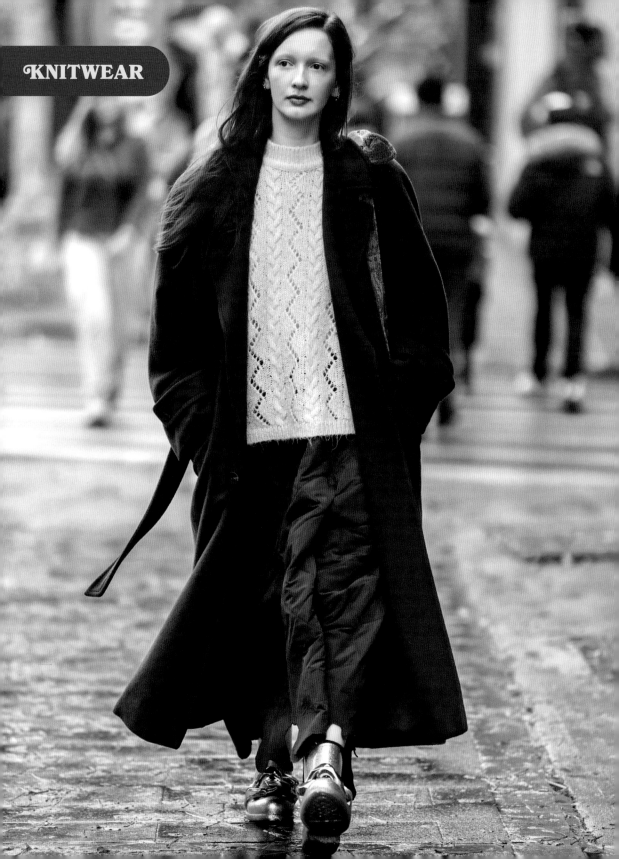

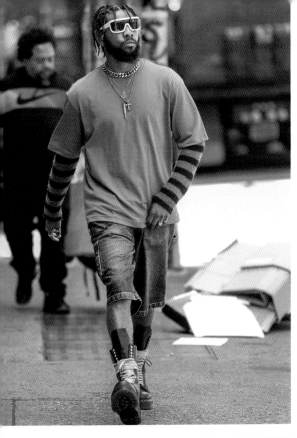
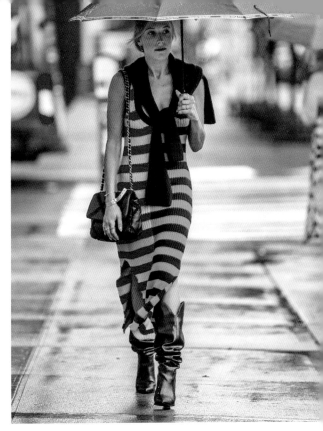
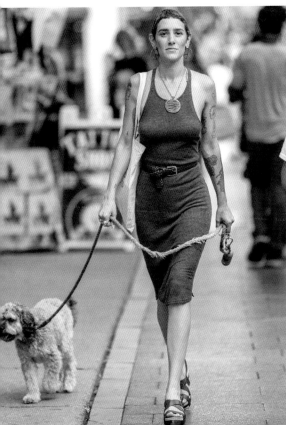
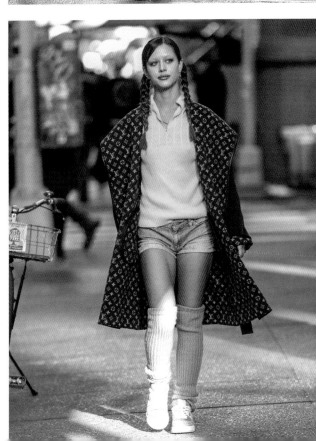

Lace,

Leather

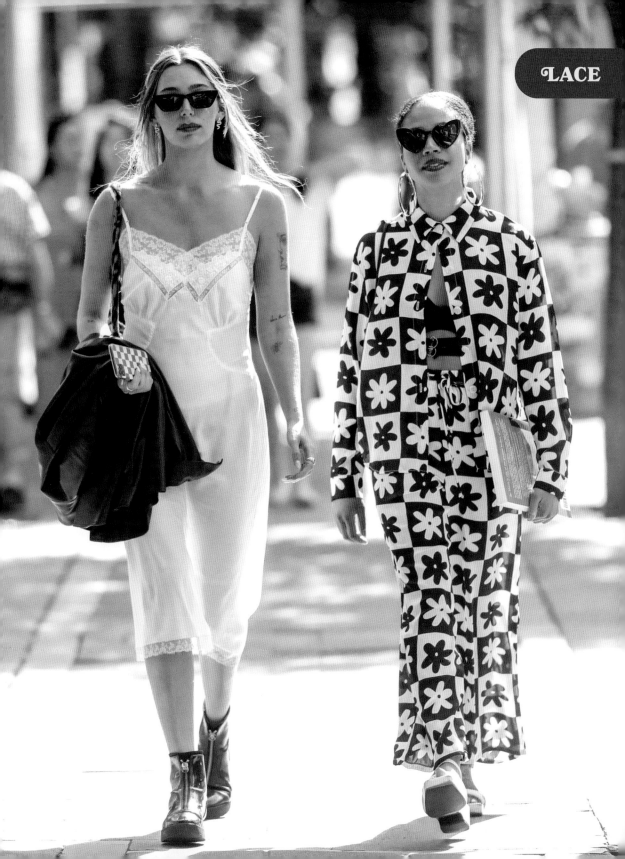

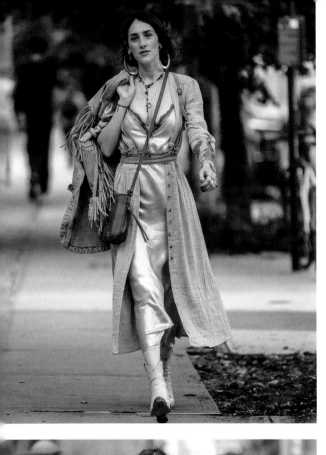
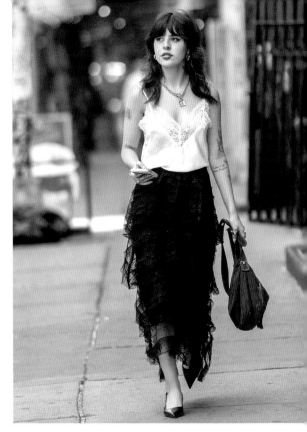
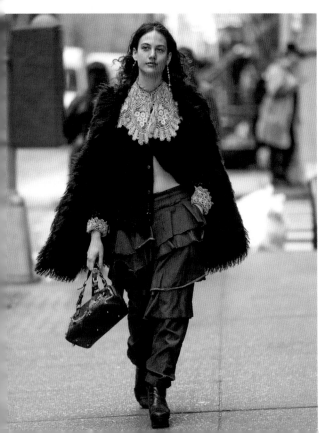
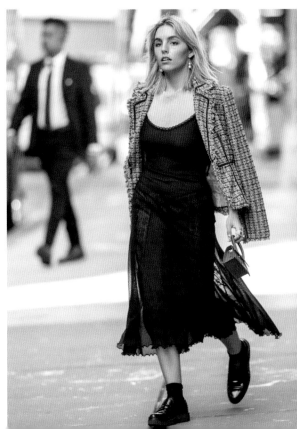

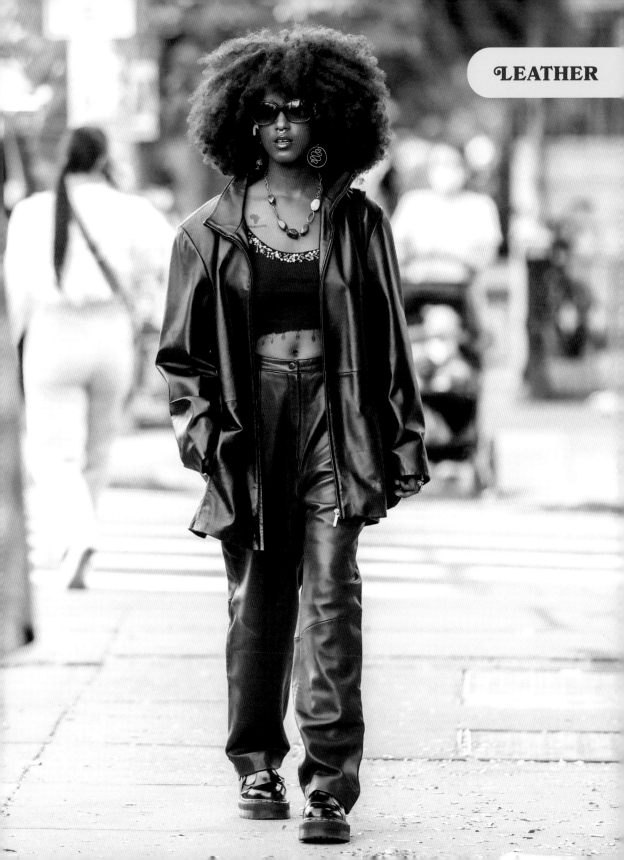

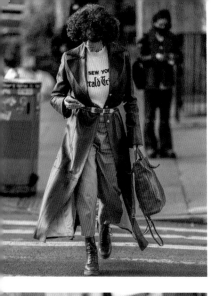
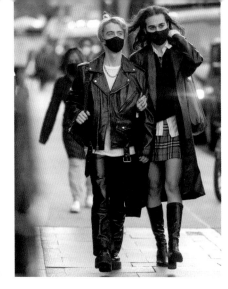
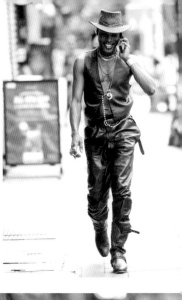
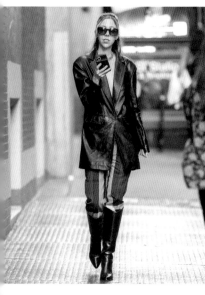
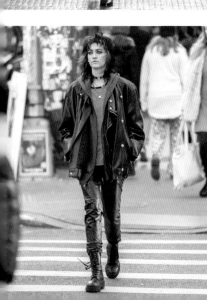
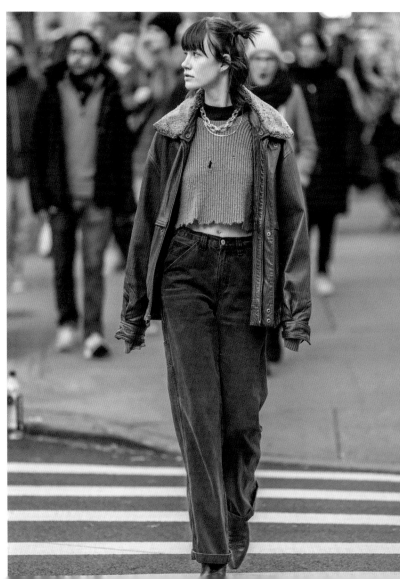

Macrame,

Maximalism,

Monochrome,

Best of Malcolm

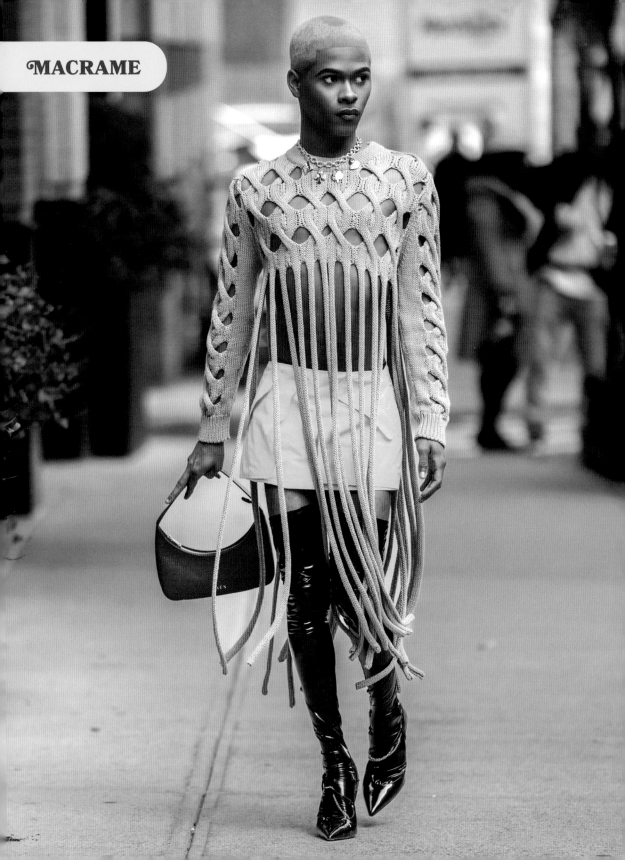

MACRAME

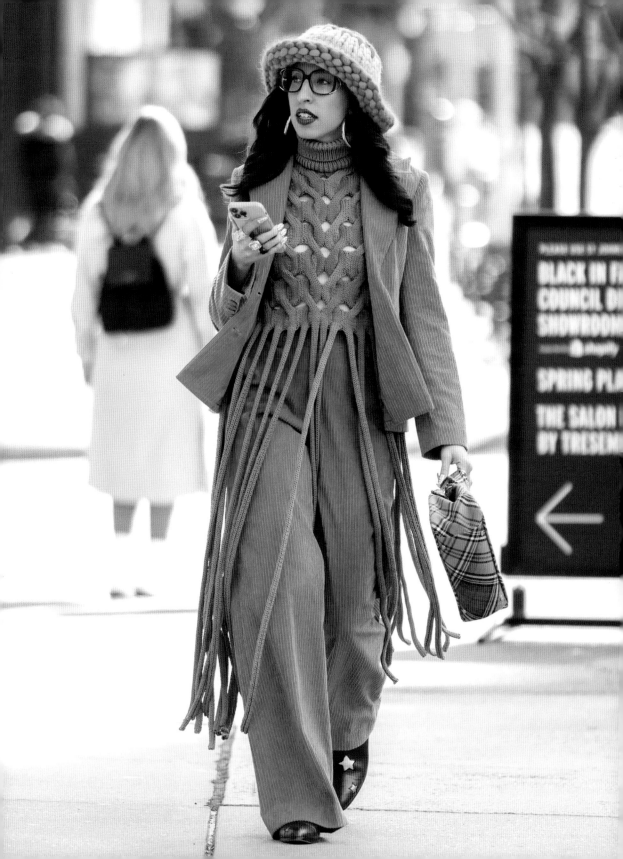

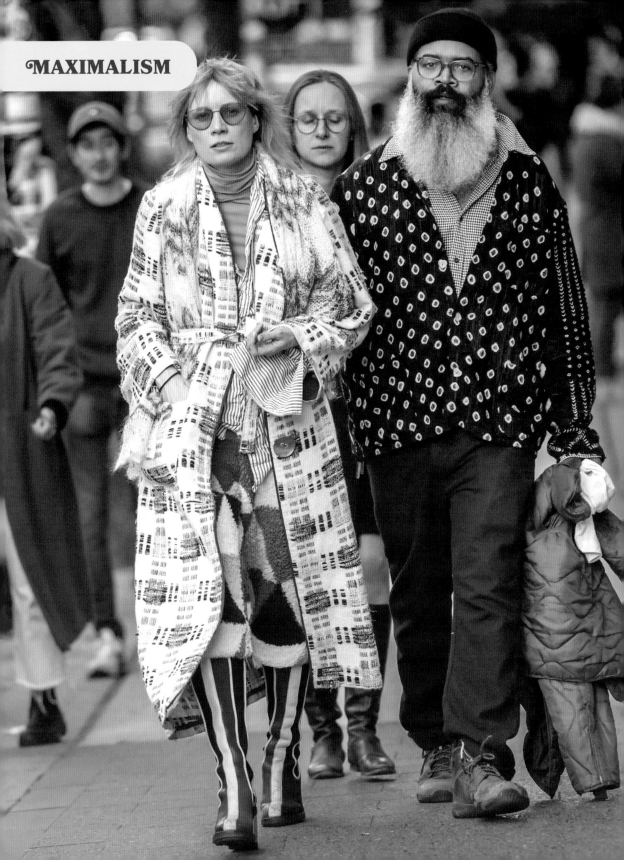

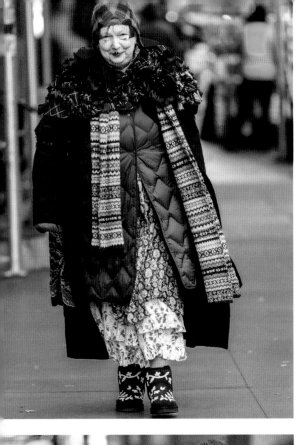
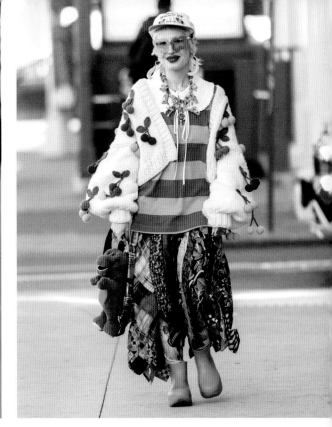
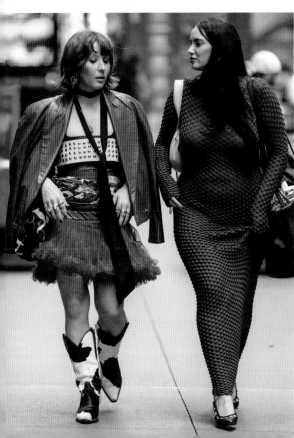
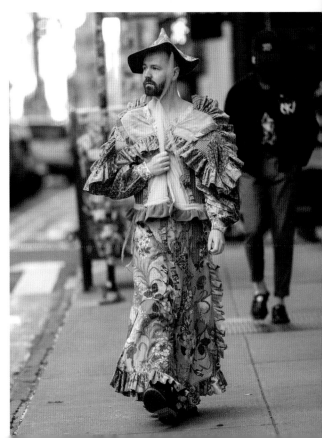

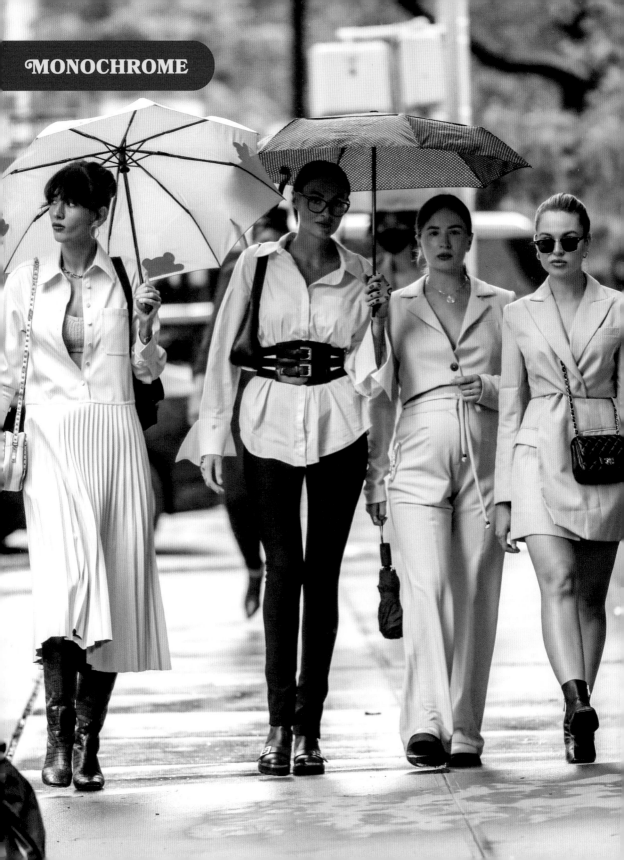

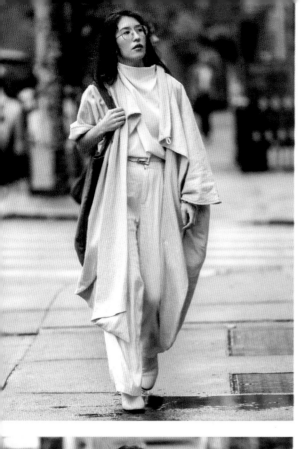
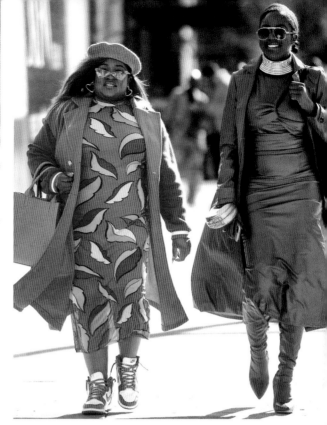
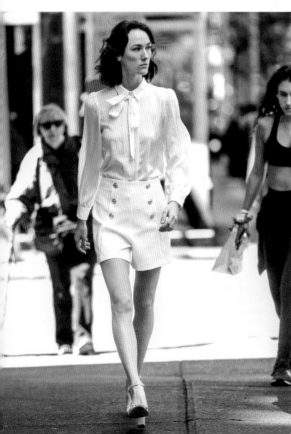
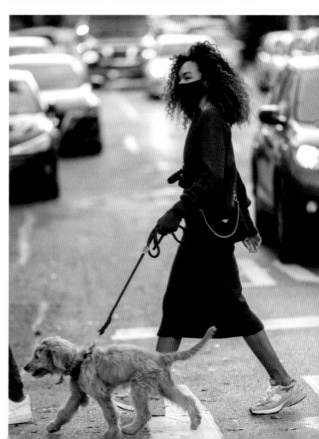

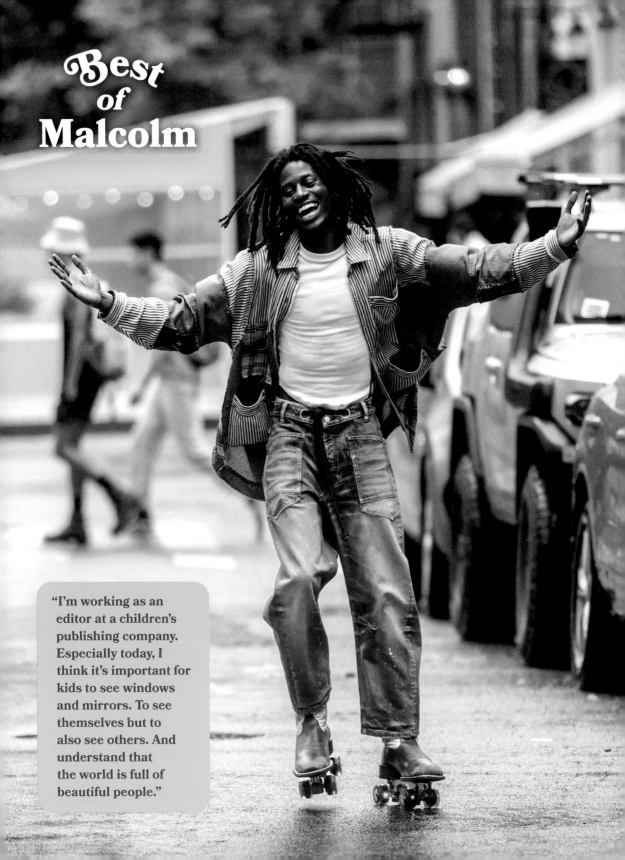

Best of
Malcolm

"I'm working as an editor at a children's publishing company. Especially today, I think it's important for kids to see windows and mirrors. To see themselves but to also see others. And understand that the world is full of beautiful people."

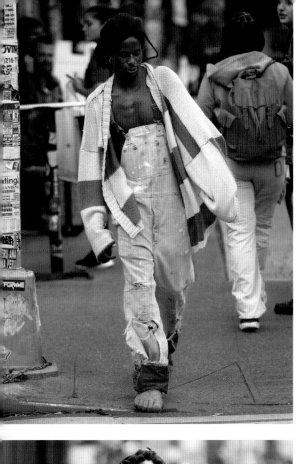
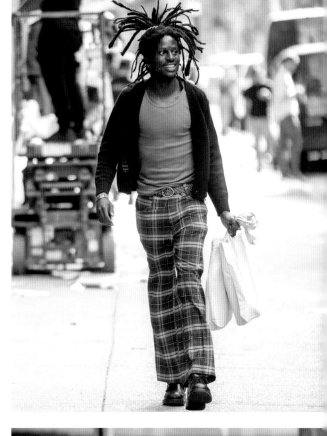
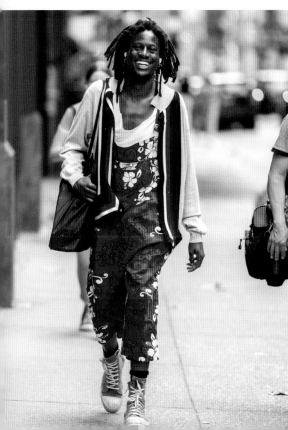
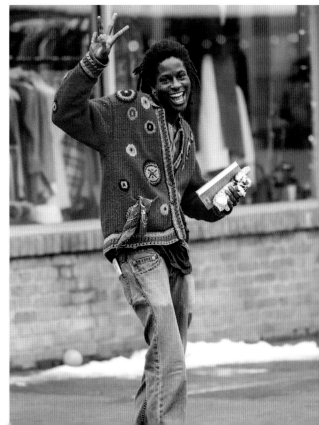

Neutrals,

NYC Icons

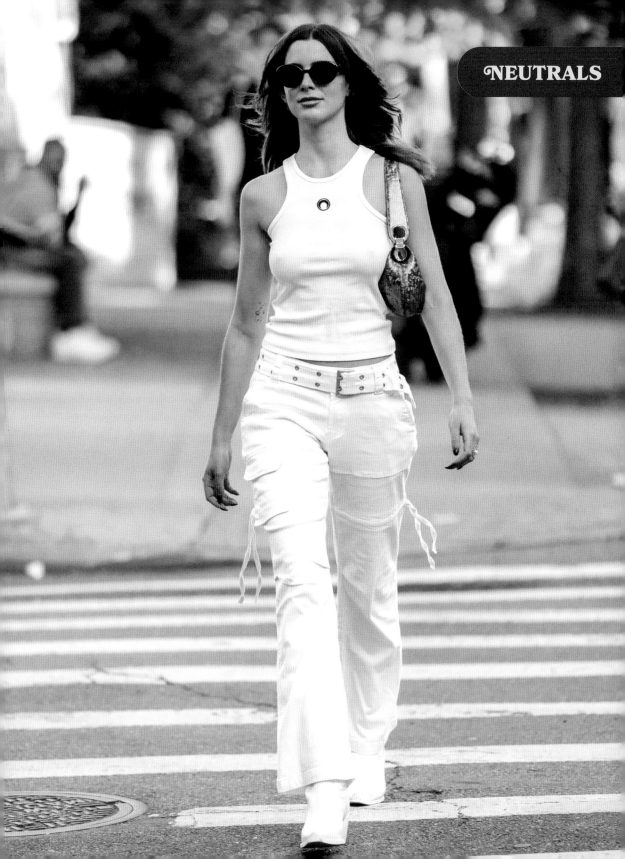

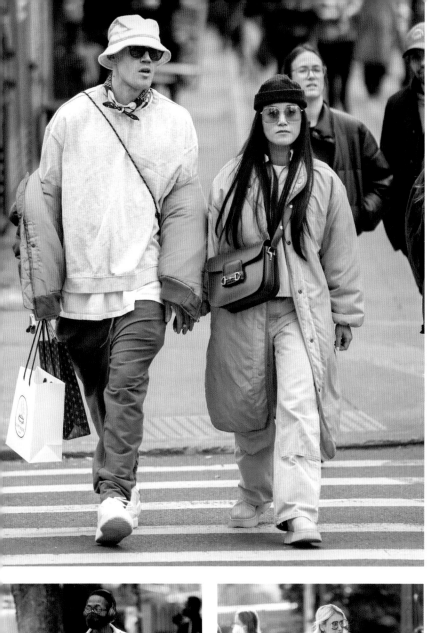
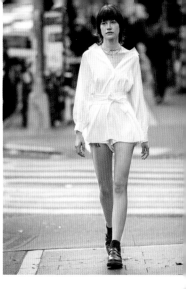
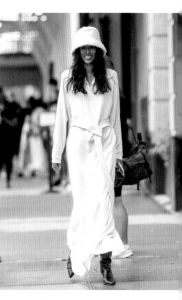
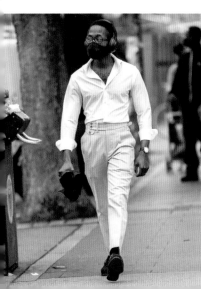
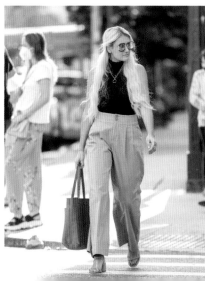

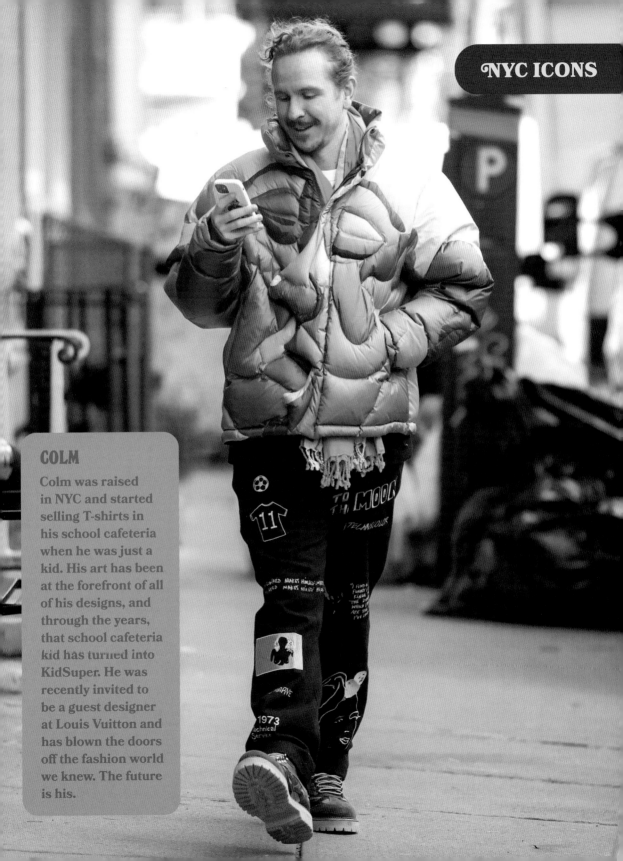

COLM

Colm was raised in NYC and started selling T-shirts in his school cafeteria when he was just a kid. His art has been at the forefront of all of his designs, and through the years, that school cafeteria kid has turned into KidSuper. He was recently invited to be a guest designer at Louis Vuitton and has blown the doors off the fashion world we knew. The future is his.

One-of-Ones,

Overalls

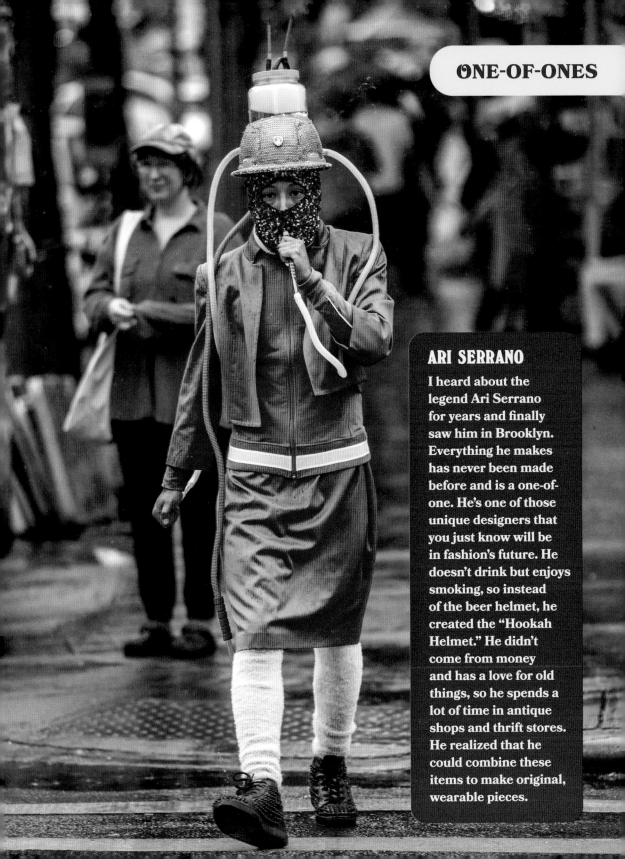

ARI SERRANO

I heard about the legend Ari Serrano for years and finally saw him in Brooklyn. Everything he makes has never been made before and is a one-of-one. He's one of those unique designers that you just know will be in fashion's future. He doesn't drink but enjoys smoking, so instead of the beer helmet, he created the "Hookah Helmet." He didn't come from money and has a love for old things, so he spends a lot of time in antique shops and thrift stores. He realized that he could combine these items to make original, wearable pieces.

JC: **Julian, nice to meet you. Can you give me a breakdown of what you're wearing right now?**

Julian: **I got full KidSuper. It's all about colors, freedom, being open-minded.**

JC: **What do you do for a living?**

Julian: **I'm a musician, I'm a singer, and I do French pop music disco funk.**

JC: **What do you want it to inspire?**

Julian: **When people listen to my music, I love when they tell me that they feel happy, like maybe safer, because I always speak about being confident and growing up with your dreams.**

JC: **What would you compare your music to?**

Julian: **Maybe a giant rainbow, but with people dancing on it.**

JC: **When you were younger, what were you like?**

Julian: **I was really touched by colors, and I grew up in a tiny village and everything was gray. I would like to quote one of my friends, he was saying when he was younger, "I was just in a gray city and one day I saw for the first time a rainbow in the sky, and I stole this rainbow," and I think that's beautiful.**

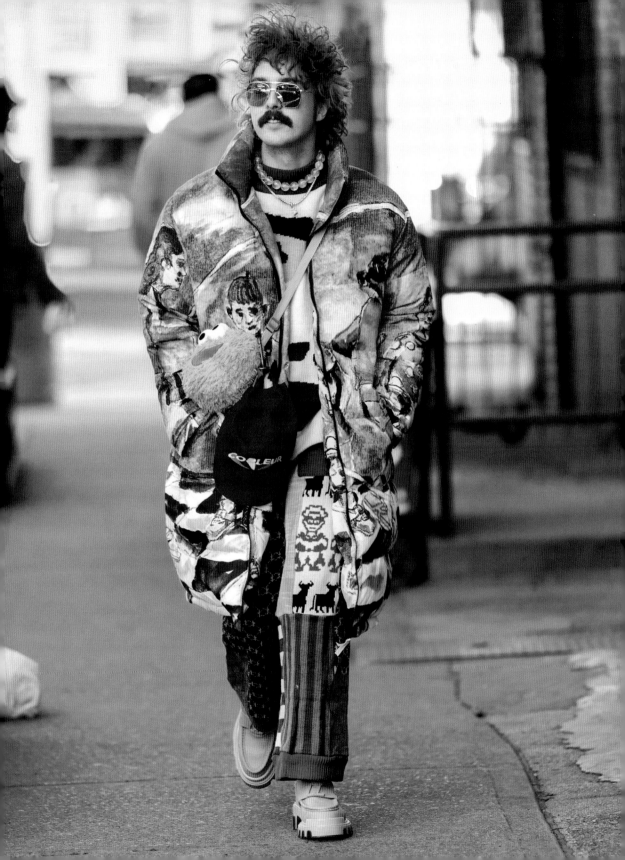

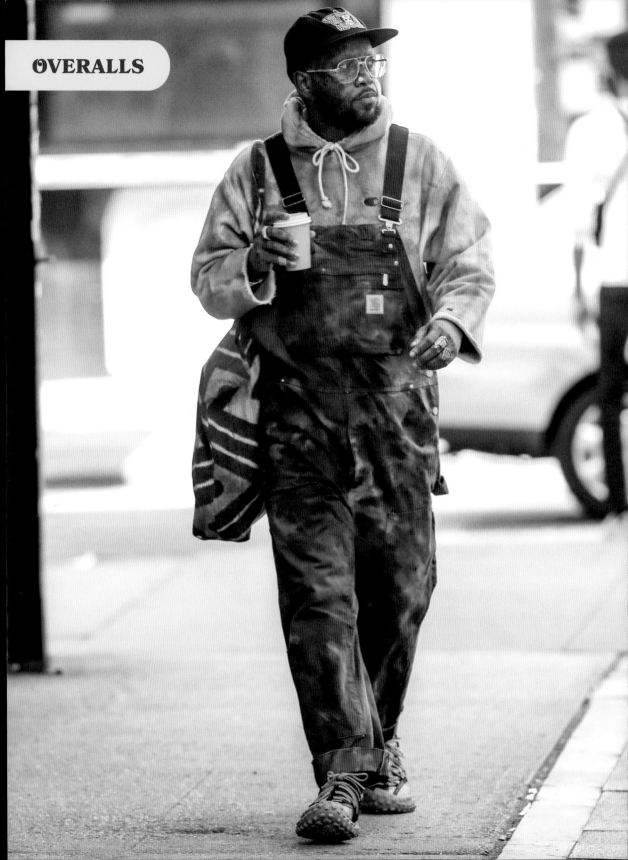

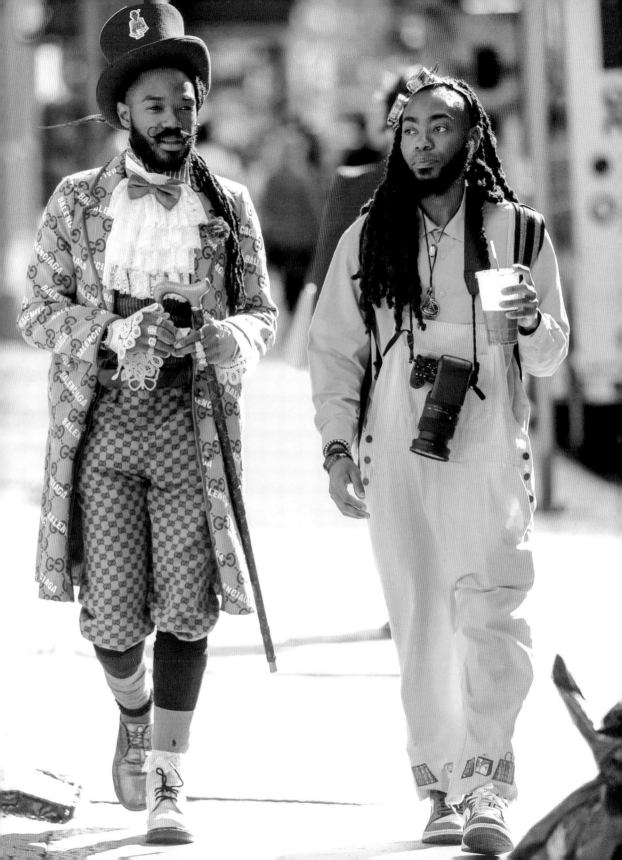

Patches,

Patterns and Prints,

Plaid, Pop of Color,

Puffers

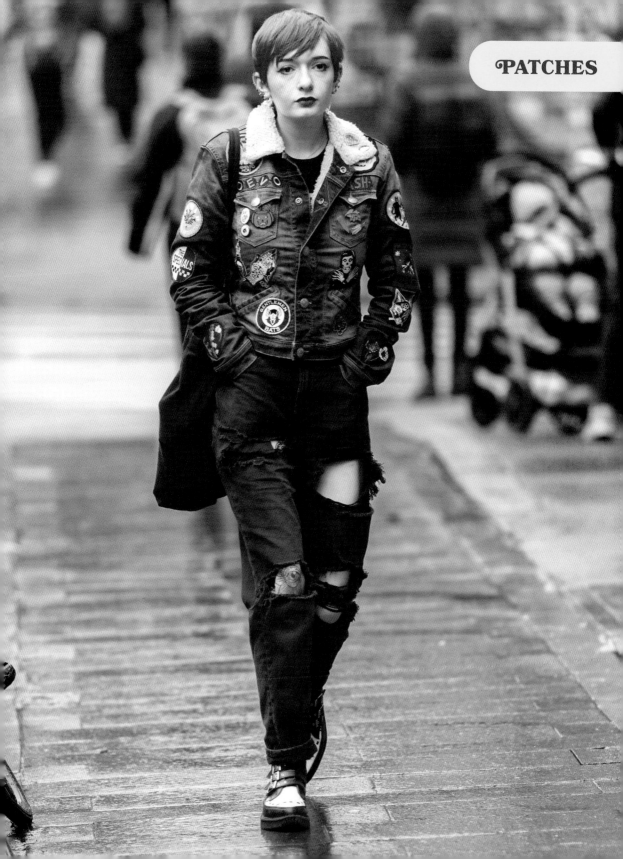

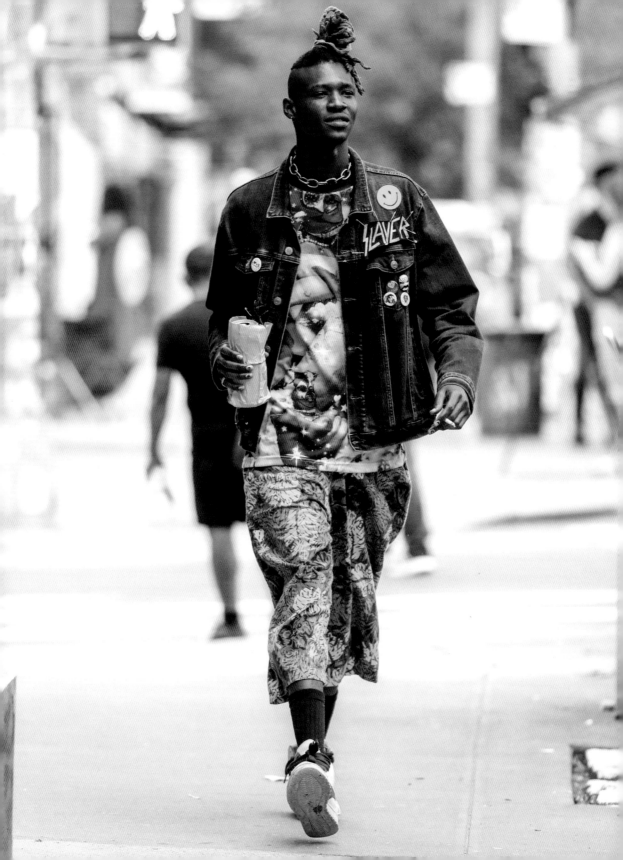

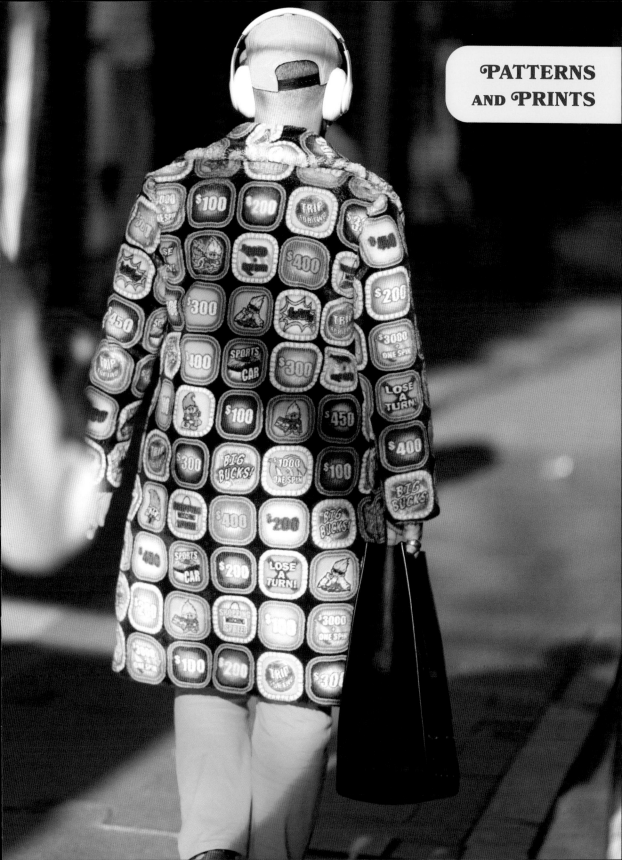

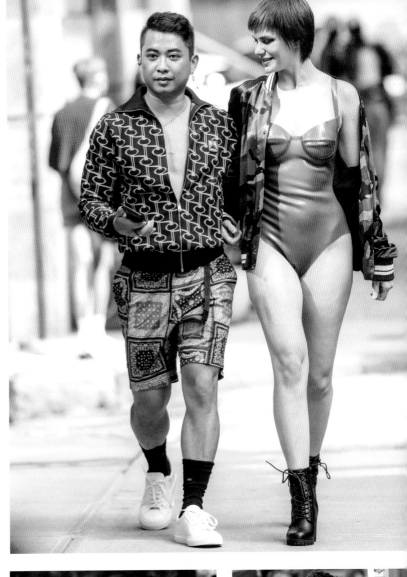
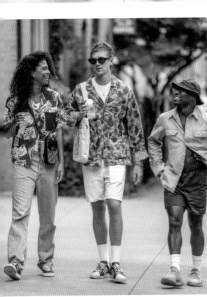
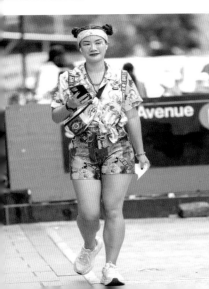
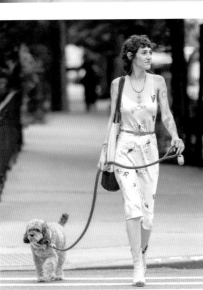
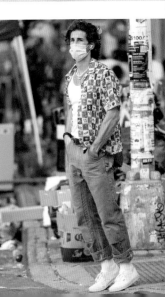

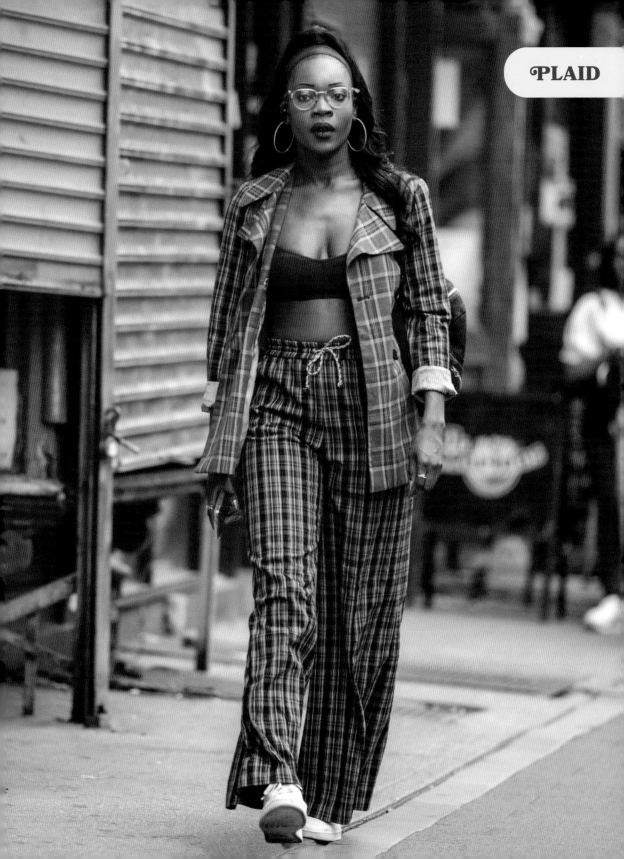

Lindsey: **This coat is vintage from Barcelona. This blazer is also vintage. This Ralph Lauren sweater is from my mom, and this is a plain polo from Housing Works. The shoes are Madewell, because we need them. My mom has a lot of clothes, so whenever I go home, I go through her closet, and I just find things that she's had from the nineties.**

JC: **Why do you think the nineties are so big right now?**

Lindsey: **Wanting to dress fun. The nineties had a lot of really big patterns. Dressing is not only about color and pattern; it's also about the fit of your clothing.**

JC: **Guys, welcome my fashion correspondent, Lindsey. What do you do with your life, Lindsey?**

Lindsey: **I'm actually a freelance florist. I worked an event with a friend, Flowers by Ford; she's amazing. We did a life-size floral vagina.**

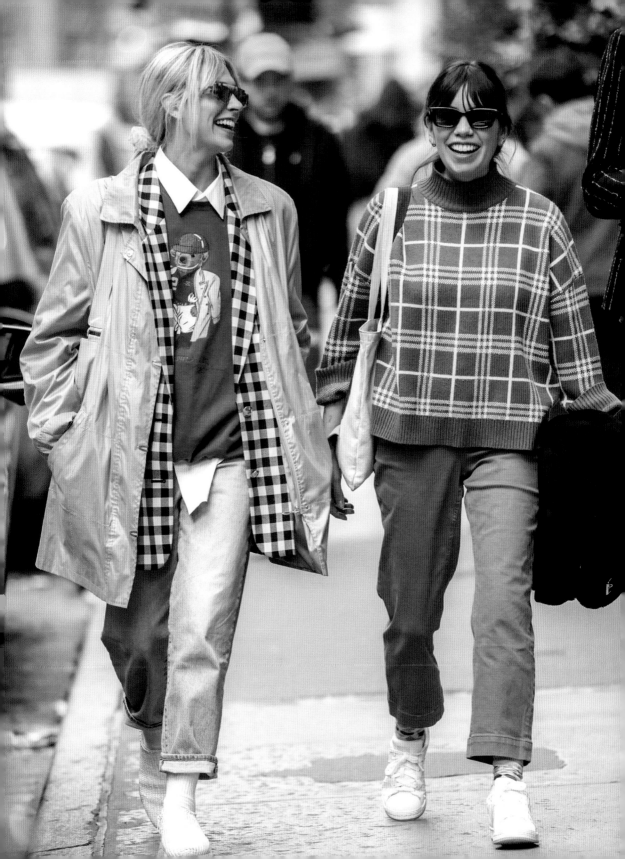

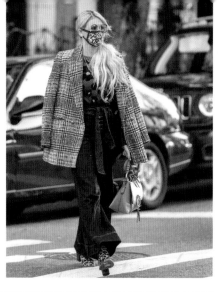
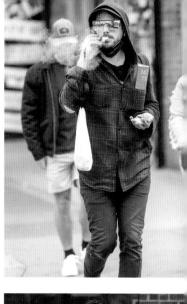
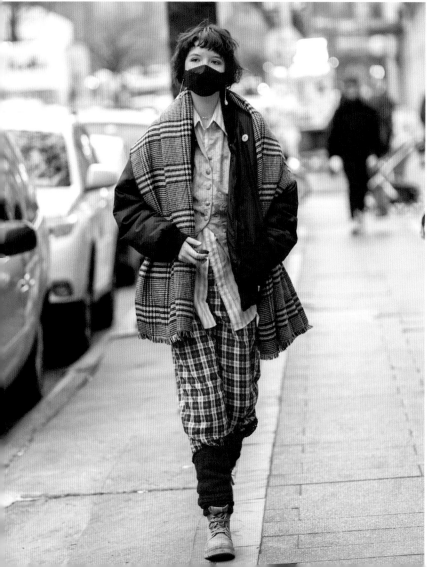
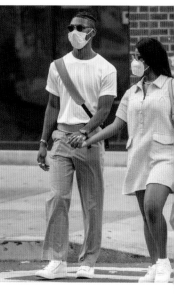
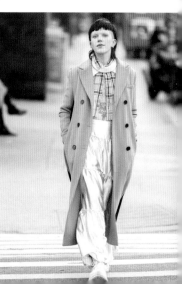

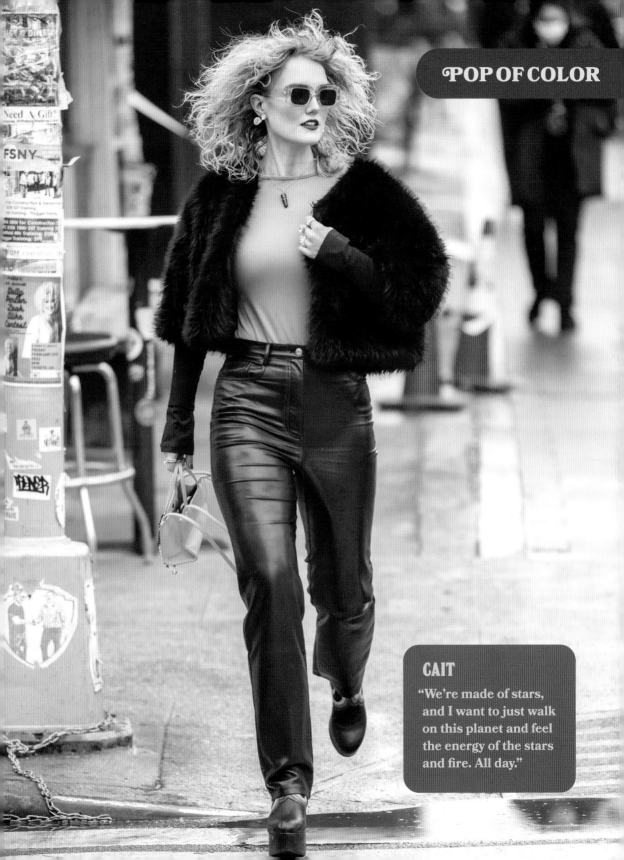

CAIT

"We're made of stars, and I want to just walk on this planet and feel the energy of the stars and fire. All day."

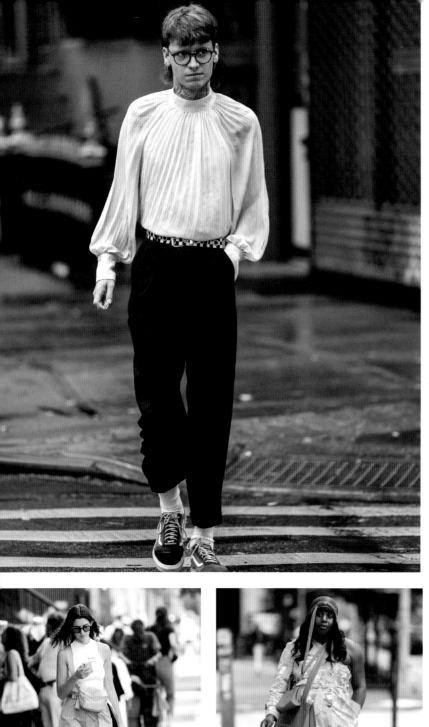

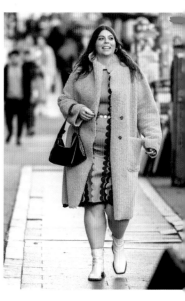
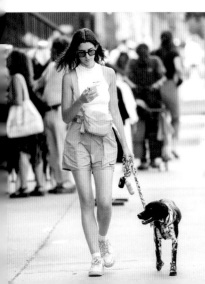
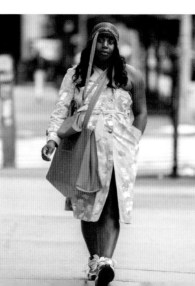
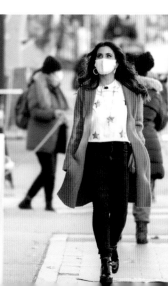

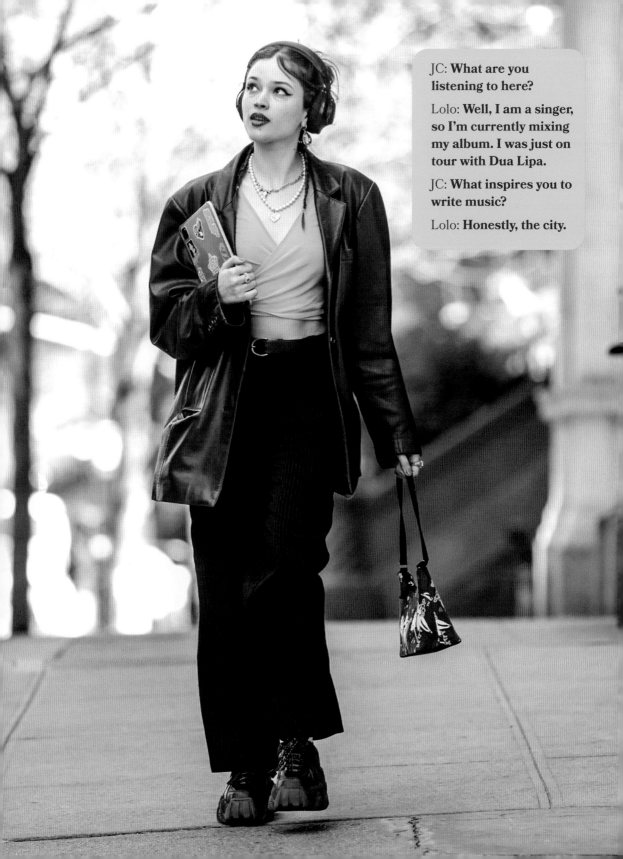

JC: **What are you listening to here?**

Lolo: **Well, I am a singer, so I'm currently mixing my album. I was just on tour with Dua Lipa.**

JC: **What inspires you to write music?**

Lolo: **Honestly, the city.**

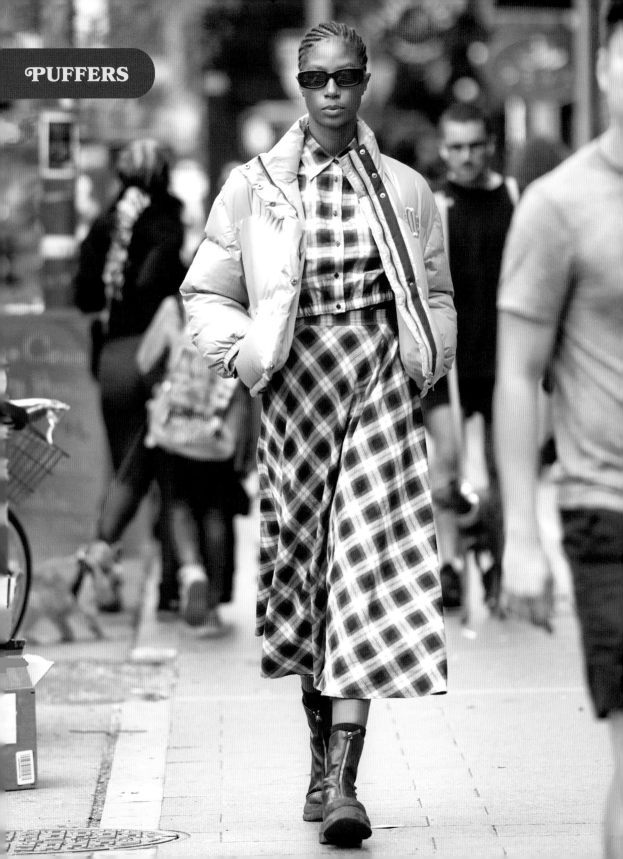

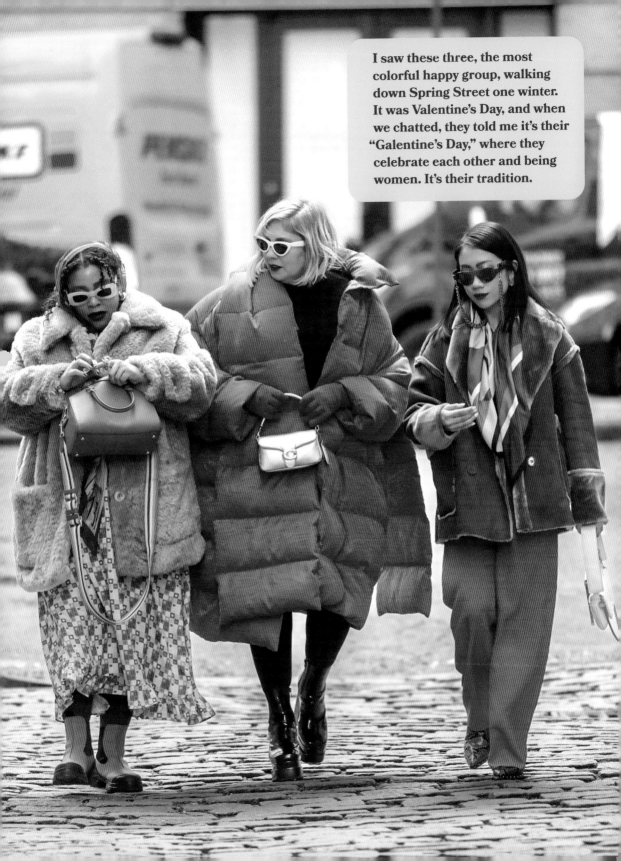

I saw these three, the most colorful happy group, walking down Spring Street one winter. It was Valentine's Day, and when we chatted, they told me it's their "Galentine's Day," where they celebrate each other and being women. It's their tradition.

Quilted

Raincoats,

Rave

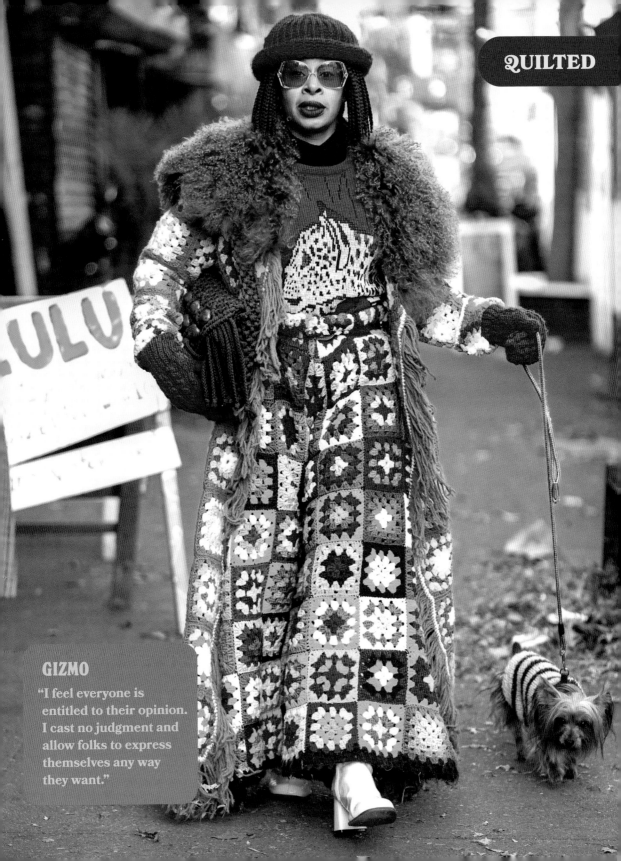

GIZMO

"I feel everyone is entitled to their opinion. I cast no judgment and allow folks to express themselves any way they want."

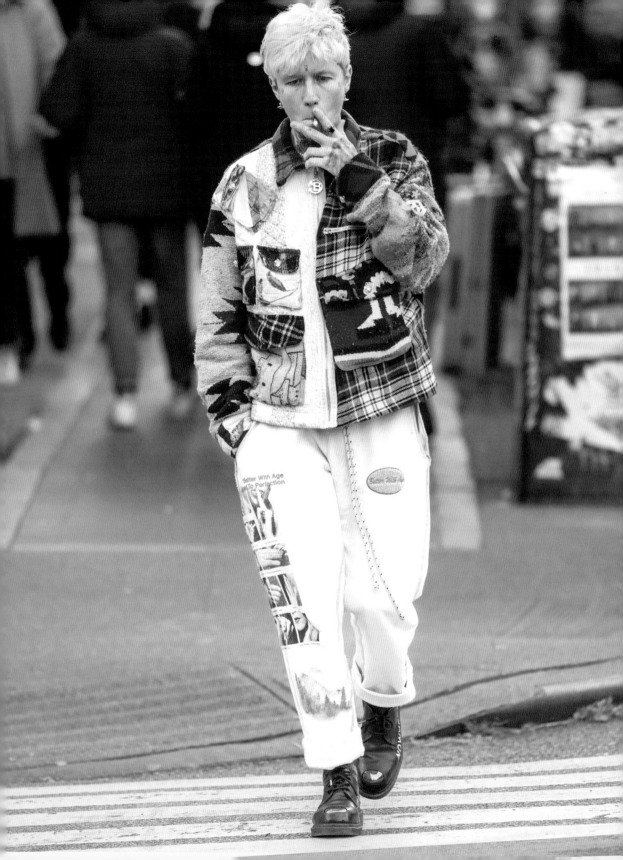

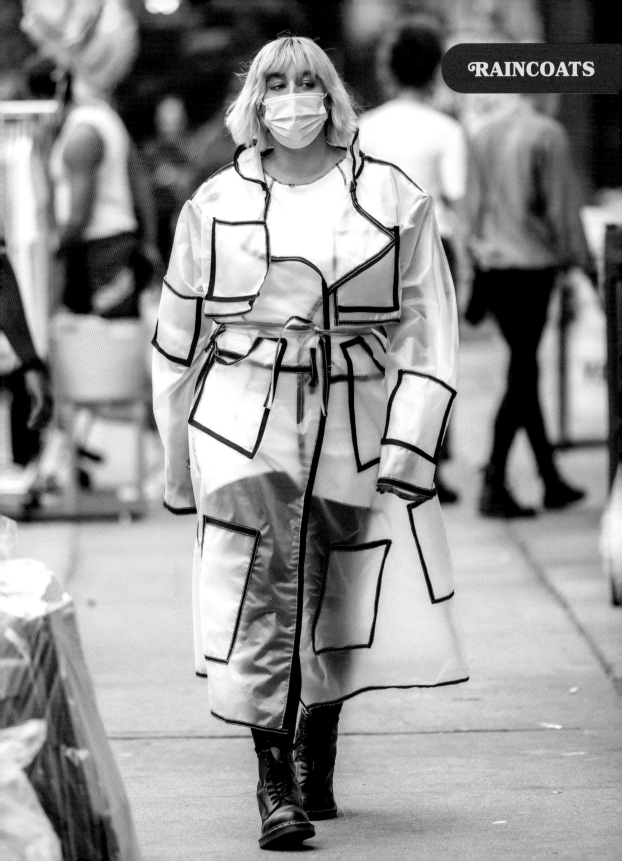

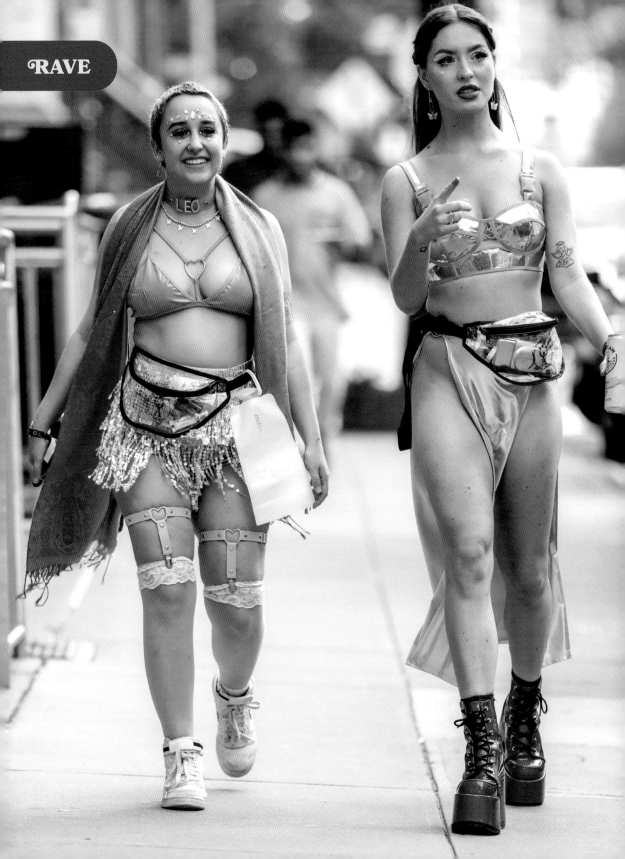

Scarves,

Shorts and Skirts,

Sports Teams, Stripes,

Suits, Sweaters,

Swimwear,

Best of Stephen Antonio

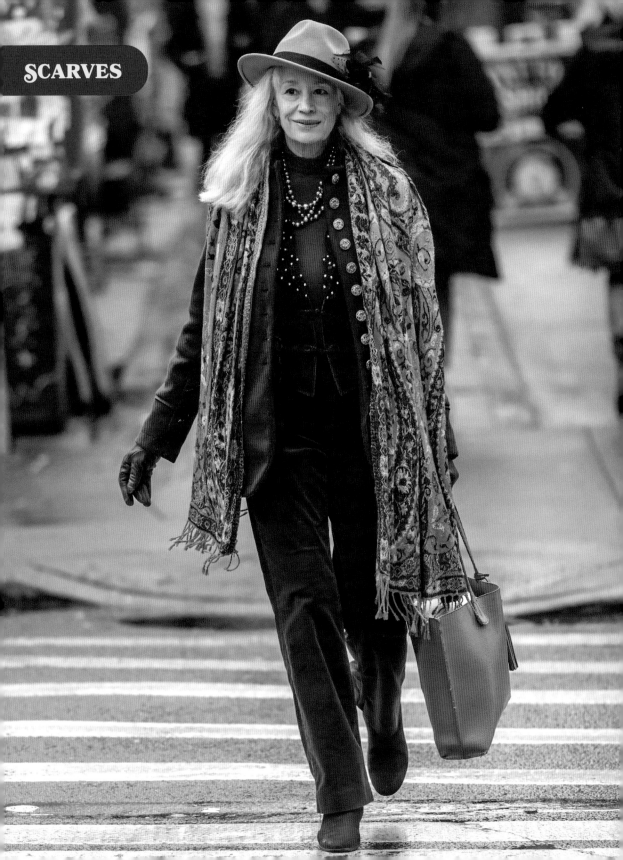

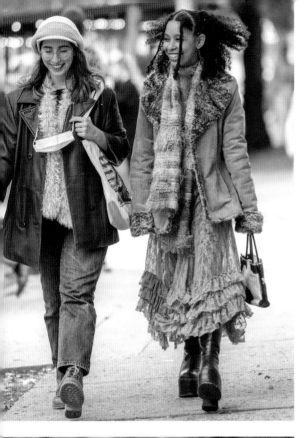
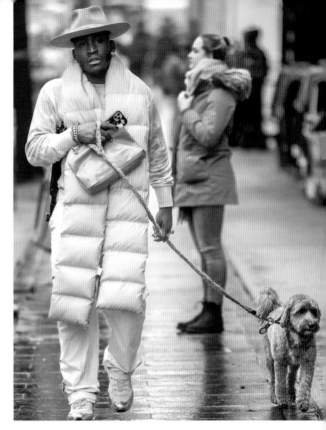
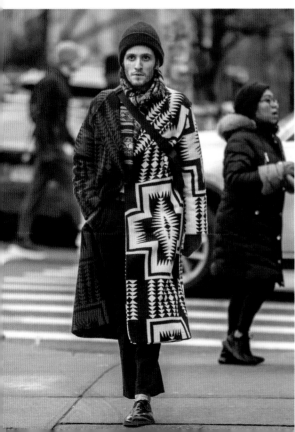
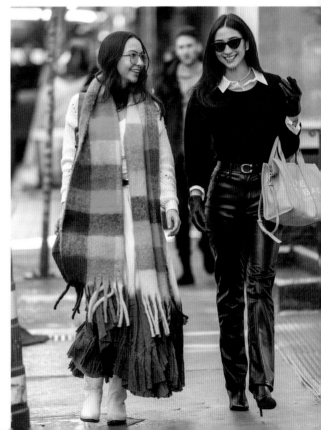

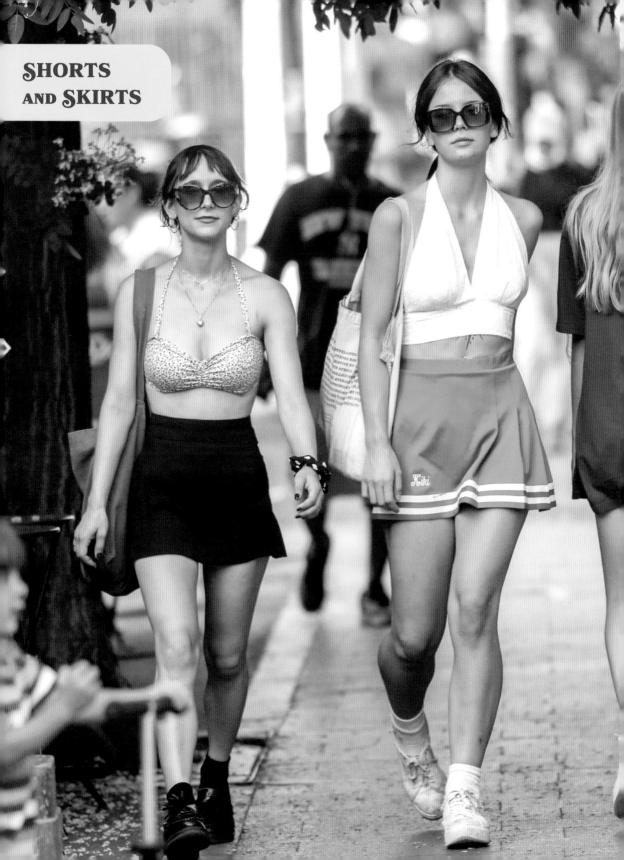

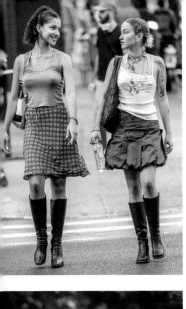
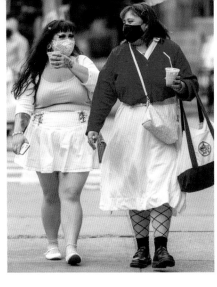
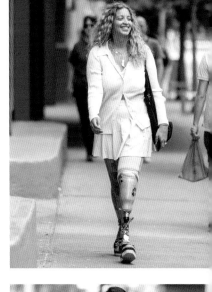
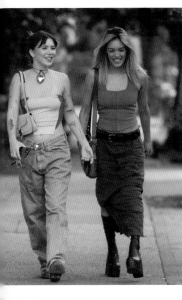
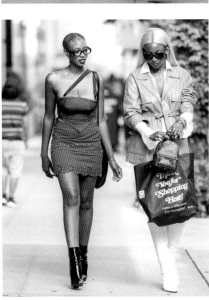
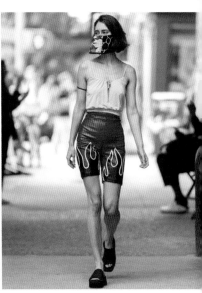
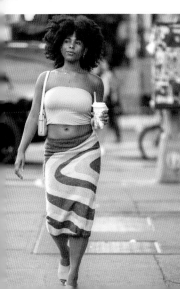
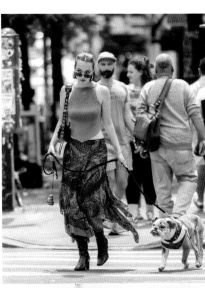
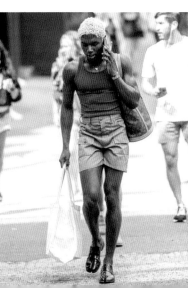

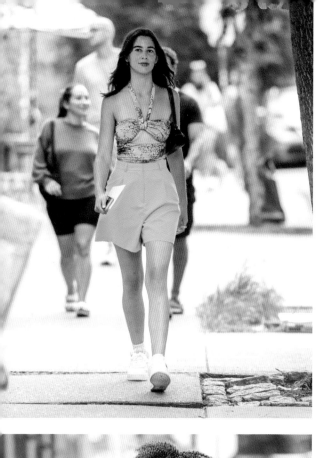
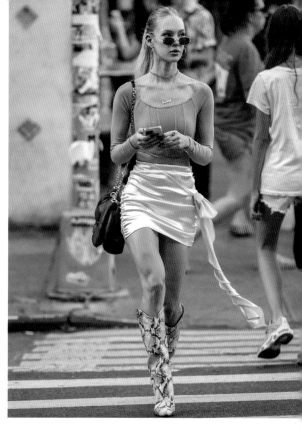
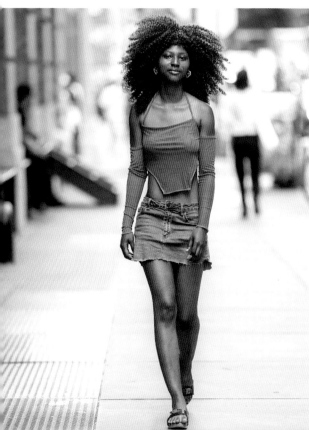
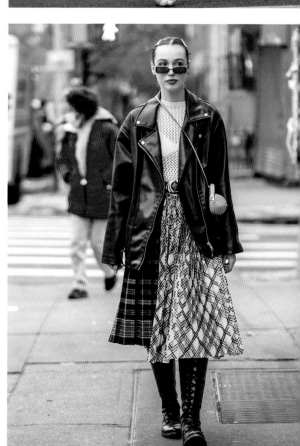

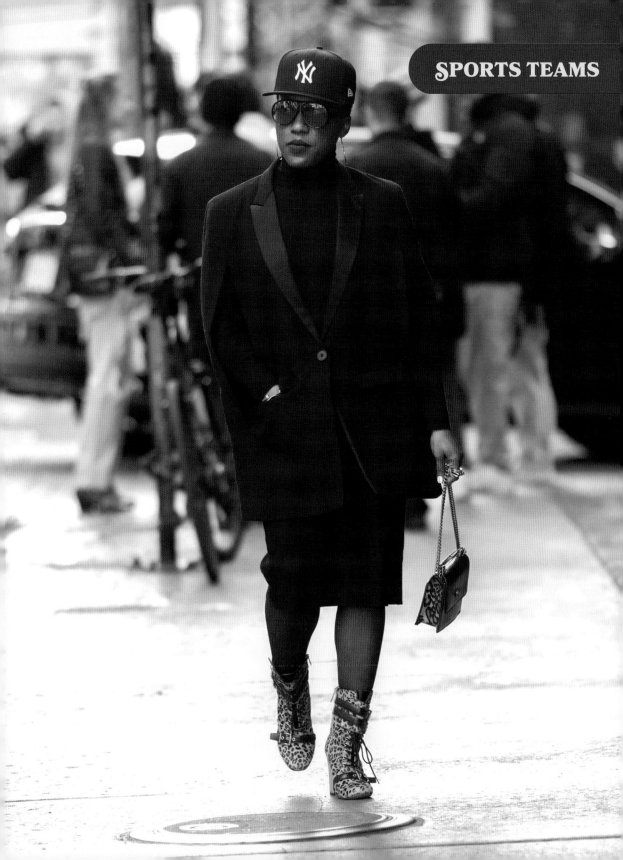

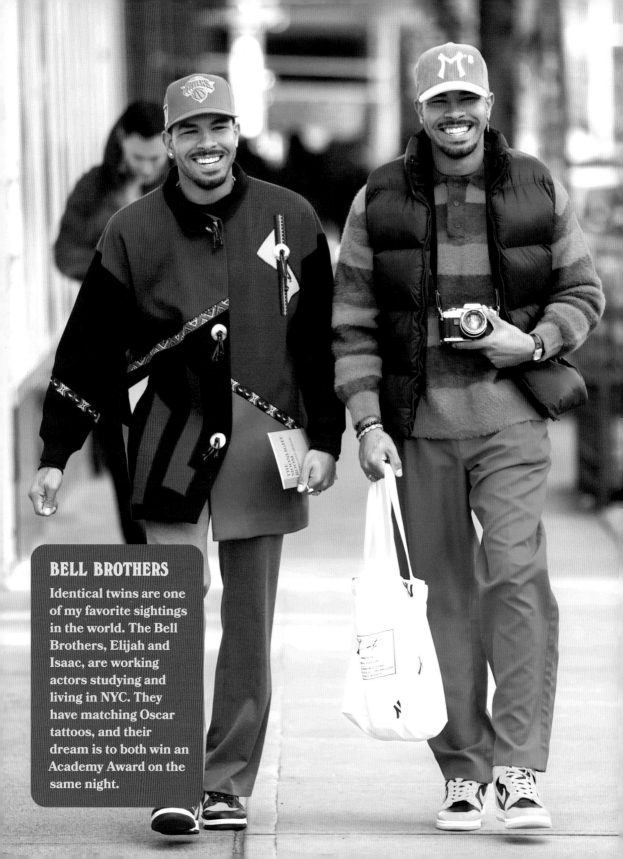

BELL BROTHERS

Identical twins are one of my favorite sightings in the world. The Bell Brothers, Elijah and Isaac, are working actors studying and living in NYC. They have matching Oscar tattoos, and their dream is to both win an Academy Award on the same night.

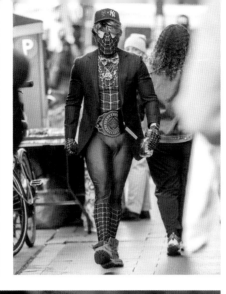
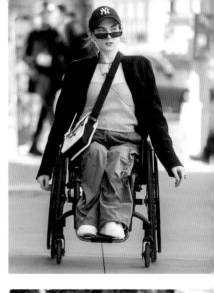
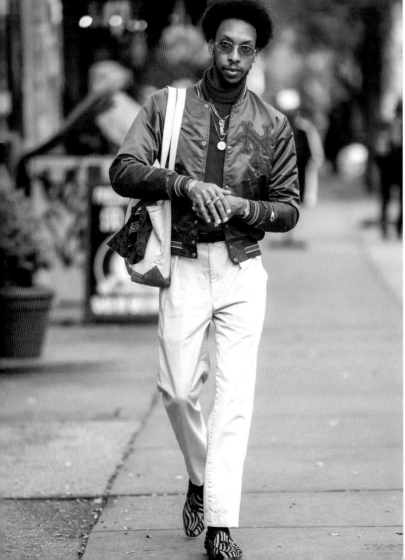
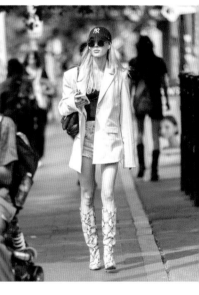
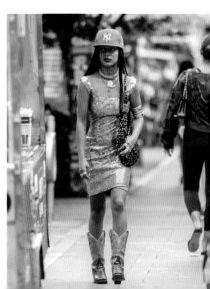

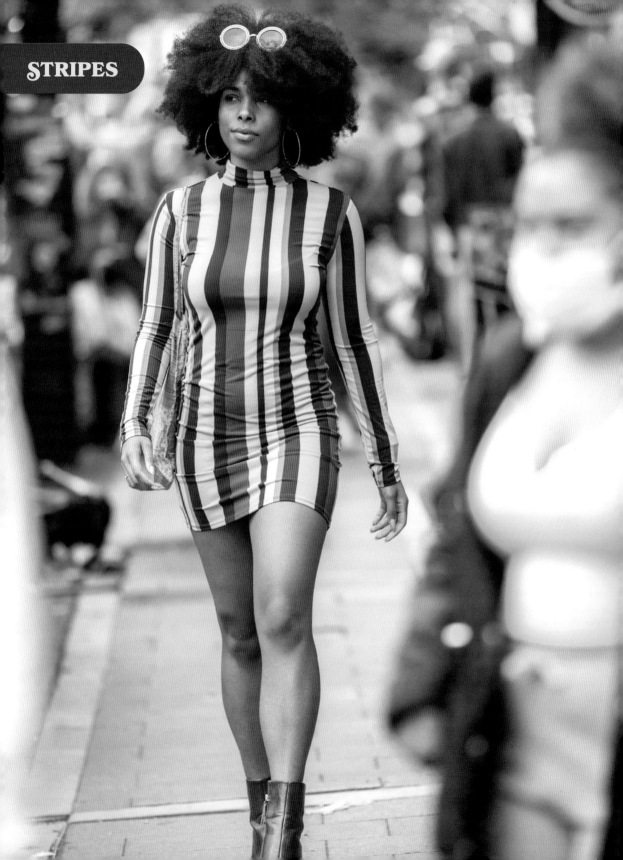

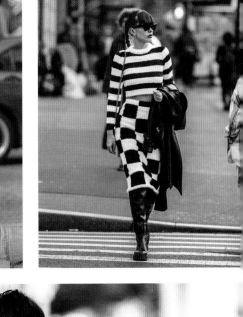
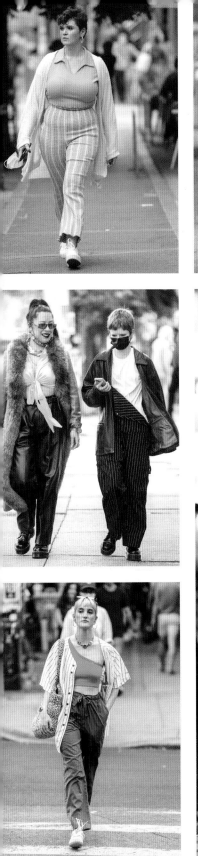
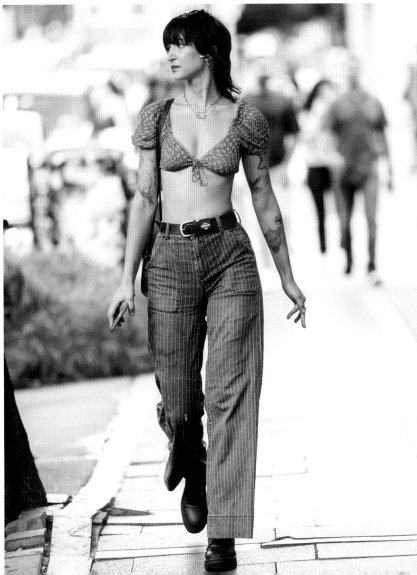

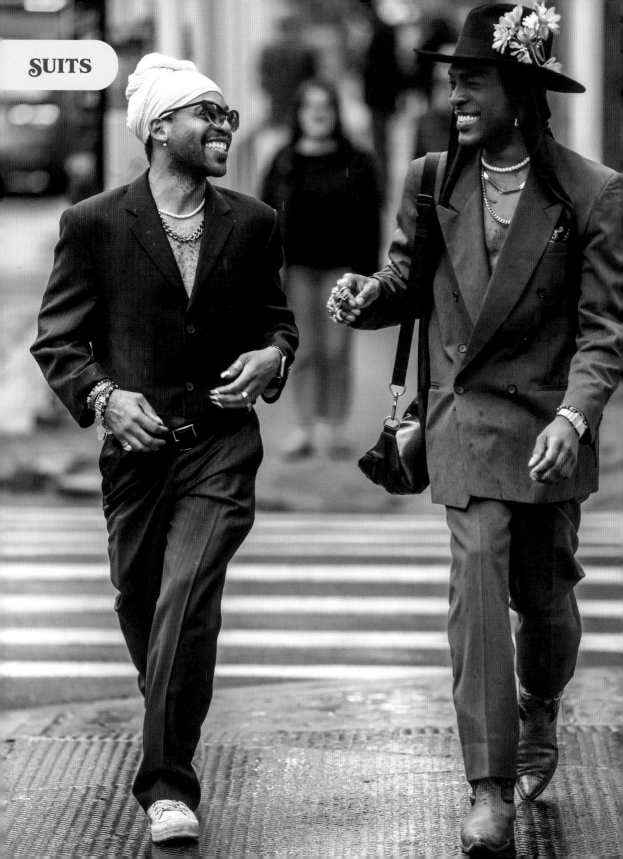

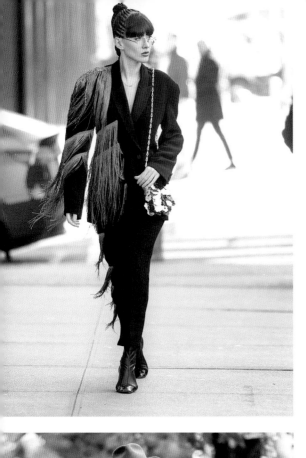
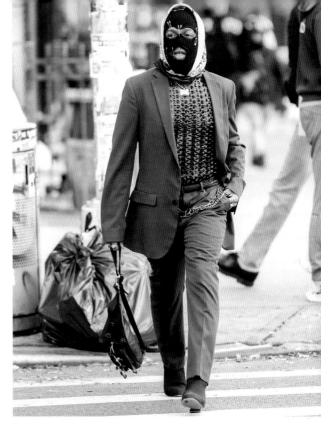
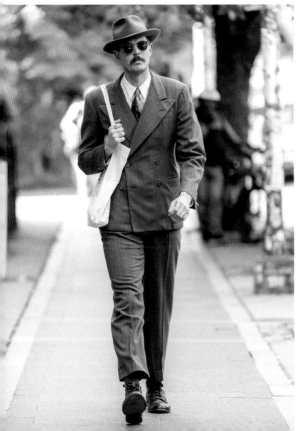
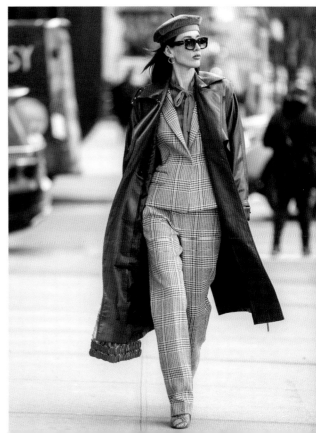

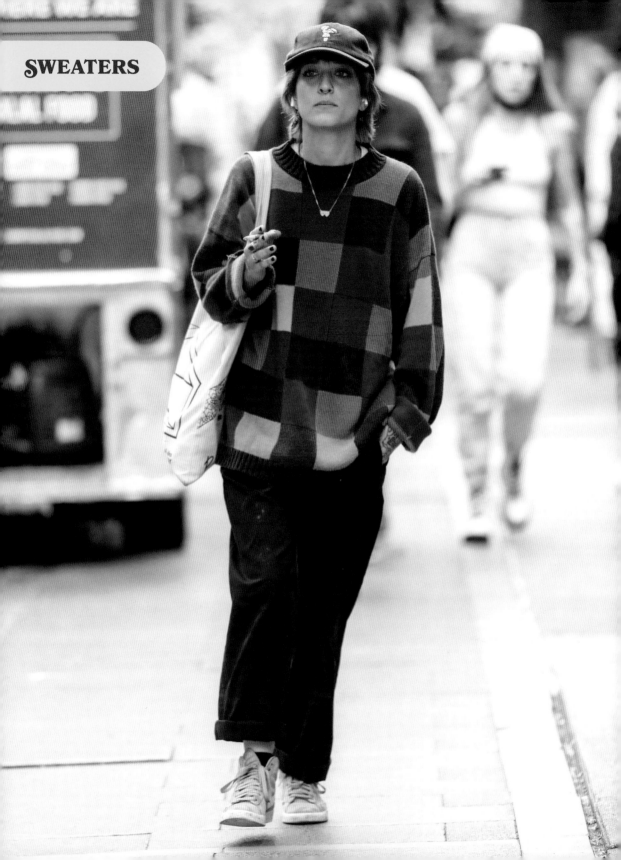

SWEATERS

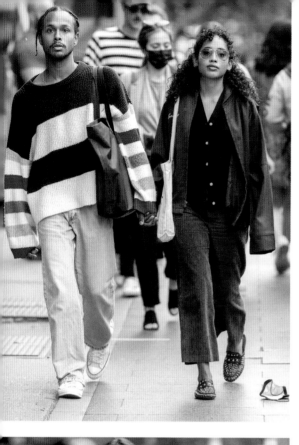
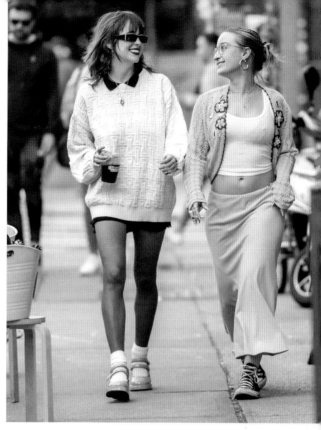
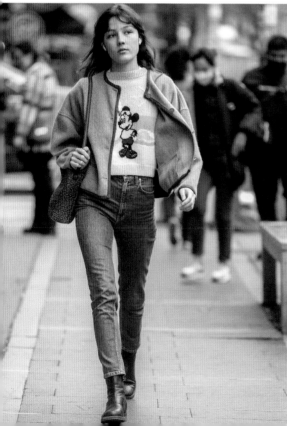
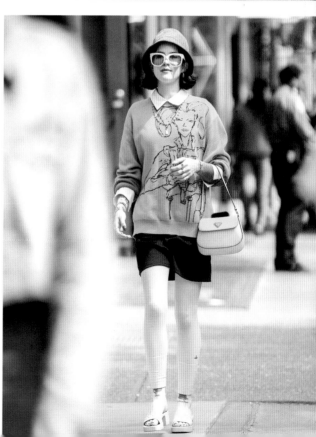

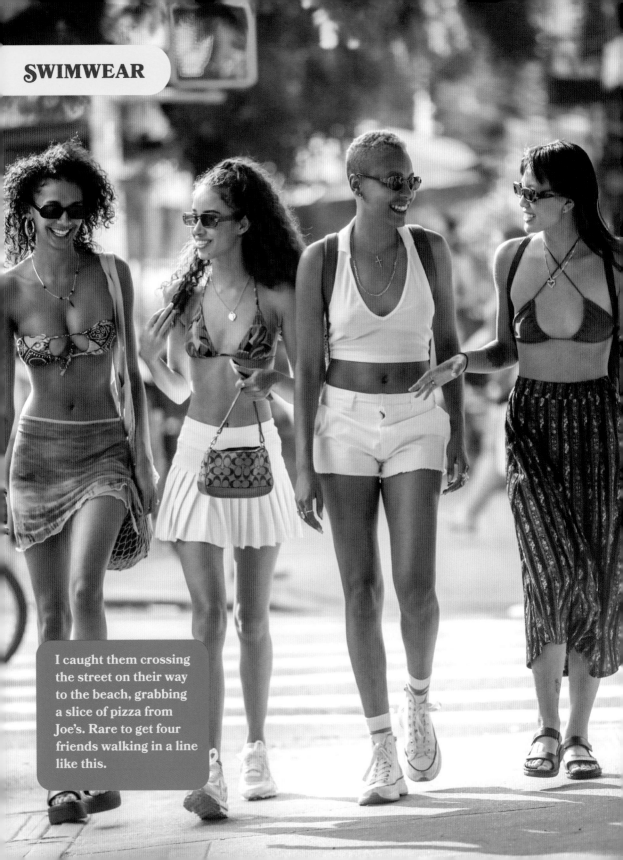

I caught them crossing the street on their way to the beach, grabbing a slice of pizza from Joe's. Rare to get four friends walking in a line like this.

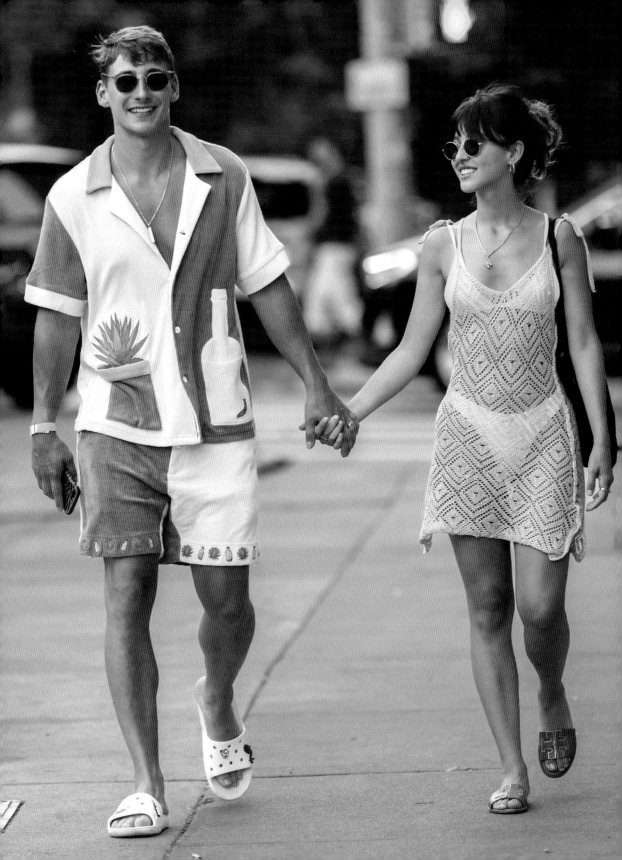

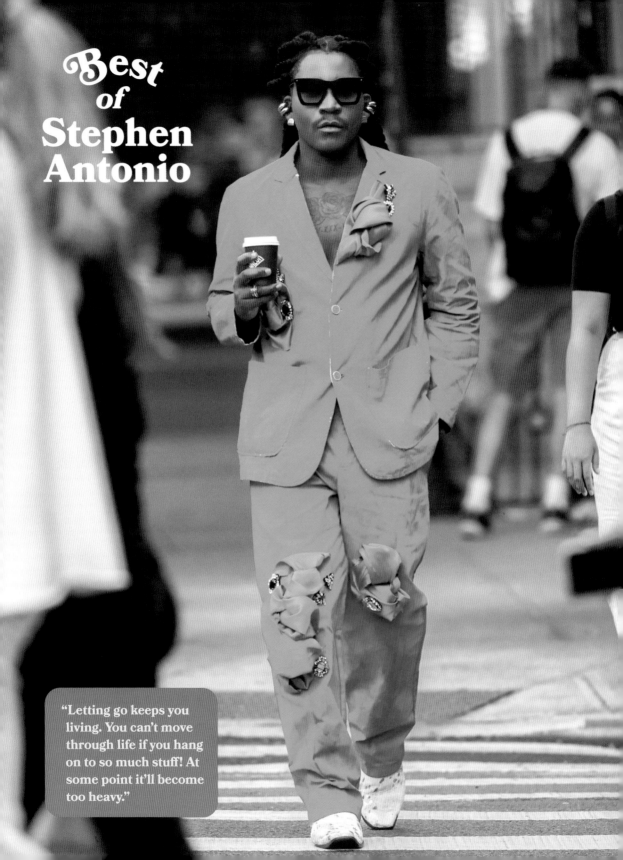

Best
of
Stephen
Antonio

"Letting go keeps you living. You can't move through life if you hang on to so much stuff! At some point it'll become too heavy."

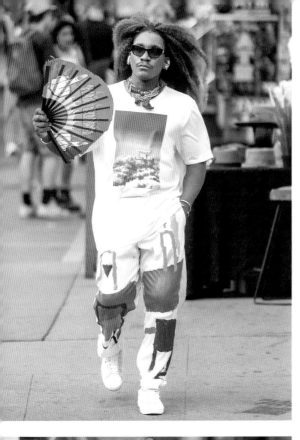
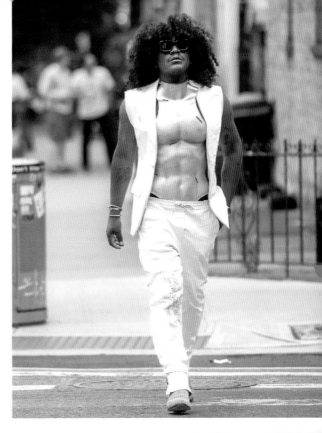
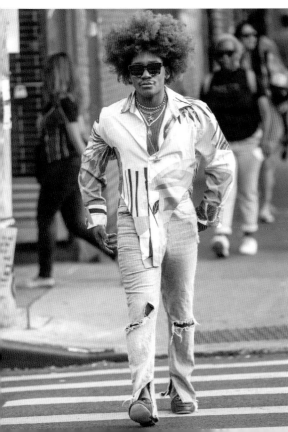
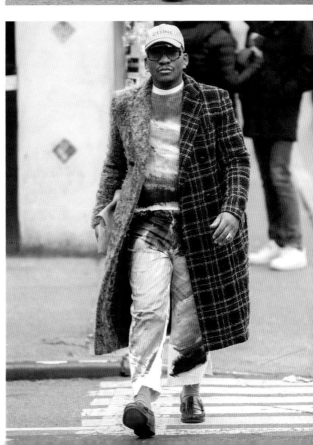

Ties,

Trench Coats,

Two-Piece

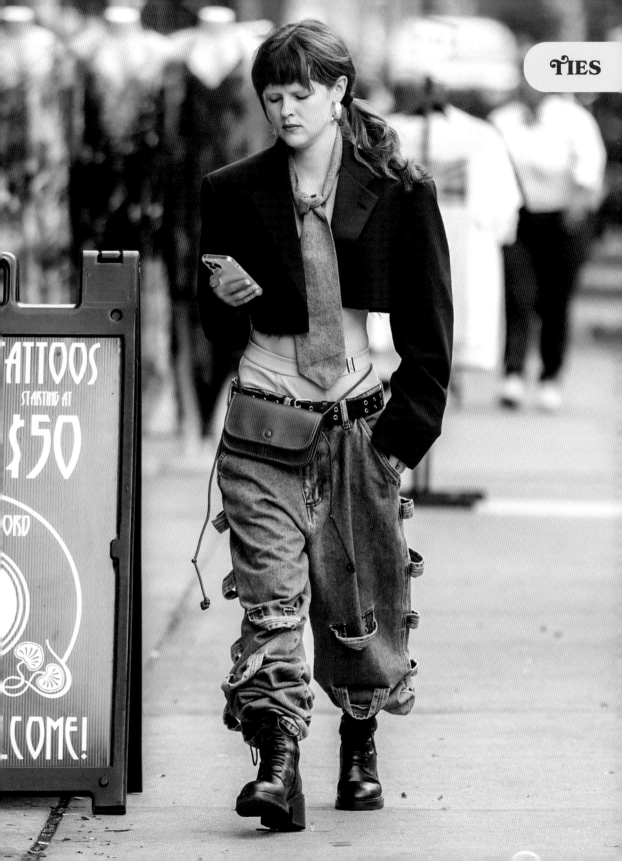

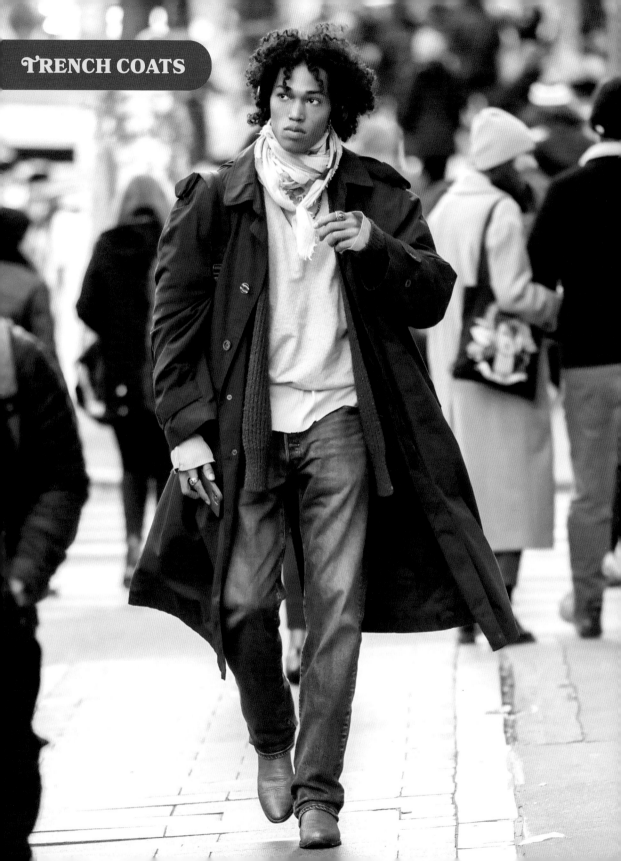

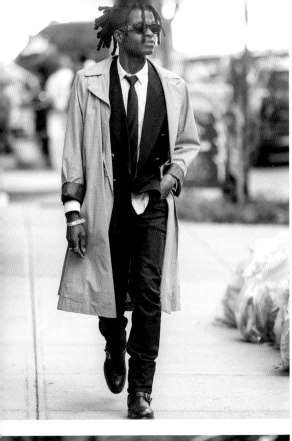
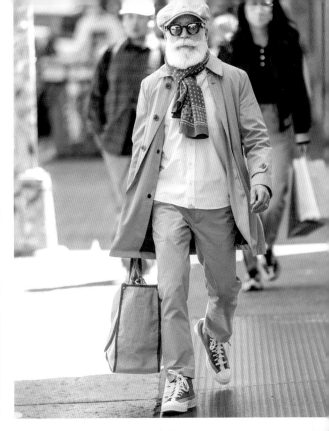
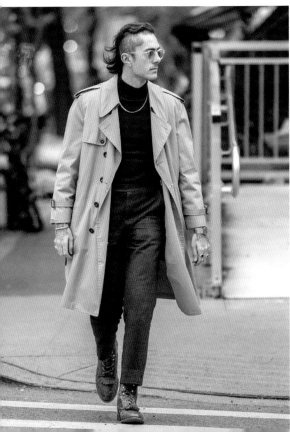
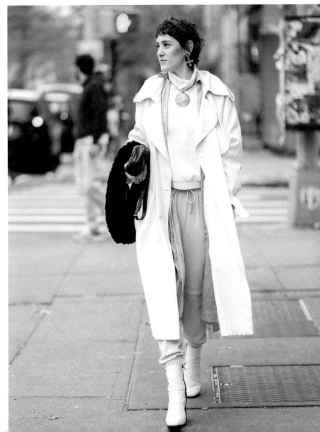

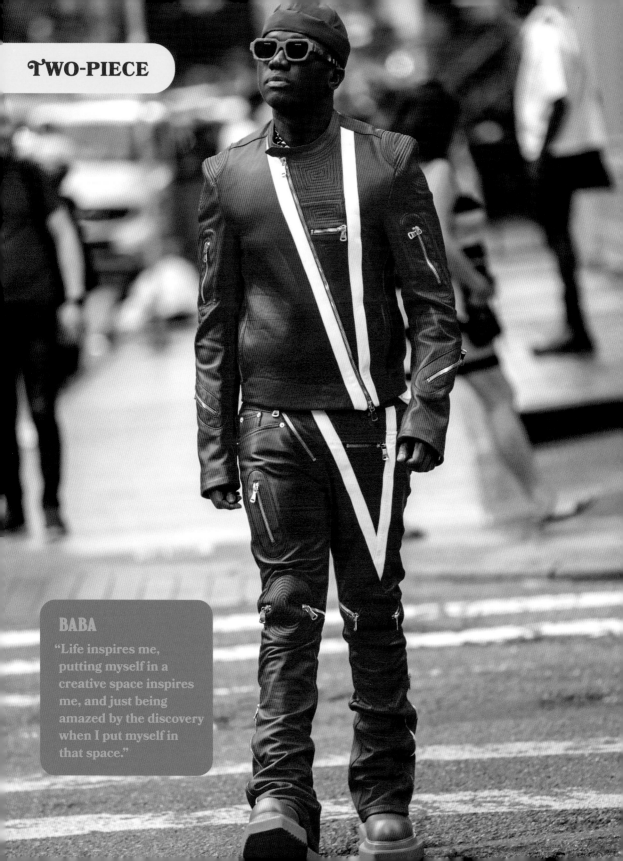

BABA

"Life inspires me, putting myself in a creative space inspires me, and just being amazed by the discovery when I put myself in that space."

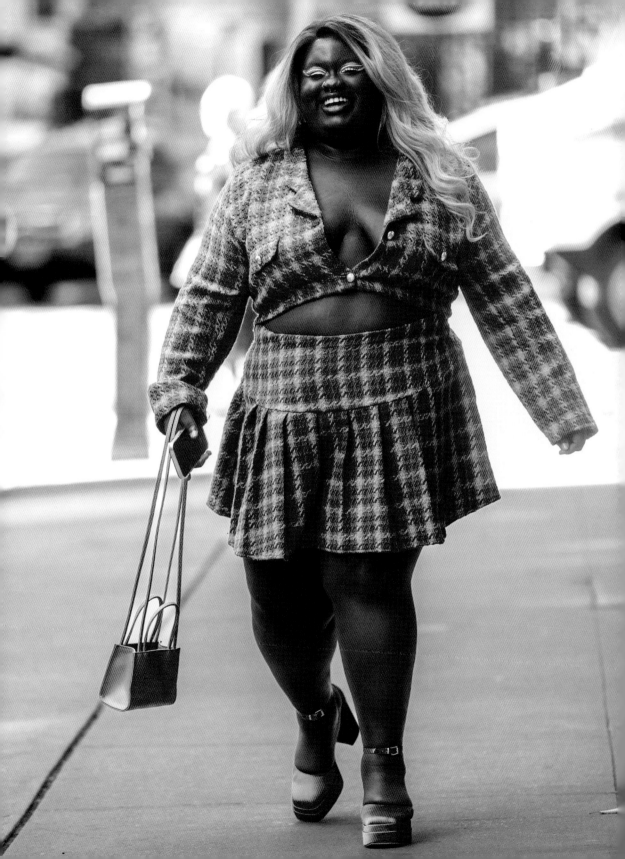

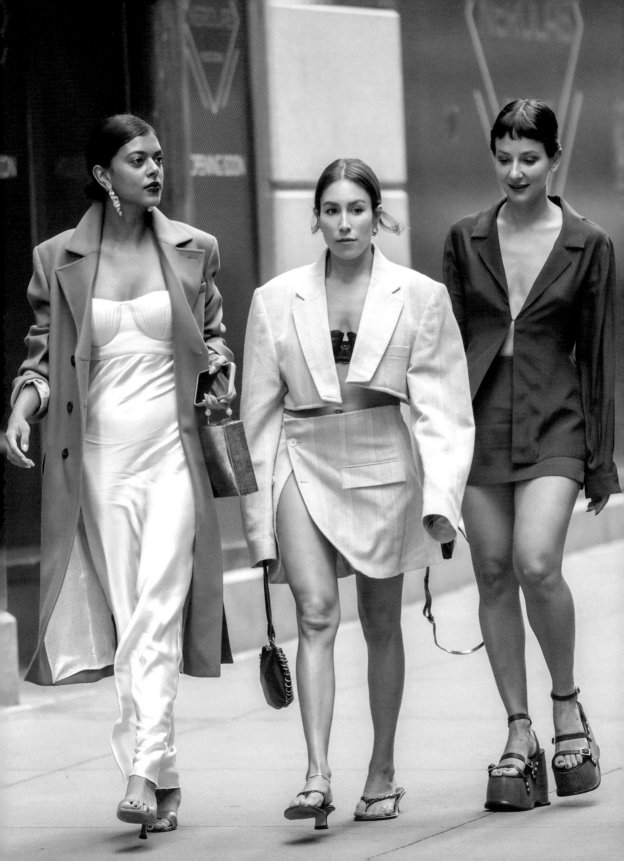

Unique

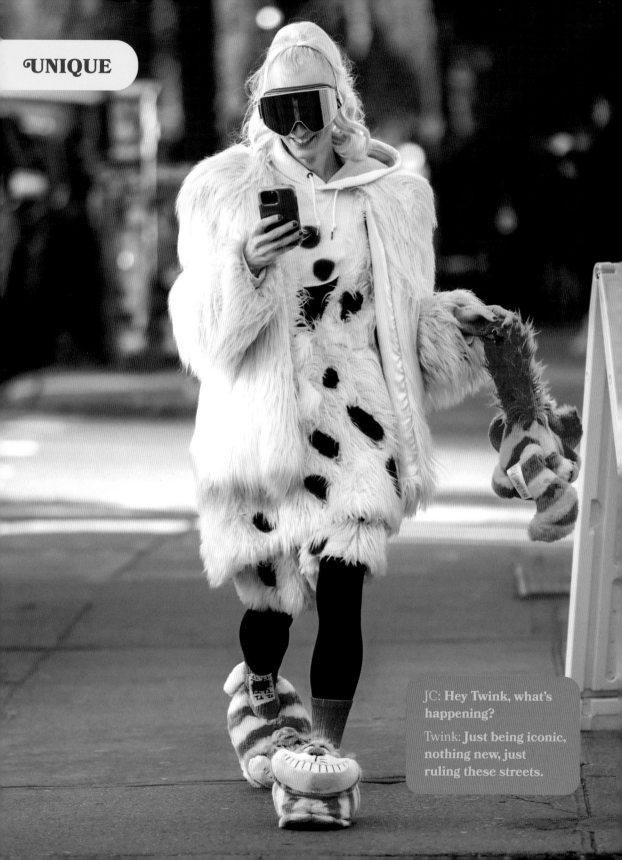

JC: Hey Twink, what's happening?

Twink: **Just being iconic, nothing new, just ruling these streets.**

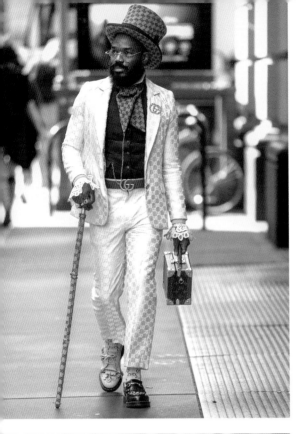
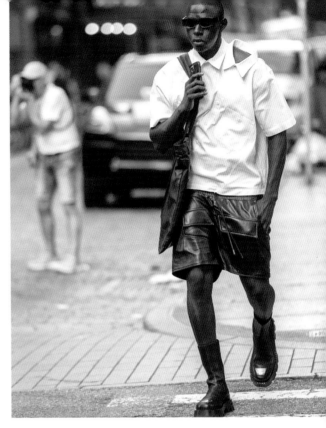
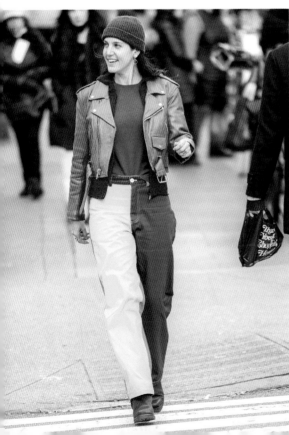
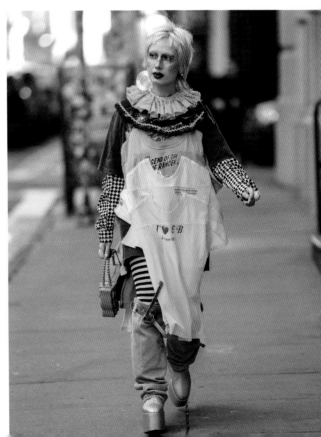

JC: **Israel, this is some very unique footwear that I've never seen before. You told me that you made all this. Can you tell me about it?**

Israel: **The eyewear and the footwear are both made from material that I made from scratch called vernum.**

JC: **What's the intention behind the design?**

Israel: **To inspire other people to really be confident in how they dress. To be themselves and what they wear and not be afraid to stand out. I'm really inspired by a lot of futuristic movies like *Blade Runner*, even inspired by Blade himself. I like just being extremely avant-garde but combining that with the streetwear aesthetic.**

JC: **Have you been designing your whole life?**

Israel: **I've always been creating. I would go buy from a thrift store and reconstruct them and paint and add my own aesthetic. I've been doing that since I was in elementary school. Now I'm in college and I'm still doing it.**

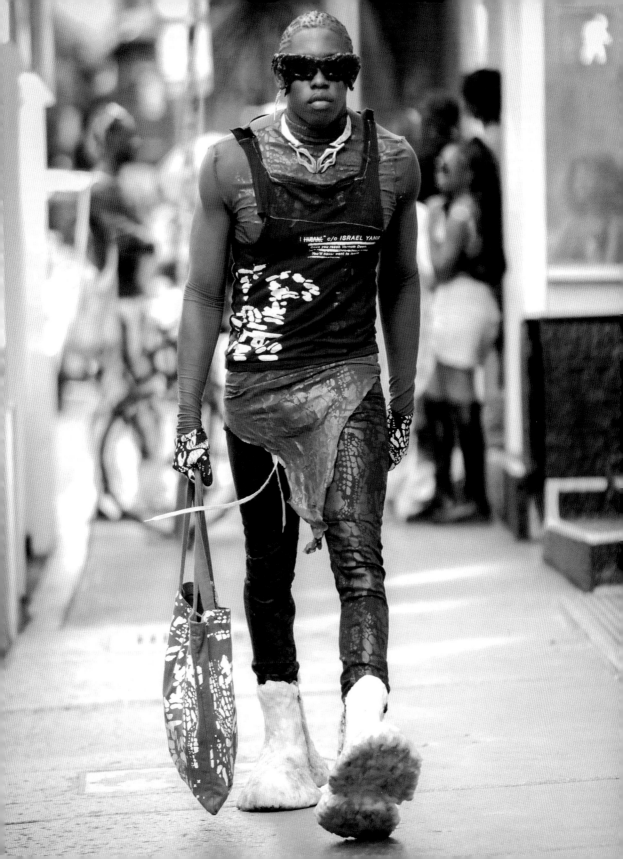

Varsity,

Velvet,

Vests

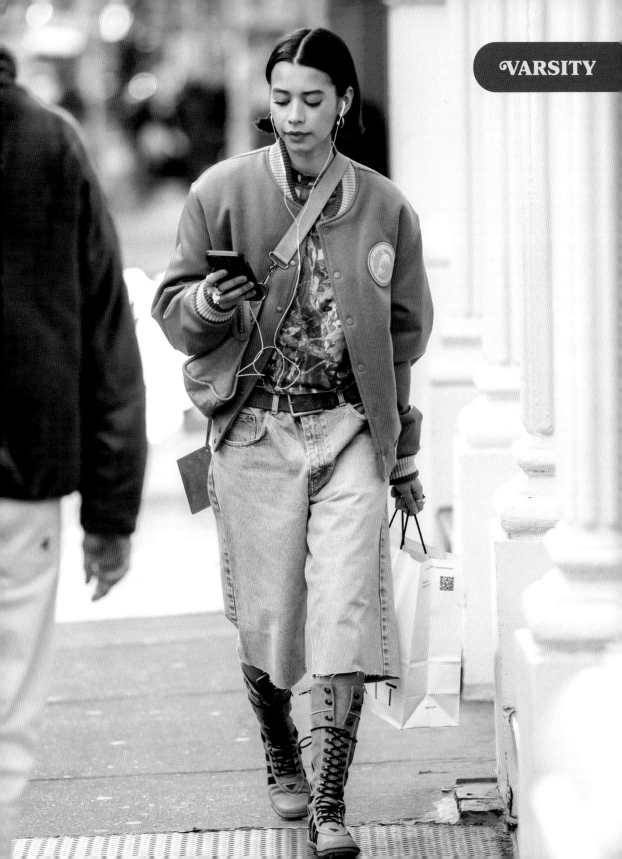

Shamir: **This is a varsity jacket by INC, and then I have these Issey Miyake trouser pants. This is a Vans mule, a collab with A$AP Worldwide. Brixton fisherman hat and my favorite piece: freshwater pearls with a little bit of gold on it.**

JC: **Shamir, can I just ask you, your nails look very manicured . . .**

Shamir: **Oh yeah, of course, manicured nails are essential. If you wanna paint them, that's up to you, that's all good, but I like to keep it clear with a nice gel coat. I'm a stylist, so I like to just show different ways to put outfits together.**

JC: **How do you go about styling somebody?**

Shamir: **I try to get a gist of your style, and then once we get into the mix of putting outfits together that work for you and you feel confident, then I'm gonna throw a wild card piece because I like to play with color. For me, it's all about feeling confident. If I make you feel confident in what you got on, my job is done. If you look good, you feel good, and like Deion Sanders said, you play good.**

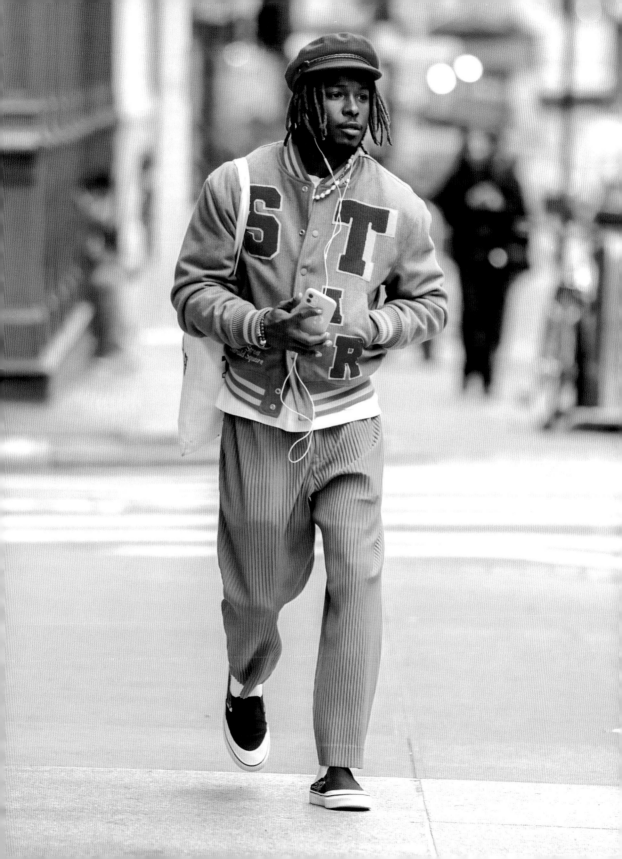

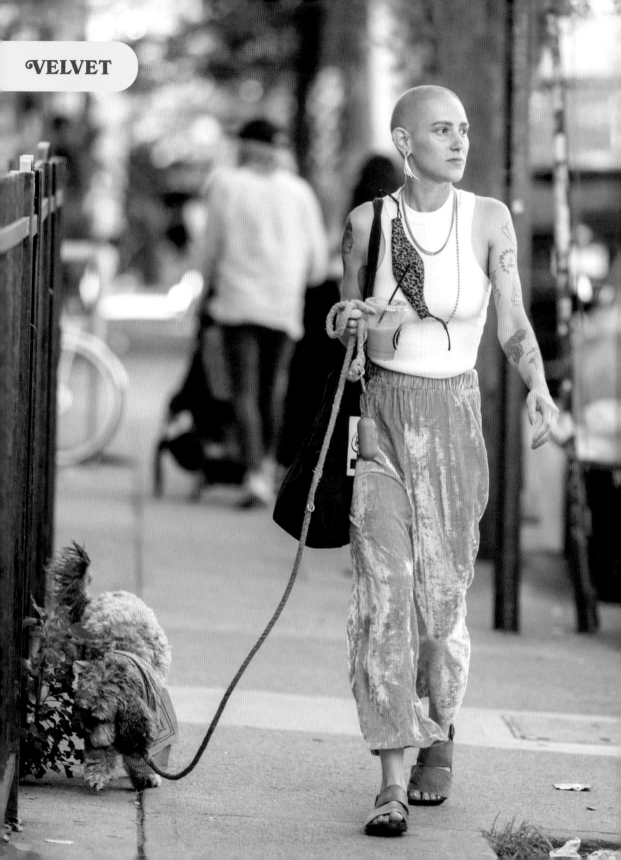

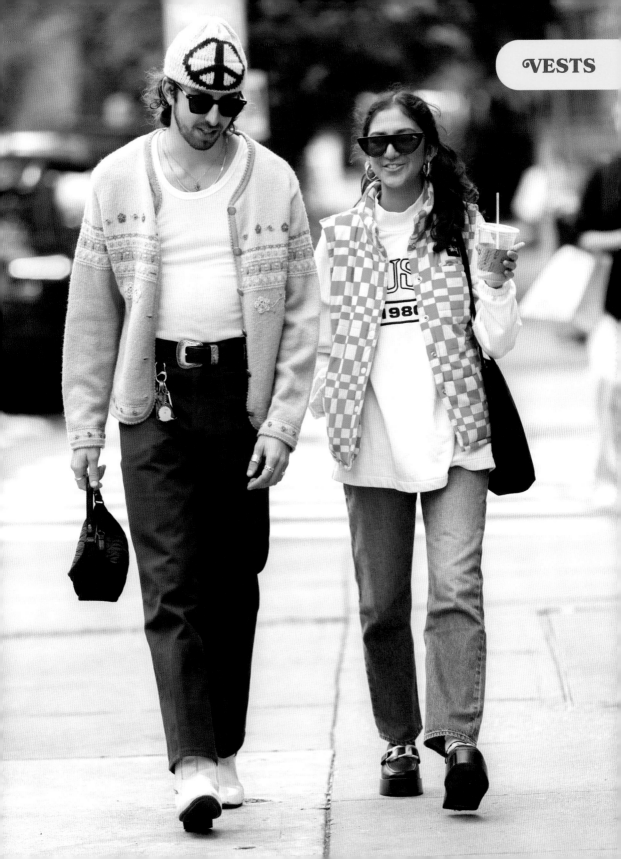

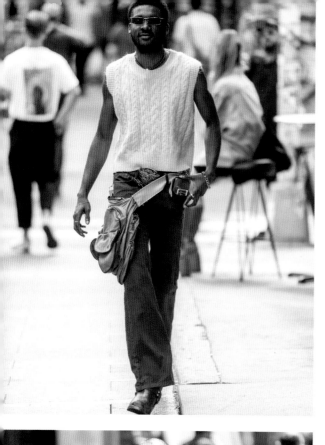
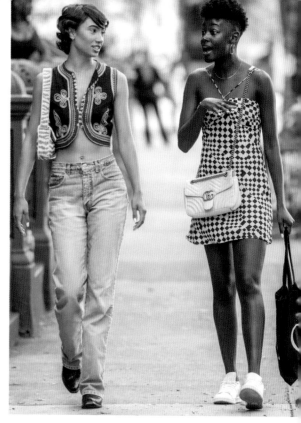
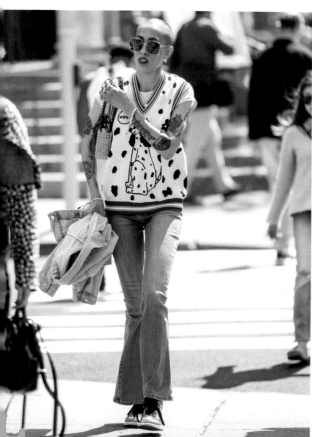
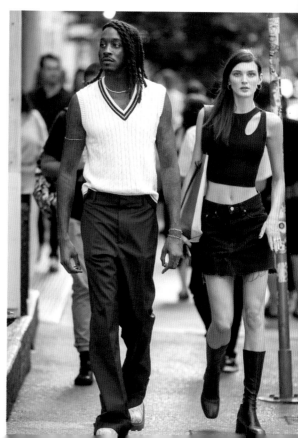

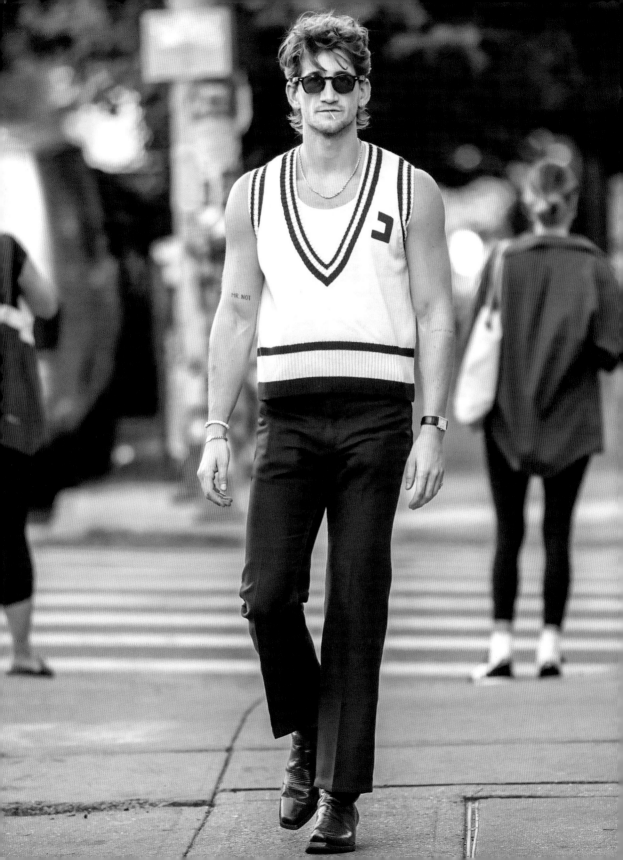

Western,

Wide Leg,

Windowpane,

Winter Coats

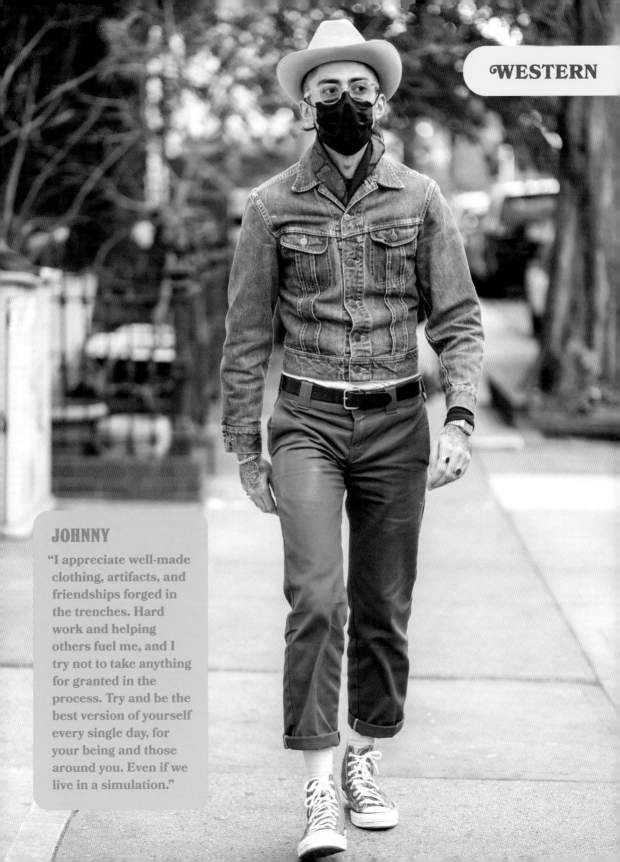

JOHNNY

"I appreciate well-made clothing, artifacts, and friendships forged in the trenches. Hard work and helping others fuel me, and I try not to take anything for granted in the process. Try and be the best version of yourself every single day, for your being and those around you. Even if we live in a simulation."

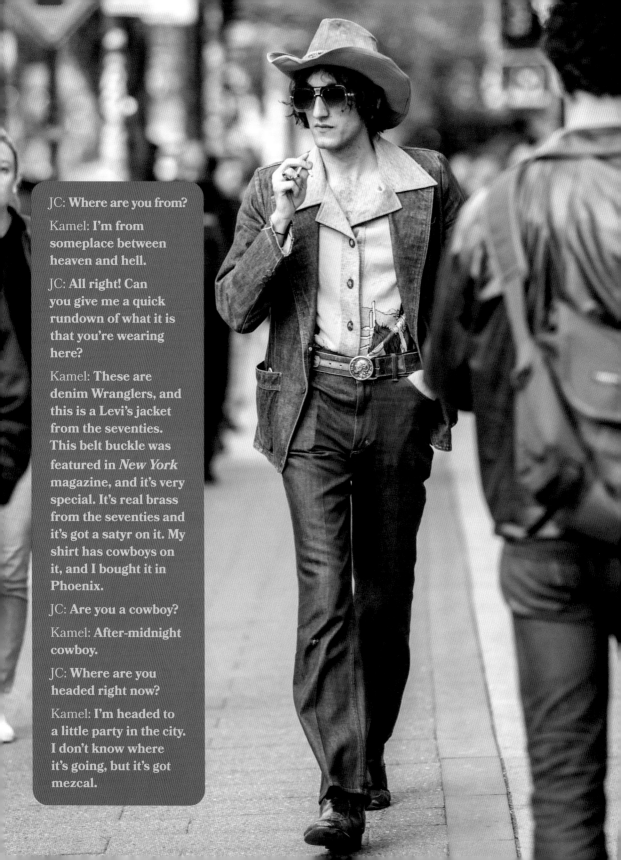

JC: Where are you from?

Kamel: **I'm from someplace between heaven and hell.**

JC: All right! Can you give me a quick rundown of what it is that you're wearing here?

Kamel: **These are denim Wranglers, and this is a Levi's jacket from the seventies. This belt buckle was featured in *New York* magazine, and it's very special. It's real brass from the seventies and it's got a satyr on it. My shirt has cowboys on it, and I bought it in Phoenix.**

JC: Are you a cowboy?

Kamel: **After-midnight cowboy.**

JC: Where are you headed right now?

Kamel: **I'm headed to a little party in the city. I don't know where it's going, but it's got mezcal.**

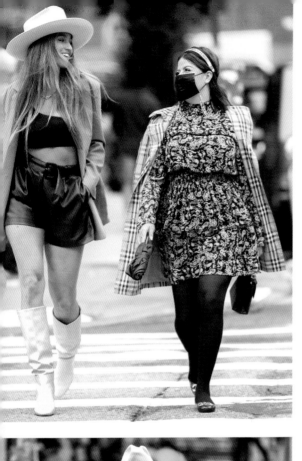
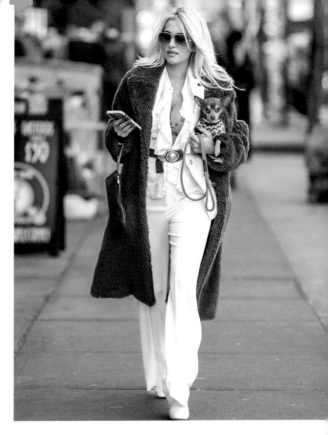
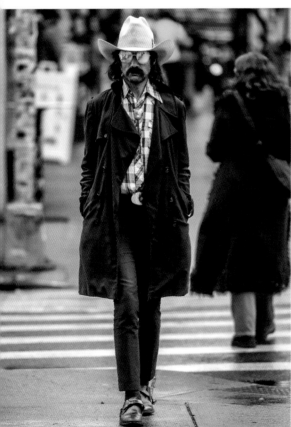
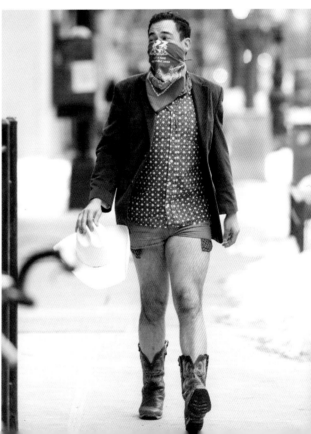

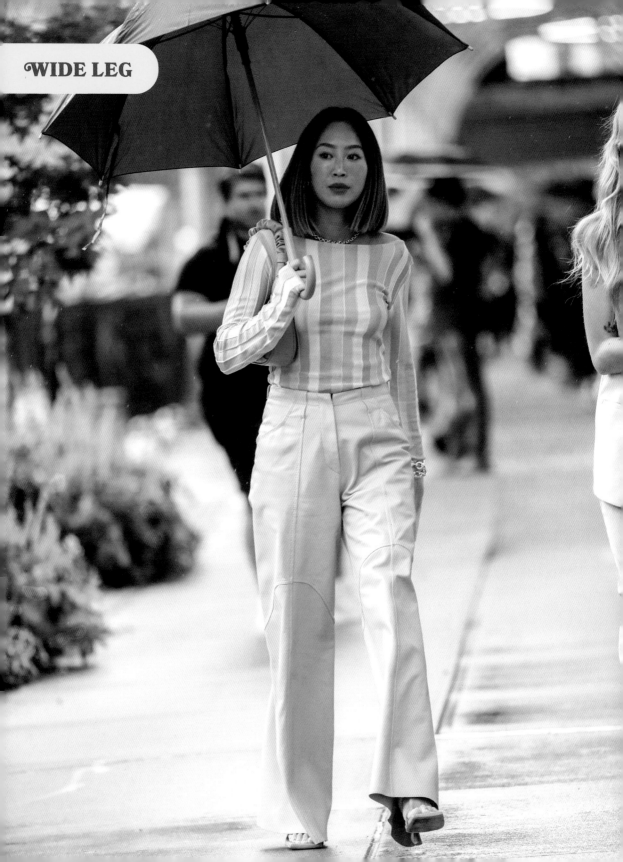

WIDE LEG

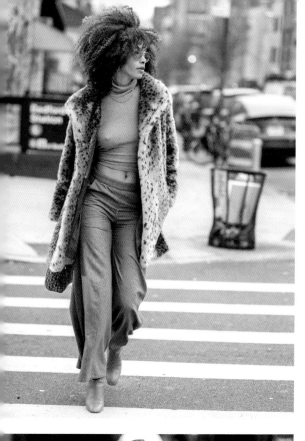
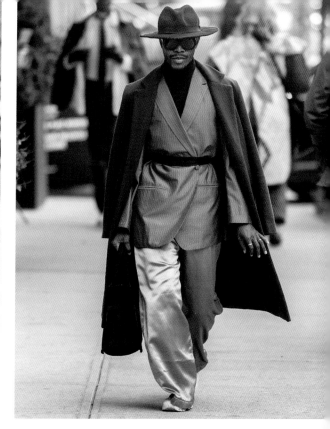
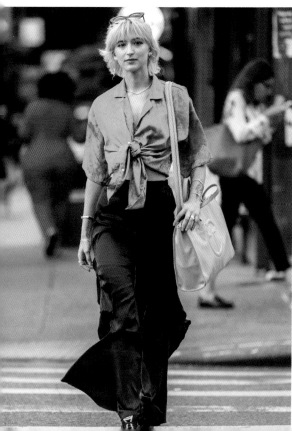
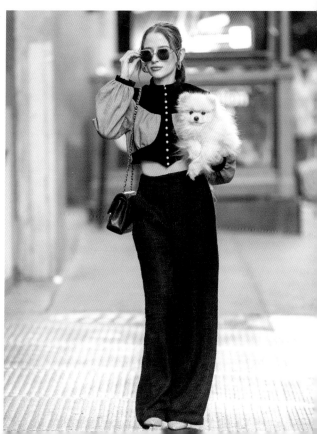

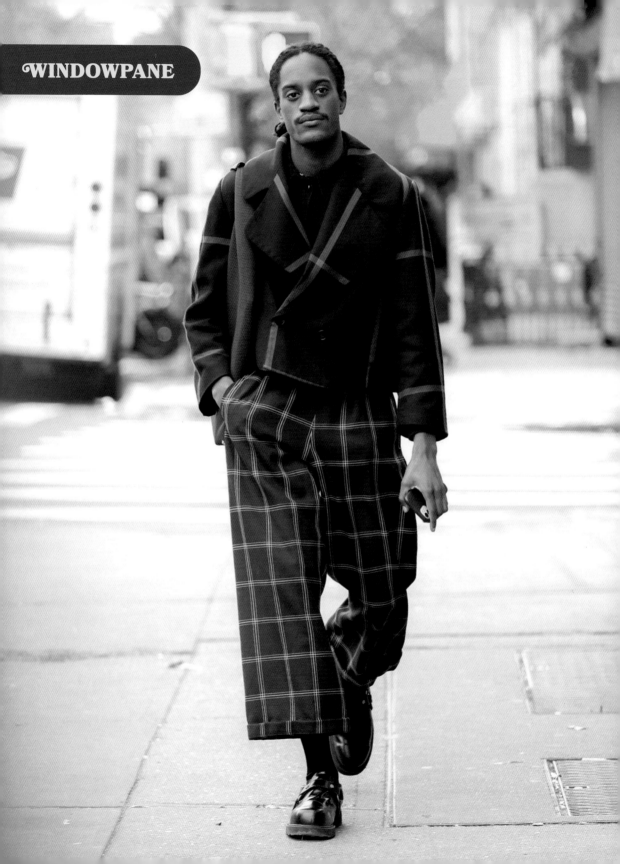

JC: **I just saw you crossing the street—what are you wearing? I've never seen any of this stuff.**

Brandon: **There's a couple things going on. This is Marni, a little Margiela, Phillip Lim, and Sandro Paris.**

JC: **Where do you go dressed like this?**

Brandon: **Nowhere important; you know, just to walk around, get a chai.**

JC: **What is it that you do?**

Brandon: **I do photography, black-and-white almost exclusively. It ranges from portraiture to landscapes to all types of things.**

JC: **What is it about photography that you enjoy?**

Brandon: **That's a beautiful question. I think one of the easiest answers is that it's a medium where you can freeze everything that's going on and scrutinize all the details and beauty of the scene.**

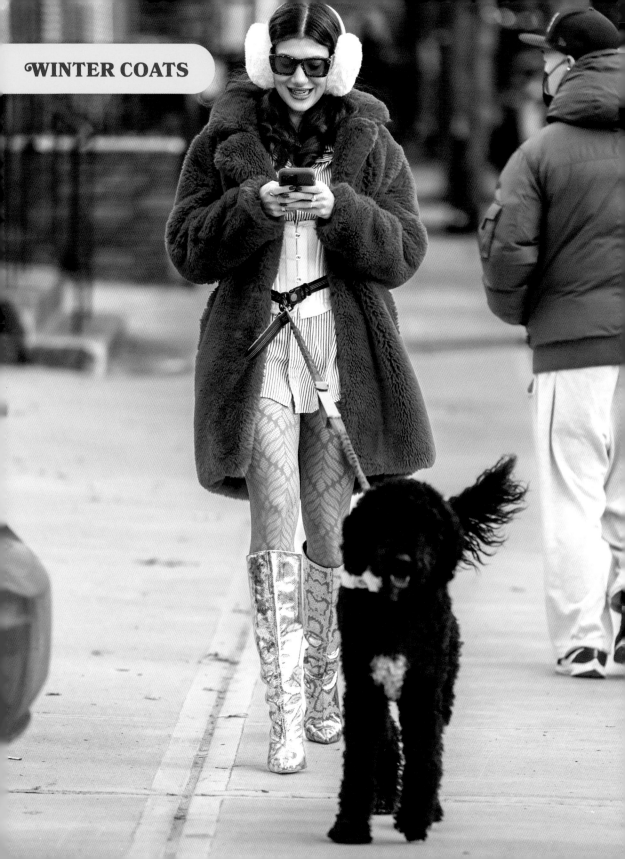

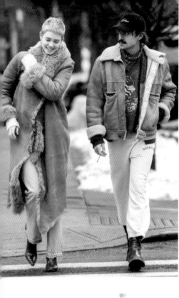
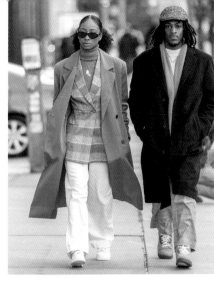
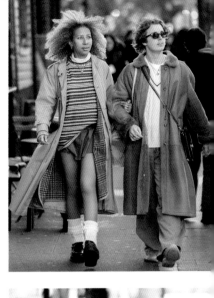
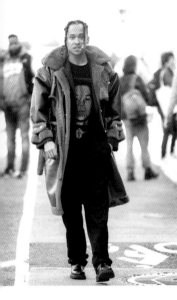
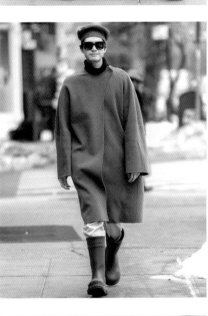
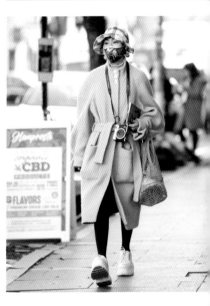
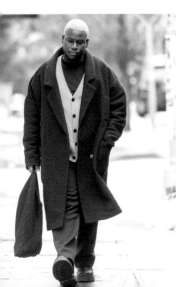
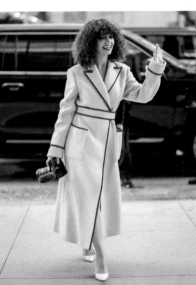
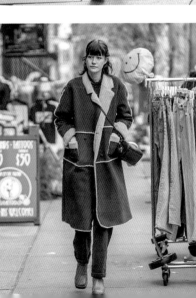

COREY

My childhood was shaped by movies like *The Goonies, Stand by Me*, and *The 'Burbs*, all of which starred Corey Feldman. "We called the pizza dude!" is something I say any time I order a pie. I caught this shot of him walking with his wife, Courtney, and a couple friends down Thirty-Fourth Street in Manhattan. We chatted for a few minutes, and it was a moment I'll never forget. He asked me an equal number of questions as I asked him and didn't leave until I mentioned letting him get back to his friends and genuinely seemed like a real nice fella. I asked him, "Where do you get your fashion inspiration from?"

"Everywhere. To me you're a living piece of art, right? We all are. Our fashion speaks for who we are, it gives us a voice, it gives us individuality. I think everybody should always dress to impress, always live your fullest and enjoy each day by making it colorful, loud, whatever you want it to be."

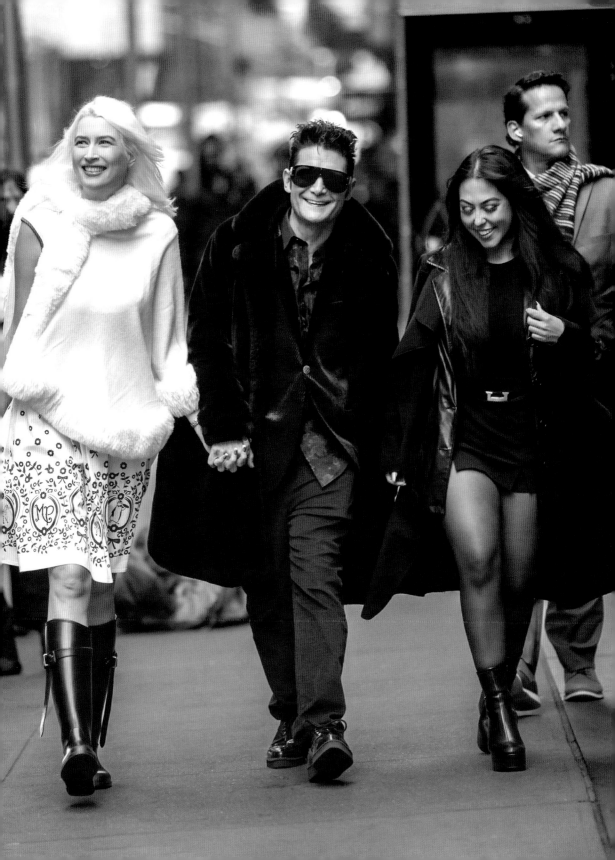

X-Ray Fabric

Yin-Yang

Z

**Zebra and
Other Animal Prints**

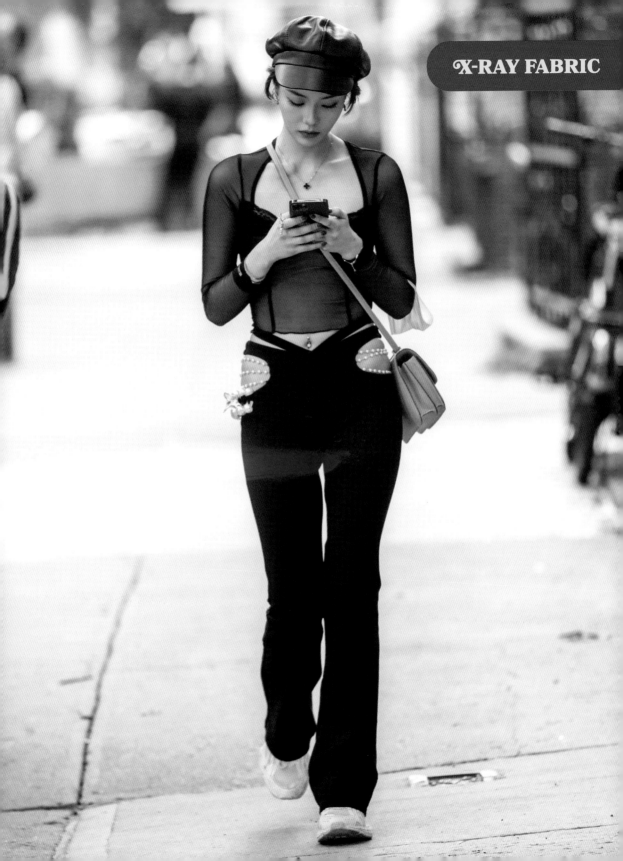

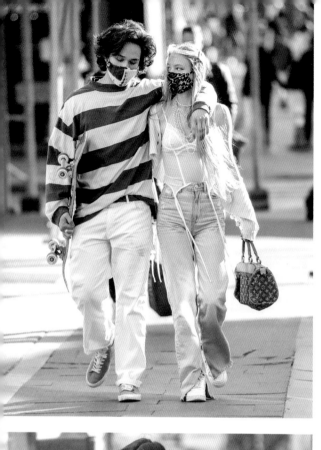
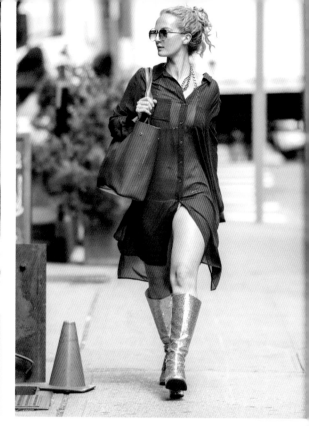
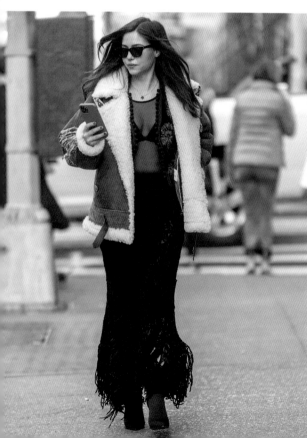
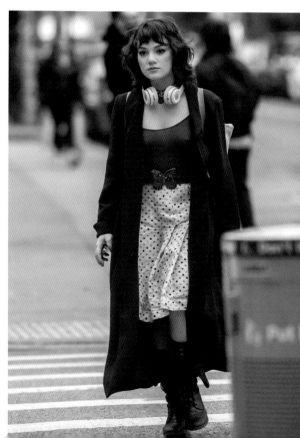

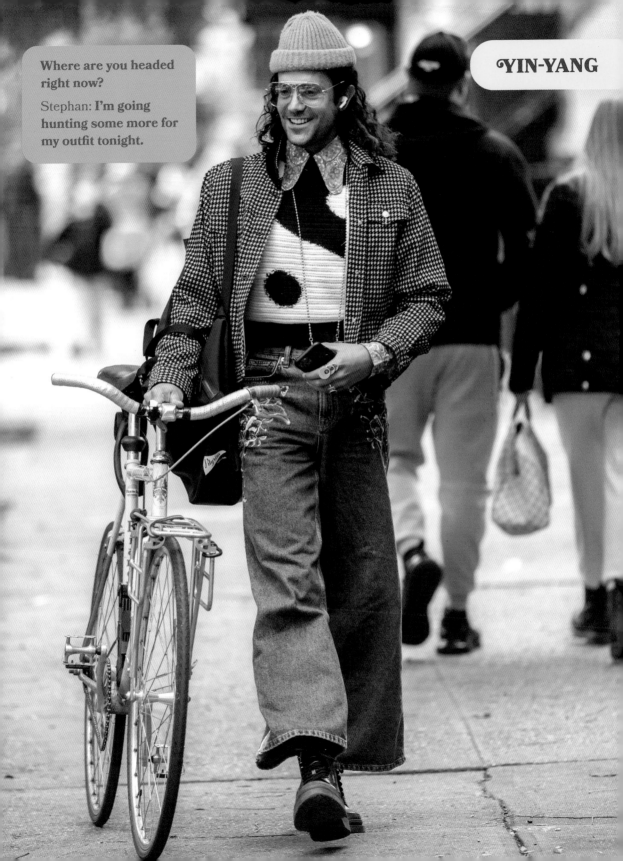

Where are you headed right now?

Stephan: **I'm going hunting some more for my outfit tonight.**

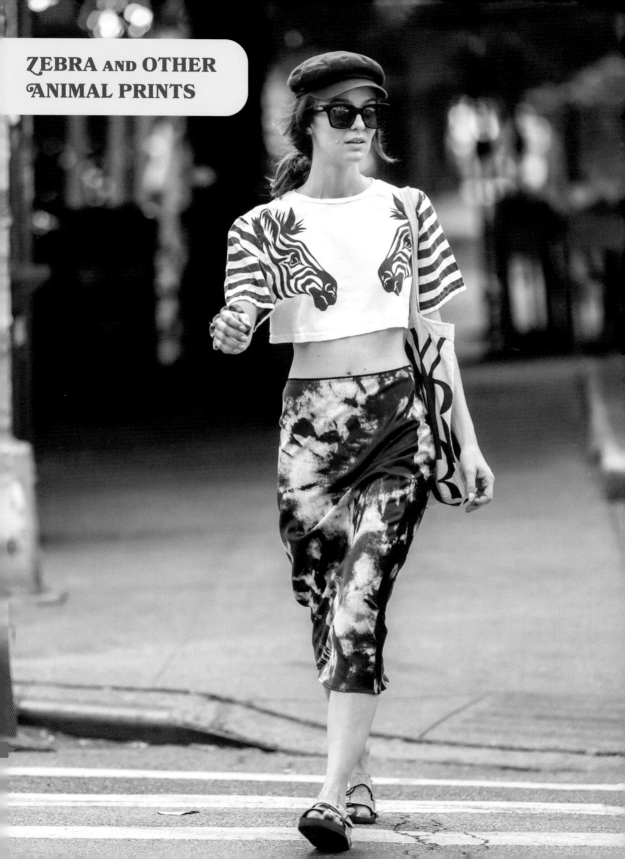

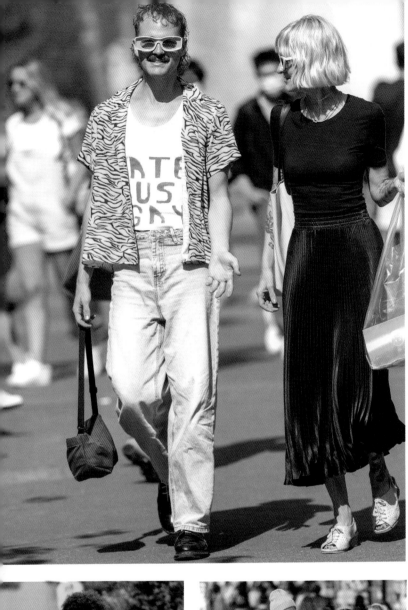
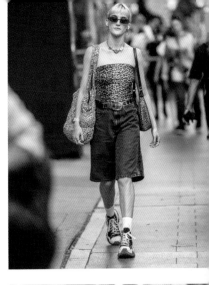
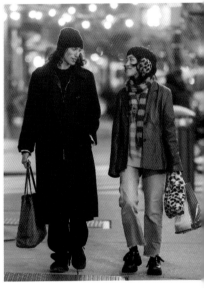
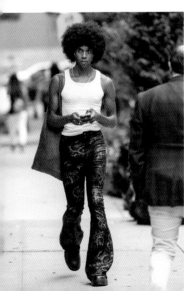
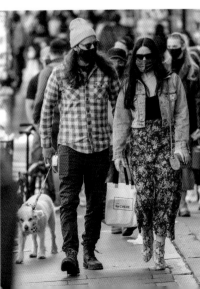
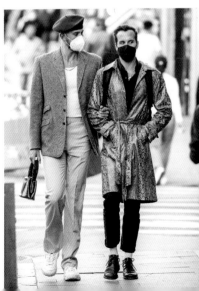

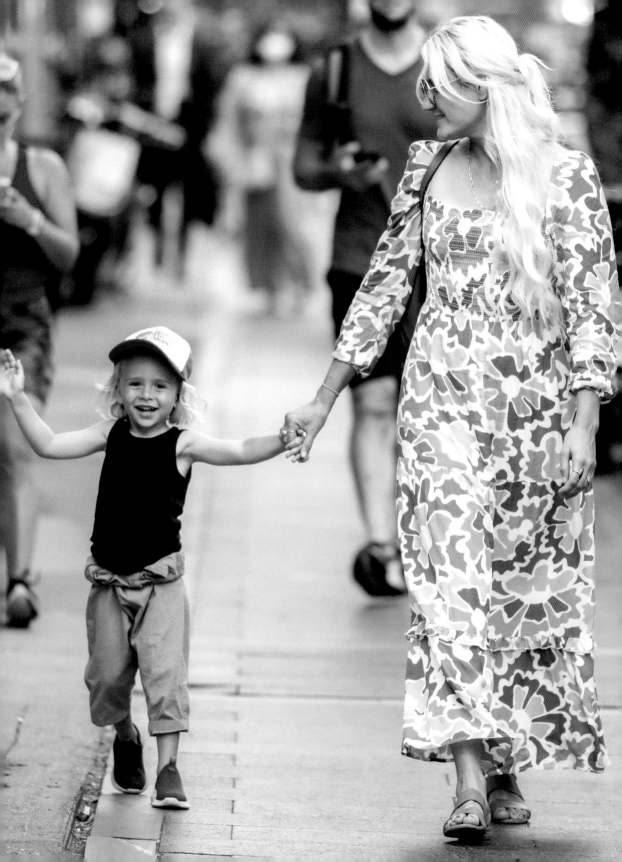

ACKNOWLEDGMENTS

I'd like to start this list at the tippy top of the mountain. I could not have done this or much else for that matter without my wife, best friend, and flawless momma, my Krissy. She believed in me when few did and encouraged me in ways that inspired. In a day, she would make sacrifices that I felt guilty over, pay the rent and bills, defend me to others, and at night tell me how much she loved the work I made that day. If there's anyone who deserves credit, it's her. Thank you, my babe.

To my dad, thanks for, even when I was little, treating me like an equal and always putting your family first. We always noticed. To my momma, who showed me her photographs from the sixties and gave me my first camera. I loved when we would sit down and color black-and-white photos with your old oils. You have more creativity on your earlobe than I have in my entire body. To the both of you, thank you for teaching me how to be good and how to be a good parent. I learned from the best.

To my little brother Nicky, the guy who's always watching Watching New York! Sorry for punching you when you were better than me at Bond, and for that shot to the face with the rubber band from upstairs. Some of the greatest memories in my life are running around the Smithtown house and playing together. You always make everyone feel included no matter what you do and are a master at creating inside jokes at the speed of light. Love you, little bro!

To my cousins, aunts, uncles, brothers-in-law, mother-in-law, and Grams, family time is the best time, and I'm so thankful for all of you.

To the ones who left, I think of you every day. Every day. Thank you for always listening.

To my friends, thank you for letting me stick a camera in your faces and bother you throughout the years. Each one of you has a piece of my heart.

To my eleventh-grade teacher Mr. Caskey, you showed me a new way that no other teacher had done before. Thank you.

To my eleventh-grade film teacher, Mrs. Smith, you inspired us all with your freedom and kindness. You were

a friend to us before a teacher. Thanks for showing me that it's art first, and to think outside the box and use your imagination. I think of you often and proudly display my "Smitty" award on my shelf and always will.

To the streets and people of New York City without whom I certainly could not have made this book, I thank you. Just when I thought I've seen it all, here comes something bigger and brighter than ever before. Keep going!

To Gigi Hadid, who I can't even believe I'm thanking in my book! She took time out to craft a beautiful foreword and treats all equally and fair in life. An inspiration.

To my neighbors who I love and adore, may all four winds always be at your backs.

To the top ten creative people who don't know me but who I have looked up to since I was little: Kevin Smith, Charles Bukowski, Jim Henson and Kermit, Elliott Smith, Martin Scor-

sese, Casey Neistat, Wes Anderson, Bill Cunningham, and Eddie Vedder.

To my literary agent, Garrett McGrath, for taking me on this journey and patiently holding my hand through the flames. Your ideas and suggestions shaped this into the book I had always dreamed of creating. Thank you.

To Soyolmaa Lkhagvadorj at Abrams, who on the first phone call was so enthusiastic I had to stand up the entire time. Thank you for ushering me in the directions you have and for pushing me to use my voice inside here.

To my dog, Louisiana, who is always at my feet looking over me.

And to my son, Cassius, who is five. Your innocence is beyond my understanding, and the love I feel for you I didn't know existed inside me. Thank you. When I told him I was making a book he simply asked, "Will it have lots of pictures?"

"As a matter of fact kid, it does."

ABOUT THE AUTHOR

Johnny Cirillo was born in Jackson Heights, Queens, in 1980 to a father who delivered UPS packages in the Garment District of Manhattan and a very creative stay-at-home mom. During high school on Long Island, he developed a passion for photography when his mom gave him his first 35mm and shared with him some of her black-and-white photographic work from the sixties. Film and photography became an obsession. He rolled his own film, built his own darkroom, and bugged every one of his friends to sit for him as he explored all facets of the medium.

Editor: Soyolmaa Lkhagvadorj

Designer: Heesang Lee

Managing Editor: Logan Hill

Production Manager: Larry Pekarek

Library of Congress Control Number: 2023941959

ISBN: 978-1-4197-6994-8

eISBN: 979-8-88707-104-6

ABRAMS The Art of Books
195 Broadway, New York, NY 10007
abramsbooks.com